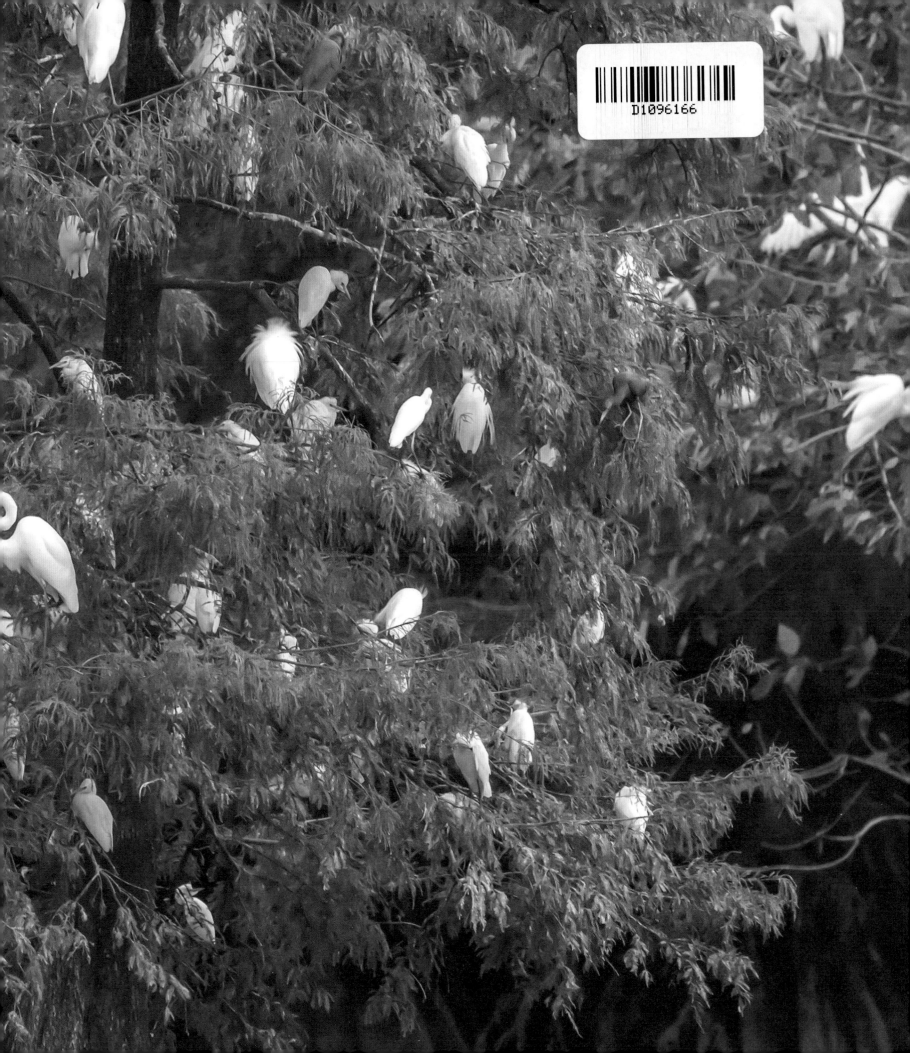

D1096166

MISSISSIPPI'S
NATURAL HERITAGE

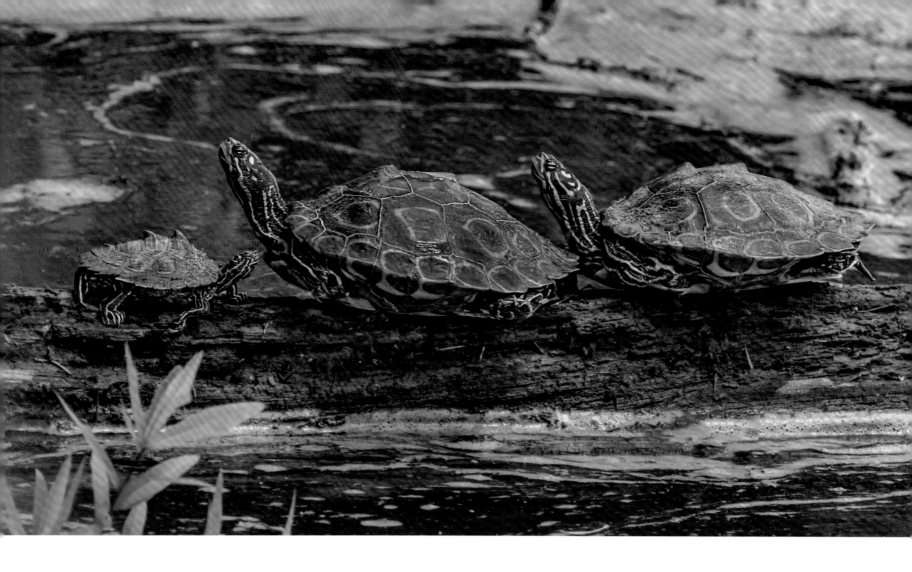

MISSISSIPPI'S
NATURAL HERITAGE

Photographs of Flora and Fauna WESLEY L. SHOOP

University Press of Mississippi / Jackson

*Publication of this book was supported in part by funds
from the Mississippi Natural Heritage Publishing Initiative.*

The University Press of Mississippi is the scholarly publishing agency of
the Mississippi Institutions of Higher Learning: Alcorn State University,
Delta State University, Jackson State University, Mississippi State University,
Mississippi University for Women, Mississippi Valley State University,
University of Mississippi, and University of Southern Mississippi.

www.upress.state.ms.us

The University Press of Mississippi is a member
of the Association of University Presses.

Copyright © 2023 by Wesley L. Shoop
All rights reserved
Manufactured in China

First printing 2023
∞

Library of Congress Control Number 2023000397
Hardback ISBN 978-1-4968-4680-8
Epub Single ISBN 978-1-4968-4681-5
Epub Institutional ISBN 978-1-4968-4682-2
PDF Single ISBN 978-1-4968-4683-9
PDF Institutional ISBN 978-1-4968-4684-6

British Library Cataloging-in-Publication Data available

To the children of Jackson:
May they always have access
to the beauty of nature and wildlife
and
To the wildlife:
May they always have a place to be wild

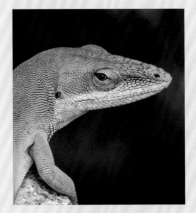

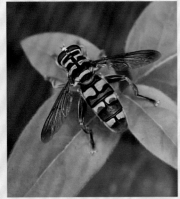

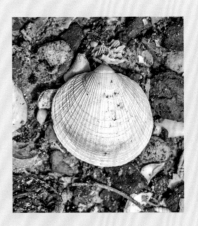

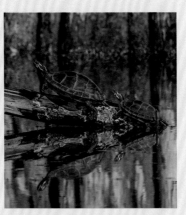

CONTENTS

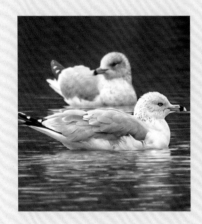

MISSISSIPPI'S
NATURAL HERITAGE

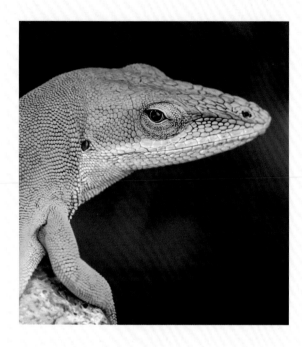

Chapter 1

INTRODUCTION

For many people, the most significant part of Mississippi's natural heritage consists of the thousands of species, both living and fossil, found there. The various species have unique life stories, and naturalists and photographers find joy in seeing and understanding those species. This volume presents photographs of diverse species spanning four kingdoms that naturalists may encounter throughout the state and provides a head start for those beginning their journey of discovering nature.

Although the species shown range widely across Mississippi, the photographs presented here were taken in one representative area, a method that has instructive advantages. First, it illustrates the beauty and diversity of life that can be found even in a small area—almost any small area—of Mississippi. Although travelling hours to distant regions to see the flora and fauna has its advantages, the point here is that hundreds of species may be encountered in local ravines and parks and even in one's backyard. Second, because every organism comes from a single area, each is related to every other in an intricately balanced web of life, meaning that an invisible but intrinsic natural structure connects them all. Plants, herbivores, predators, and decomposers all have roles relative to the others.

Third, this approach provides a deeper historical and geological context of the area in which these organisms are found—for

example, it allows the consideration of ancient and now extinct species that lived millions of years ago but are known today only by their fossils. These organisms existed before humans evolved, offering a reminder that the flora, fauna, and environment we see today has not always been as it is now. Every species in this book has its story, and all those that remain living unfold in a continuous, life-and-death play presented in an ever-changing ecological theater. It reminds us that we too are now part of that play—always as actors and often as directors.

The Pearl River is the backbone of a bottomland hardwood forest corridor more than 240 miles long from mid-central Mississippi to the Gulf of Mexico. As such, this corridor represents important habitat and a natural cross-section of the biota within the state. The Pearl River itself has a meander length of nearly 450 miles and has wandered for thousands of years within its bottomlands. The bodies of water often called lakes and sloughs adjacent to the river are actually old oxbows—vestiges of ancient river channels that were amputated unceremoniously when the river discovered more direct routes to the Gulf. Together, the river, oxbows, and floodplain comprise a narrow and nearly unbroken chain of bottomland in both Mississippi and Louisiana that is protected from development by threat of flood. This flood-protected corridor is a refugium for hundreds of species of invertebrates, amphibians, reptiles, birds, mammals, plants, and fungi.

LeFleur's Bluff State Park is a 305-acre section of the Pearl River corridor. It is located on the west bank of the Pearl River in Jackson, the capital of Mississippi. Despite its size and proximity to the state's largest urban center, this sanctuary is home to a significant percentage of Mississippi's known plants and animals. More than a thousand species of flora and fauna have been identified on its bluff and floodplain and if cataloged would fill several volumes equal to this one. None of those species, of course, is confined to the boundaries of the park, and all are distributed widely across Mississippi. The Pearl River corridor is a natural cross-section of the biota within the state, and LeFleur's Bluff State Park is a natural cross-section of that corridor. The park, in essence, is a microcosm of the state.

How LeFleur's Bluff State Park came to be is a confluence of political, geological, and hydrological axes. Originally, the land that now comprises the park was part of the Choctaw Nation. The park itself was named after Louis LeFleur, an American of French heritage. He married the niece of a Choctaw chief, Pushmataha, and

sited a trading post on the bluffs on the western side of the Pearl River in the late 1700s. Neither LeFleur nor the Choctaws could have known that 70 million years ago, much of Mississippi was covered by a 200-foot-deep sea and that a volcano erupted underwater exactly where the Choctaw camp and LeFleur's trading post lay then and Jackson and the park lie today. The volcanic uplift produced a roughly 180-square-mile island called Jackson Island in the middle of what was then the Mississippi Embayment. The volcano's height can never be known with certainty, but distorted strata associated with the igneous center were thrust upward as much as 10,000 feet. The volcanic cone height likely would have been some fraction of this, but it undoubtedly was a substantial geological event in Mississippi ancient history. Since that time, much sedimentation has occurred in what was the embayment, the sea has retreated, and erosion has truncated the uplift, but the vulcanism has left an indelible geological fingerprint known as the Jackson Dome as well as higher terrain including the bluffs of LeFleur's Bluff State Park. Jackson has the singular distinction of being the only US state capital that sits directly on a volcano. The Jackson Volcano is now considered extinct, and the tip of its igneous core lies 3,000 feet below the city. However, the deep groundwater in Jackson and the surrounding area is still warmer than the groundwater outside that zone as a consequence of volcanic heat remaining in the Earth.

The uplifted bluffs on the western side of the Pearl River in Jackson provided ideal sites to access the river while protecting early inhabitants from its annual floods. The trading post LeFleur established on that high ground allowed him to exchange goods and furs with the native Mississippians and have access to the Gulf of Mexico and the rest of the world via the Pearl River. He also had access to the developing Natchez Trace, a wilderness highway between the cities of Natchez on the Mississippi River and Nashville in the Ohio River Valley. The nascent Mississippi Legislature, then in Natchez, was searching for a site for a permanent, centrally located state capital, and homed in on the same characteristics LeFleur found attractive for his trading post. Depending on exactly where the state's boundaries were drawn, LeFleur's Bluff was about 20 miles away from the true center of the state. No matter where the lines were drawn, LeFleur's Bluff was more central than Natchez. As the young capital established and grew, the colloquial name LeFleur's Bluff nearly vanished into history, giving way to the name Jackson, after the hero who saved New Orleans in 1812. Interestingly,

both LeFleur and Pushmataha served as officers under Jackson in the Battle of New Orleans, but name and rank clearly had their privileges.

Over the years, the development of roads and railways lessened Jackson's dependence on the Pearl River for transportation, but the capital has remained inextricably tied to the river for drinking water. And just as the Pearl River has provided that life-sustaining water, its seasonal floods have repeatedly menaced Jackson and the surrounding cities as they encroach ever deeper into its floodplain. As in the rest of the Pearl River corridor, that seasonal flooding has protected much of the park from modern development and kept its bottomland hardwood forests wild.

Nearly 600 species of plants and over 200 species of birds have been recorded in LeFleur's Bluff State Park, a significant proportion of the total found in greater Mississippi. Among reptiles, the park is home to the apex predator in the state, the American alligator, as well as venomous snakes and one of the most endangered and beautiful turtles in the world, the ringed sawback turtle. No attempt has even been made to catalog the park's insects and other extant invertebrates, which likely comprise the largest groups of all. In fact, the Pearl River is named for the many species of mussels found there and the occasional pearls they produce. Le Page du Pratz's 1758 map refers to the waterway as the River of Pearls.

LeFleur's Bluff State Park is not only a living ecosystem comprised of a significant percentage of extant species found in Mississippi but also a cemetery of sorts of the area's ancient past. The park is a type locality for numerous extinct species, many of which lived here 35 million years ago, when much of Mississippi was underwater. Because of the volcanic uplift, the bluffs expose fossil-laden strata that create a rare opportunity to observe remains of organisms that no longer exist. These fossil remains, all of which are marine, remind us that the area we know as a park—and the entire state—have a greater and more complex history than most observers would ever guess.

At the end of the nineteenth century, nearly 95 percent of the entire human population lived in rural areas and the small remainder was found in urban settings. Today, those percentages have reversed. During that unplanned societal migration, our formerly intimate relationship with the flora and fauna has become estranged. We now live with fenced yards, manicured lawns, and nonnative plants and can rarely identify even the backyard birds. At the same time, our impact on wildlife has been magnified as our excesses have pushed them and their habitats to the margins. The Pearl River

corridor is one of those margins. This effort cannot rectify those excesses, nor can it provide an exhaustive list of all that is there, but illustrating some of the living diversity found in this state, this corridor, and this park can instill a greater appreciation of what we have and how impoverished we will be if we do not protect it. Mississippi is our home and our heritage, but it does not belong to just us. The photographs found herein are in situ images of the invertebrates, amphibians, reptiles, birds, mammals, plants, and fungi as naturally observed in the park and in the state that is their home too.

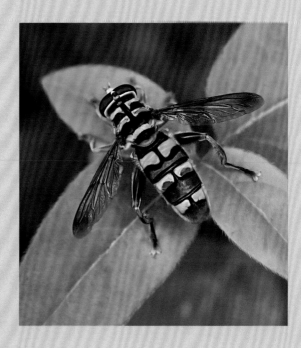

Chapter 2

INVERTEBRATES

Invertebrates are animals that lack backbones. The term covers a wide variety of groups such as sponges, cnidarians, worms (flat, round, and segmented), mollusks, echinoderms, arthropods, and numerous lesser phyla. Many of these groups have not evolved adaptations for life on land and almost exclusively comprise marine species. As such, they do not occur in either the park or terrestrial Mississippi as living specimens, but some can be found as fossils (see chapter 3) from when this area and much of the state was a shallow sea. This chapter covers the living invertebrates that naturalists are likely to observe on casual hikes in the park or elsewhere in the state.

Without question, the most likely invertebrates to be encountered are found within the phylum Arthropoda and are the Insecta. In fact, insects are the most numerous animals on the planet, comprising between half and three-quarters of all scientifically described species. Groundbreaking theoretical ecologist Robert May, when asked to describe life on this planet in one word, said, "Insect." Members of this class have colonized virtually every niche in fresh water, land, and air and serve as important internal and external parasites of other animals and plants.

What has made insects so successful? For one, they have an exoskeleton (a skeleton on the outside of the body) made of chitin

that protects internal organs and tissues, reduces water loss, and provides rigidity for muscle attachment. Development of chitin, a long-chain sugar polymer with simple nitrogen side chains, was an evolutionary innovation that allowed insects to divorce themselves from water, a feat that few of their invertebrate relatives ever accomplished. As a result, in terms of numbers of organisms and species, insects have colonized land like no other.

Insects also were the first animal group to divide their bodies into heads, thoraxes, and abdomens, thereby allowing different parts to specialize for specific functions, an evolutionary advancement over the simple repetition of segments that is observed in annelids such as earthworms and leeches. That three-part body plan is seen today in vertebrates, including humans. As adults, all insects have six legs, increasing their mobility on land relative to their wormlike ancestors. In fact, many of their larval stages are still very wormlike. Moving quickly requires an animal to have senses that are equal to the task of interpreting the environment. Insects have compound eyes, which give them excellent vision that rivals that of any other invertebrate except some in the Mollusca. Speaking of moving fast, one of the key evolutionary inventions of insects is they were the first animal group to develop flight—in addition to being strong, chitin is light. Most adult insects have two pairs of wings, but some, such as flies, have lost one pair, while others (among them fleas, lice, and ants) have secondarily lost both pairs for parasitic or ground-dwelling modes of existence.

Insects are familiar to everyone and can be divided into many diverse groups with common names such as flies, fleas, mosquitos, gnats, lice, botflies, moths, butterflies, beetles, dragonflies, damselflies, wasps, bees, ants, grasshoppers, and true bugs. As they should, insects comprise the majority of photographs in this chapter. And if we were truly being fair, they would comprise most of the photos in this book. But we will sacrifice some of that fairness in the interest of diversity.

Anyone traversing the trails of LeFleur's Bluff State Park will frequently encounter members of other invertebrate groups. It is almost impossible for a summer or fall hiker not to find spiders and their webs. Spiders are another group of arthropods that have chitinous exoskeletons. Their bodies, however, are divided into only two parts: the head and thorax are fused to make a cephalothorax, while the abdomen remains separate. All spiders have eight legs and run down, ambush, or trap their prey with silk webs. Be thankful they cannot fly. Some, such as the golden silk orb weaver, can reach the size of a human hand and produce golden webs 1.5 meters (5 feet) across.

Numerous other orb weavers also set silken traps for insect prey. In contrast, wolf spiders forgo webs and hunt along the forest floor, fishing spiders hunt on the surface of water, and jumping spiders hunt in the vegetation.

Naturalists are also likely to encounter members of another major invertebrate group, mollusks—snails, slugs, and mussels. Mollusks are soft-bodied animals that often have hard calcium carbonate shells for protection. Some mollusks, such as slugs, have secondarily lost or reduced shells. Because of the hard shell, many mollusks are better represented in the park's fossil beds than as living creatures. Mollusks typically have a muscular "foot" for locomotion or burrowing. They are generally grazers or filter feeders, but some are carnivorous. The Pearl River derives its name from pearls found in the many mussel species that live there. The mussel industry was significant on the river in decades past, and mother-of-pearl provided material for buttons and other objects before the advent of plastic.

Because of the severity of the spring floods, the invertebrate life on the swamp floors is periodically savaged. The Pearl River in and around the park can rise and fall by more than 7 meters (20 feet) before it even leaves its banks and then can easily rise another 3 meters (10 feet). It is a rare year in which a spring flood in the bottomland would not submerge the head of a human visitor. Invertebrate species that live on the swamp floors with limited mobility are particularly vulnerable. It can take the remainder of the spring and summer for many of them to recolonize the bottomlands. But as sure as the summer doldrums come, so the invertebrates return.

Figure 1. Yellow sandshell (*Lampsilis teres*). All mussels are aquatic, so naturalists do not generally encounter them. However, their shells are occasionally seen along the water edges, especially following predation by animals such as the common raccoon (*Procyon lotor*). The yellow sandshell's uniform white inner shell made it especially prized in the button industry before the advent of plastic.

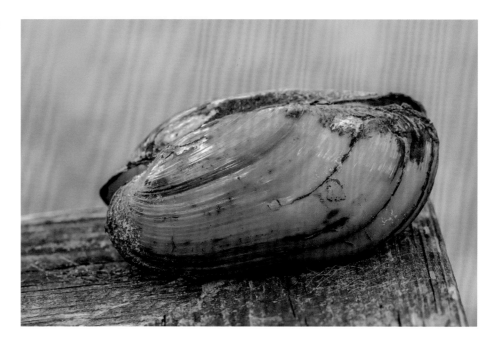

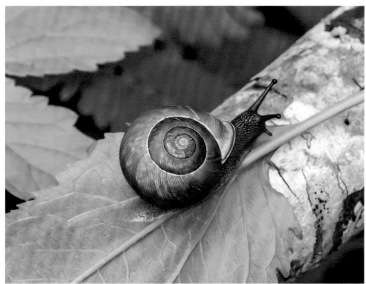

Figure 2. Eastern whitelip (*Neohelix albolabris*).

Figure 3. Amber snail (*Succinea* sp.).

Figure 4. Crawfish mud chimney. Numerous species of crawfish are found both in the state and in the park, though as aquatic creatures, they are not typically encountered on the trails. However, their mud chimneys are commonly seen on low-lying land near water. Many chimneys are freestanding, but it is not unusual to find them attached to the buttresses of bald cypresses (*Taxodium distichum*). The chimneys may simply constitute a means of storing mud that crawfish move as they dig tunnels to the water table, although some observers believe that the chimneys help aerate the tunnels.

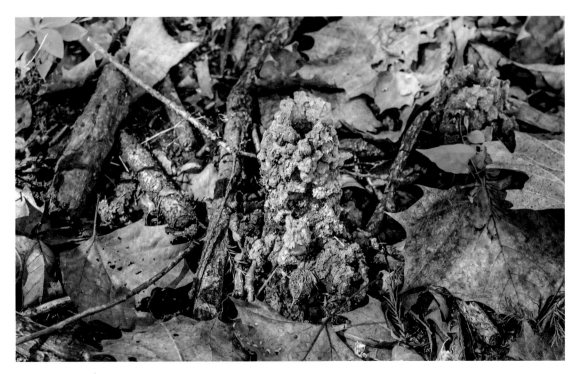

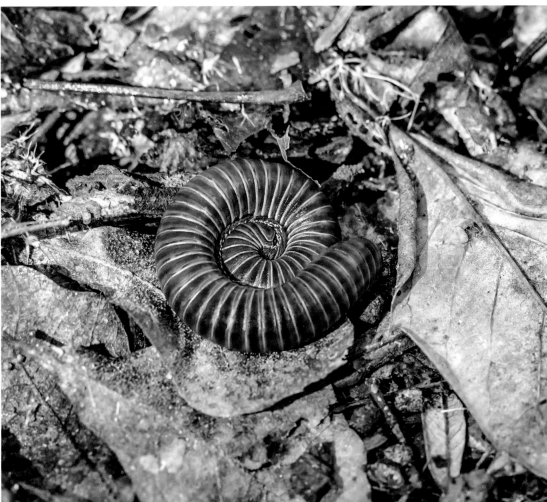

Figure 5. American giant millipede (*Narceus americanus*). The largest millipede in the United States, this species can reach nearly 10 centimeters (4 inches) long. Although *millipede* means "thousand legs," each member of this species has about one hundred segments with four legs per segment.

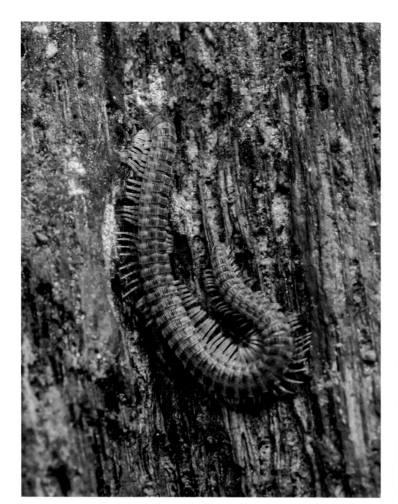

Figure 6. Crested millipede (*Abacion* sp.).

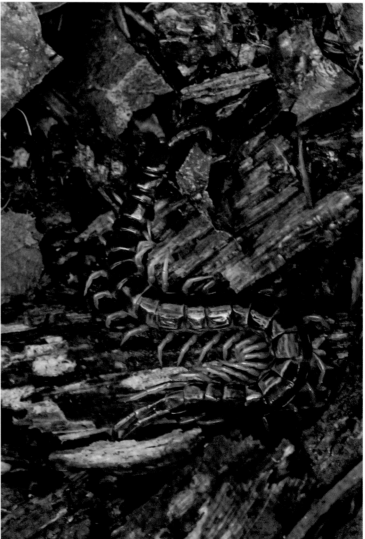

Figure 7. Eastern red centipede (*Scolopocryptops sexspinosus*). Whereas most millipedes are scavengers, centipedes are carnivorous. They are typically flattened, have two legs per segment, and possess jaws with venom glands. They hunt insects and worms.

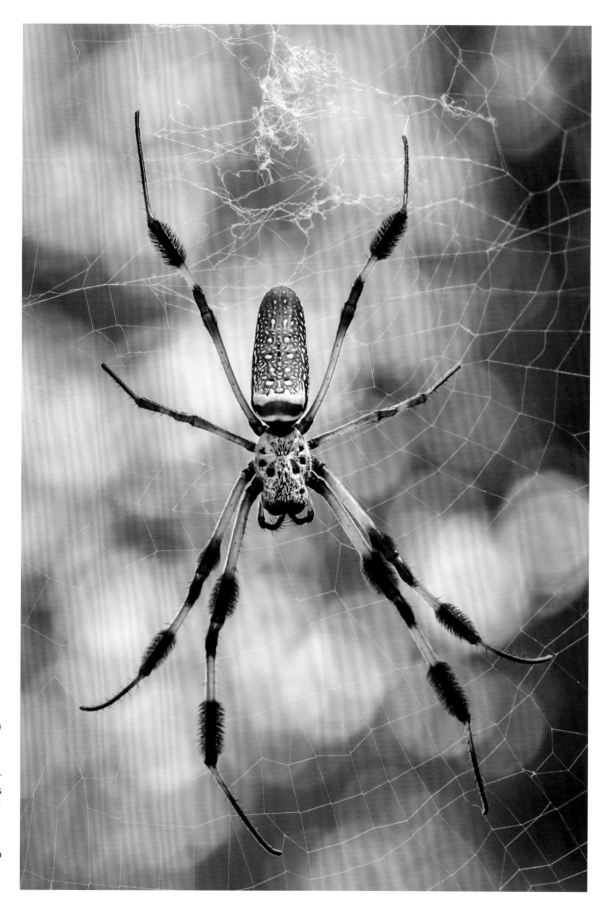

Figure 8. Golden silk orb weaver (*Trichonephila clavipes*). The female golden silk orb weaver's body can measure 6–8 centimeters (2–3 inches) long; including the legs, it can reach 15 centimeters (6 inches), making it the largest spider in the park and perhaps the state. The males are tiny—as little as 2 percent of the body mass of the female. "Golden silk" refers to the color of the web, which is asymmetrical and quite strong, as any hiker who has accidentally walked through one can attest.

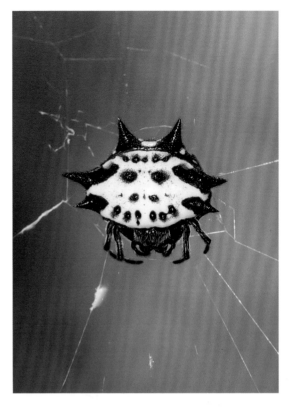

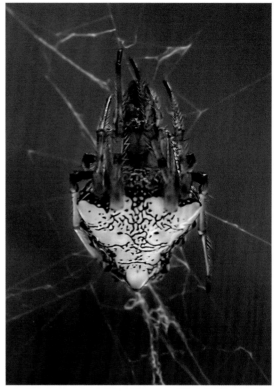

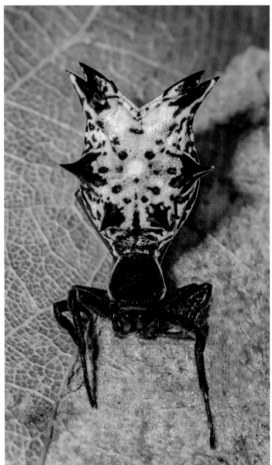

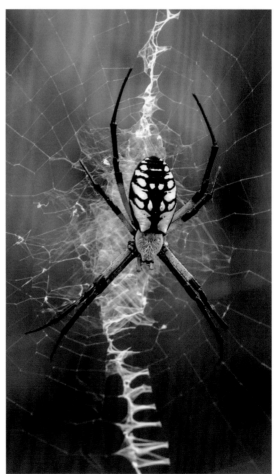

(Top left) Figure 9. Spiny-backed orb weaver (*Gasteracantha cancriformis*). Several different color morphs occur, including white, orange, and yellow.

(Top right) Figure 10. Arrowhead orb weaver (*Verrucosa arenata*).

(Bottom left) Figure 11. Spined micrathena (*Micrathena gracilis*).

(Bottom right) Figure 12. Yellow garden spider (*Argiope aurantia*). This species creates a circular web with a thick zigzag of silk, the stabilimentum, whose function is not well understood.

Figure 13. Wolf spider (*Tigrosa georgicola*). These spiders do not make webs but get their name because they hunt down their prey on the swamp floor.

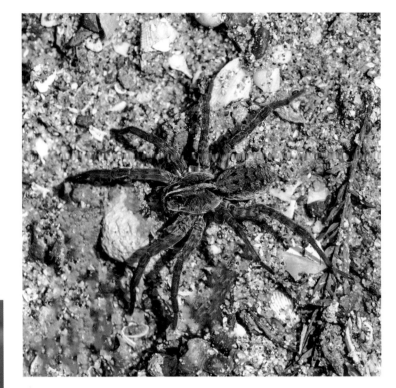

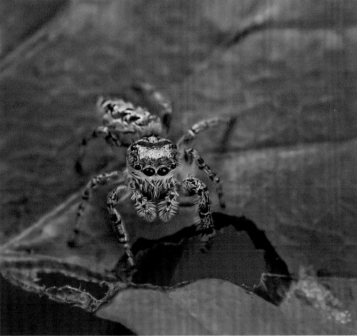

Figure 14. Bronze jumping spider (*Eris militaris*). In addition to regular locomotion, these spiders may jump many times their own length either to capture prey or to escape when threatened. They also have a unique eye pattern, with the middle pair larger than the other three pairs.

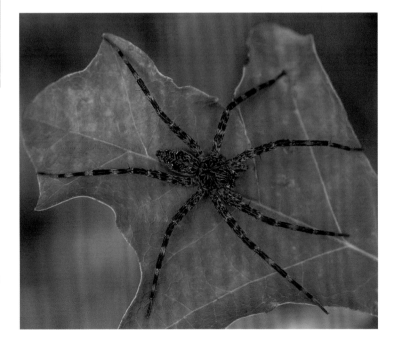

Figure 15. Dark fishing spider (*Dolomedes tenebrosus*). Many *Dolomedes* species spend much of their time on the water. Despite its name, however, the dark fishing spider spends most of its time on land hunting invertebrates in wooded and swampy areas.

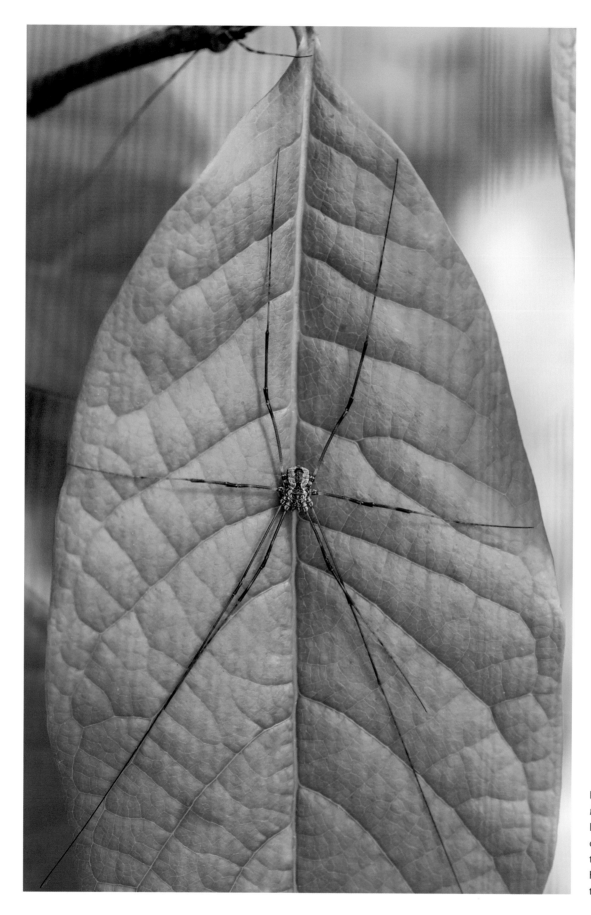

Figure 16. Harvestman (*Leiobunum flavum*). The harvestmen or daddy longlegs have a single round fused cephalothorax and abdomen and thus are not true spiders. In addition, harvestmen are scavengers rather than hunters and do not produce silk.

Figure 17. Roseate skimmer (*Orthemis ferruginea*). Male. Dragonflies eat mosquitoes, midges, and virtually any other flying insect they can catch.

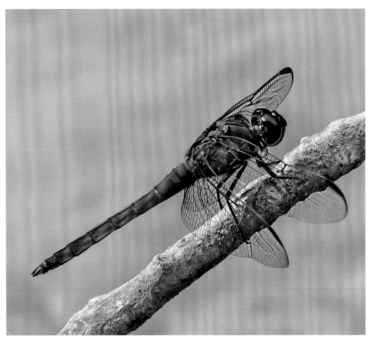

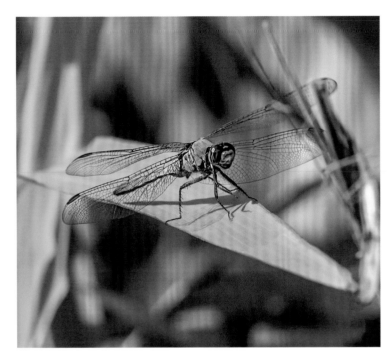

Figure 18. Eastern pondhawk (*Erythemis simplicicollis*). Male.

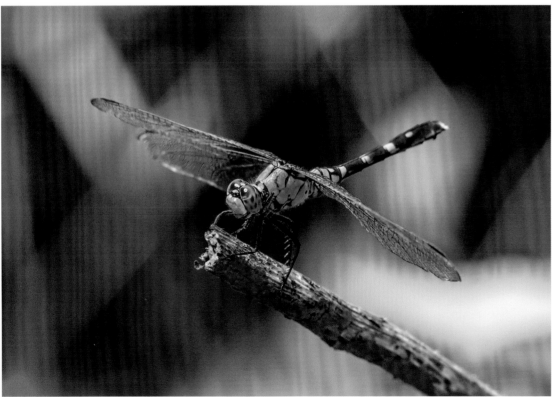

Figure 19. Eastern pondhawk (*Erythemis simplicicollis*). Female.

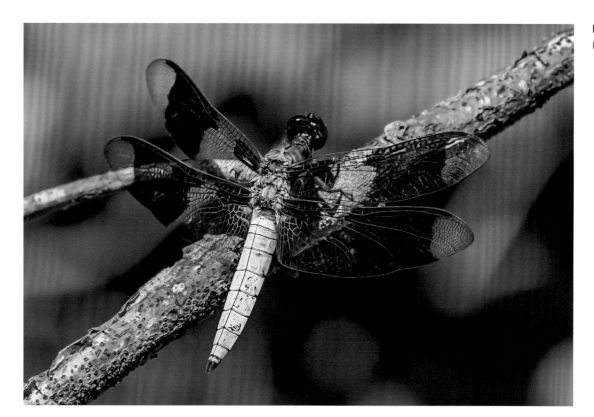

Figure 20. Common whitetail (*Plathemis lydia*). Male.

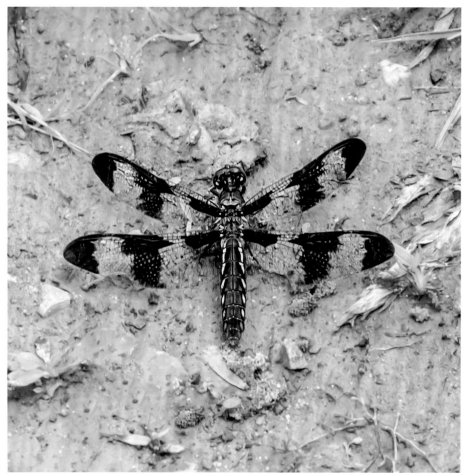

Figure 21. Common whitetail (*Plathemis lydia*). Female.

Figure 22. Eastern amberwing (*Perithemis tenera*). One of the smaller dragonflies, the eastern amberwing is thought to mimic a wasp to deter predation.

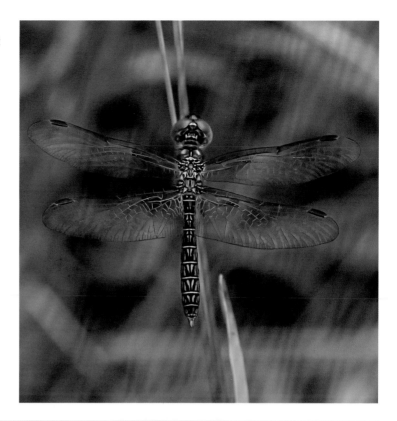

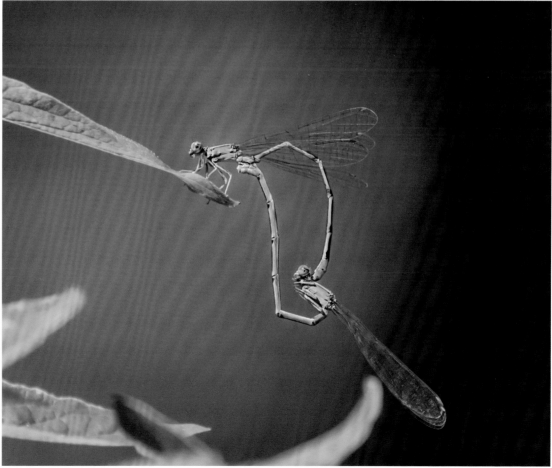

Figure 23. Slender bluet (*Enallagma traviatum*). In these mating damselflies, the male clasps the female behind the head while she extends her posterior forward and upward to receive sperm.

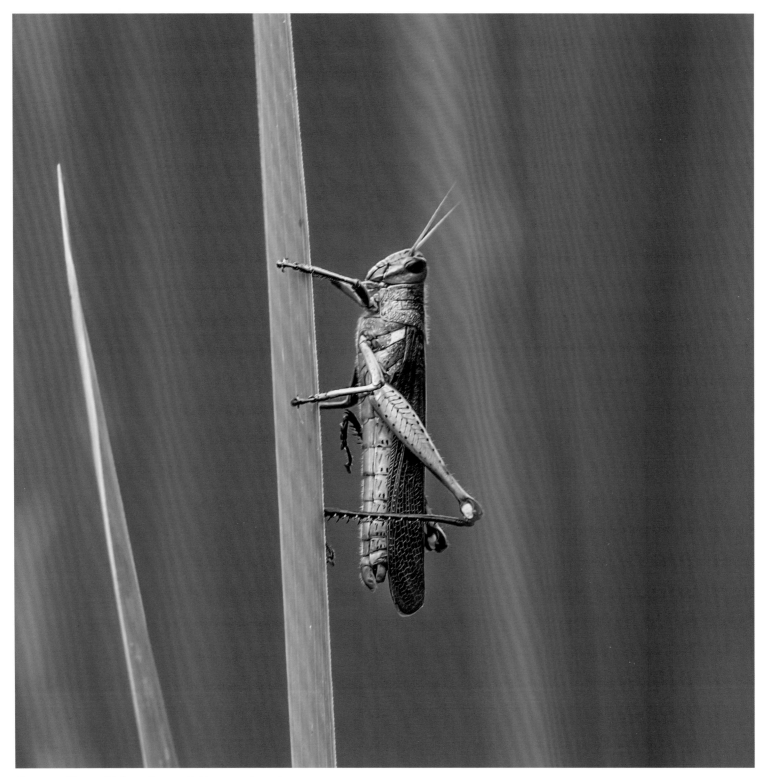

Figure 24. Obscure bird grasshopper (*Schistocerca obscura*).

Figure 25. Oblong-winged katydid (*Amblycorypha oblongifolia*). This beautiful katydid is usually green, but pink and yellow forms, as seen here, can be found on rare occasions.

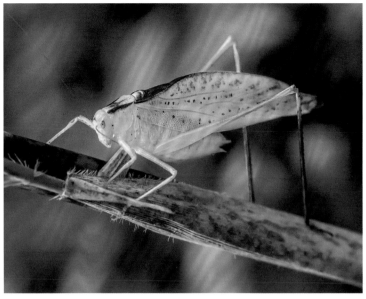

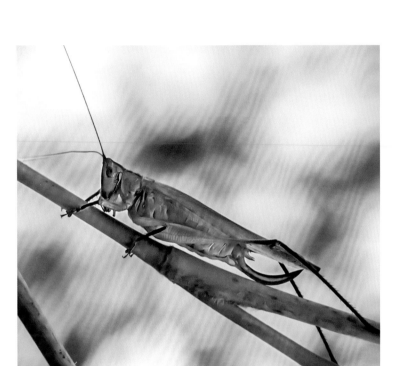

Figure 26. Black-legged meadow katydid (*Orchelimum nigripes*). Female. The sickle-shaped structure is an ovipositor.

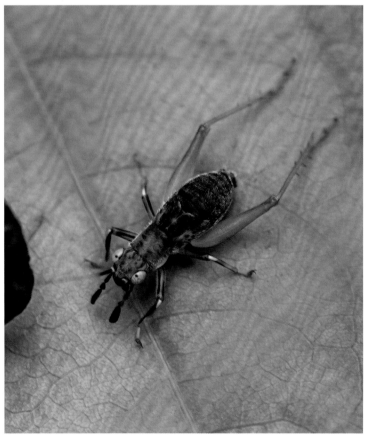

Figure 27. Red-headed bush cricket (*Phyllopalpus pulchellus*).

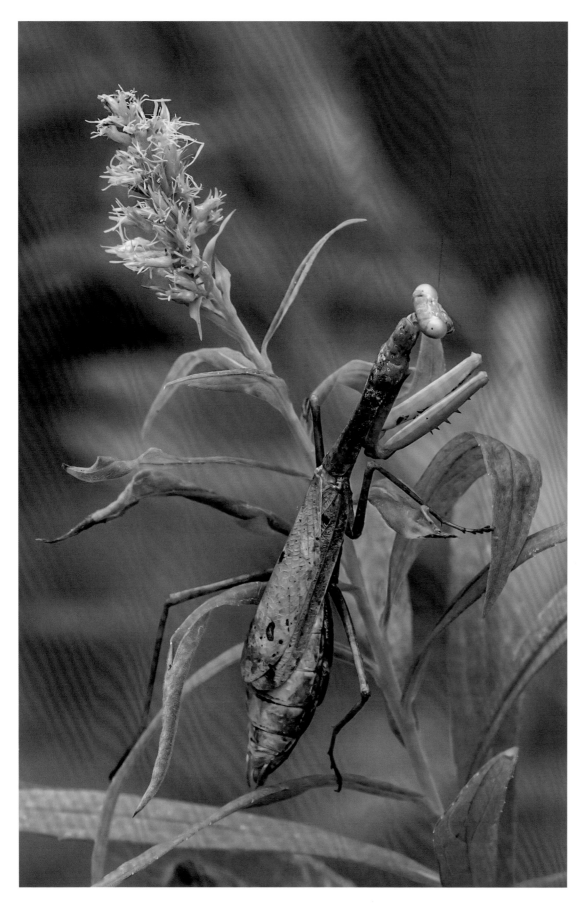

Figure 28. Carolina mantis (*Stagmomantis carolina*). This predatory mantis has folded forelegs that give it another common name, praying mantis. It feeds on a variety of insects, including members of its own species.

Figure 29. Florida leaf-footed bug (*Acanthocephala femorata*). This species is regarded as a "true bug" because it has a non-retractable proboscis. It uses that proboscis to suck juice from citrus and other plants and is regarded as a pest.

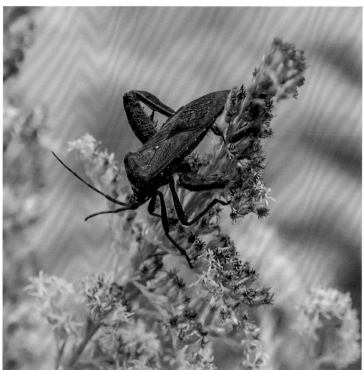

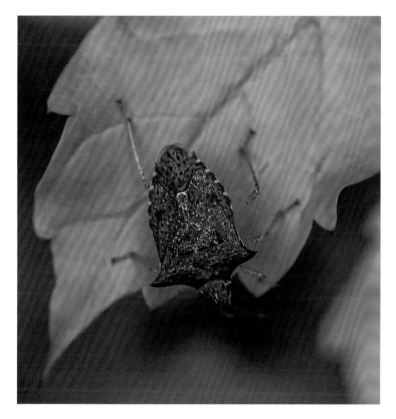

Figure 30. Dusky stink bug (*Euschistus tristigmus*). A true bug that feeds on plant juices from fruit trees.

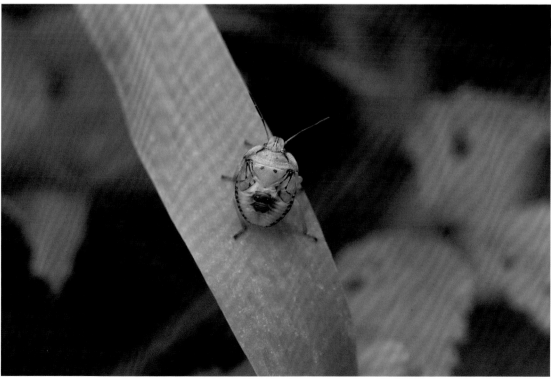

Figure 31. Green stink bug (*Chinavia hilaris*). A true bug that feeds on juices from various plants.

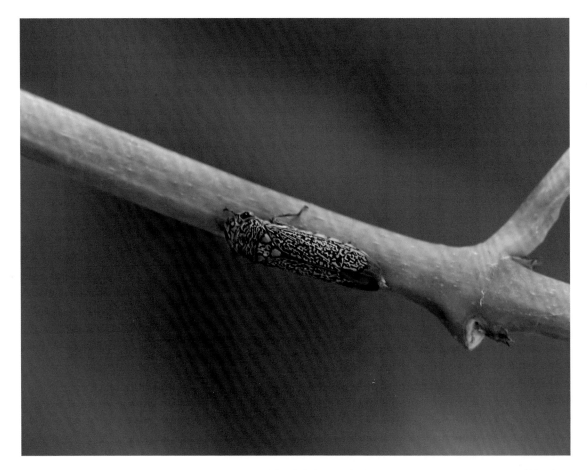

Figure 32. Broad-headed sharp-shooter (*Oncometopia orbona*). This leafhopper is a true bug and feeds on plants: the term *sharpshooter* comes from the creature's ability to forcibly eject residual plant liquid from its intestinal tract, as many an unsuspecting naturalist who has felt a brief, cool blast of liquid while lounging near a tree on a summer day can attest.

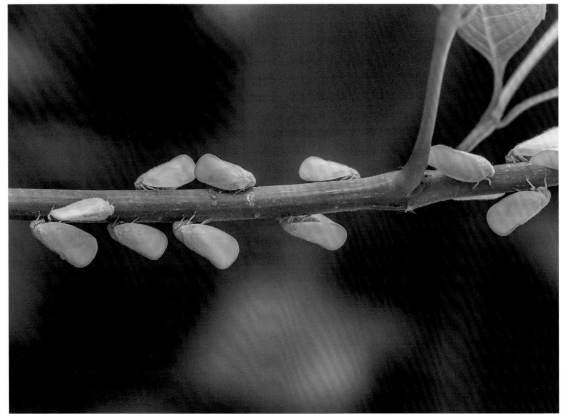

Figure 33. Flatid planthopper (*Ormenoides venusta*). A true bug that feeds on juices from various plants.

Figure 34. Yellow-striped leafhopper (*Sibovia occatoria*). Leafhoppers are true bugs because of their nonretractable proboscises and make their living sucking sap from plants.

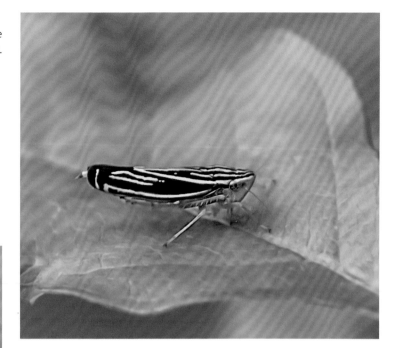

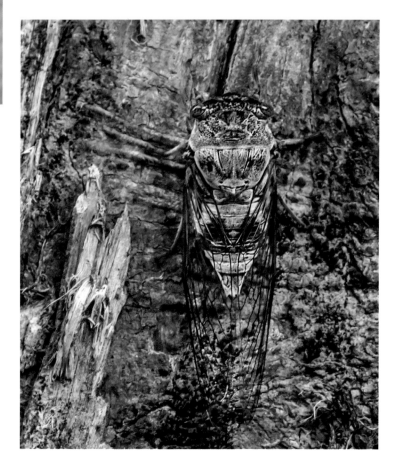

Figure 35. Red-banded leafhopper (*Graphocephala coccinea*). Another true bug that makes its living sucking sap from plants.

Figure 36. Northern dusk-singing cicada (*Megatibicen auletes*). A true bug with nonretractable proboscis, this cicada gets its name because it sings almost exclusively at dusk.

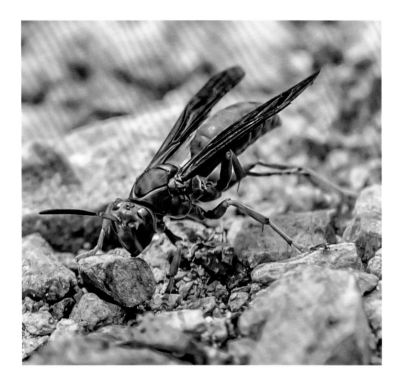

Figure 37. Fine-backed red paper wasp (*Polistes carolina*).

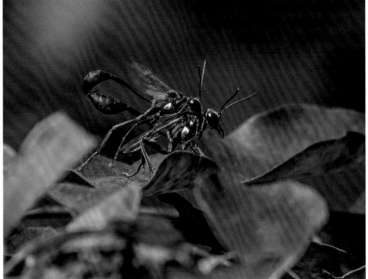

Figure 38. Thread-waisted wasp (*Eremnophila aureono-tata*). These digger wasps are shown mating. The female will then dig a small hole and find, sting, and paralyze a caterpillar. The wasp inserts the caterpillar into the hole and lays eggs, which hatch into larvae and feed on the caterpillar. The larvae pupate and emerge as adults, who then feed on wildflower nectar.

Figure 39. Acorn plum gall wasp (*Amphibolips quercusjuglans*). These galls are created by the tissue of an oak tree when wasp larvae are present and can easily be mistaken for fruit. Inside each gall is a white larva eating the plant tissue. The larva eventually leaves the gall, pupates, and metamorphoses into an adult wasp, which then lays eggs on another acorn, continuing the cycle.

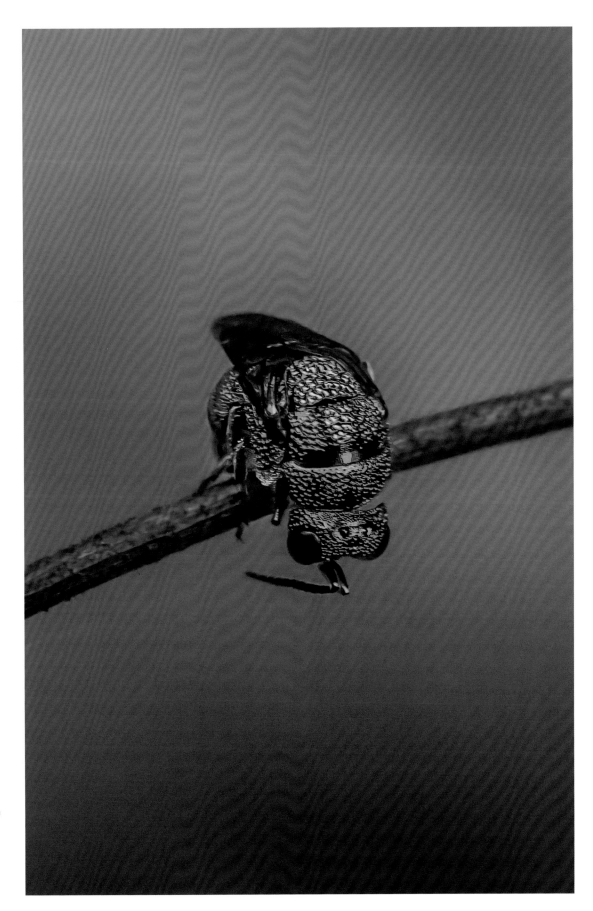

Figure 40. Emerald cuckoo wasp (*Holopyga ventralis*). These small but beautiful wasps get their name from their behavior of laying eggs in the nest of solitary wasps and bees. The eggs hatch and the larvae of the emerald cuckoo eat the bee and wasp offspring as well as the provisions left by their parents.

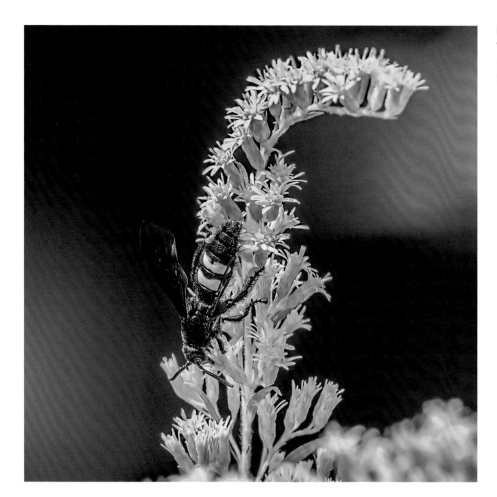

Figure 41. Double-banded scoliid wasp (*Scolia bicincta*). This wasp finds a beetle larva in the ground, stings and paralyzes it, and then lays a single egg on it. When it hatches, the larva then consumes the beetle larva.

Figure 42. Furry oak leaf gall wasp (*Callirhytis furva*). Cynipid wasps lay their eggs on oak trees—in this case, a water oak (*Quercus nigra*). The furry brown gall is a host reaction to the egg and its hatched larva. After a period of development, the larva leaves the gall, falls to the ground, pupates, and develops into an adult wasp. The oak is rarely harmed.

Figure 43. Eastern velvet ant (*Dasymutilla occidentalis*). Despite the name, this is a wasp. Sometimes referred to as a "cow killers," females are wingless, and as in other species of wasps, the ovipositor is modified into a stinger. The bright red coloration is believed to be a warning signal to potential predators. Males are winged, cannot sting, benefit from having coloration like females, and are less commonly encountered.

Figure 44. Western honeybee (*Apis mellifera*). This species was brought to North America by humans for honey production and pollination. These bees collect nectar and pollen from flowers, ingesting the nectar and taking it to the hive to convert to honey and collecting the pollen in orange pollen baskets to make bee bread.

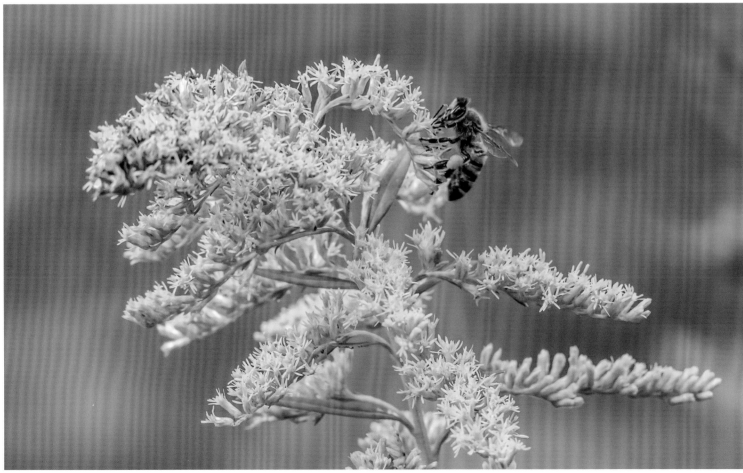

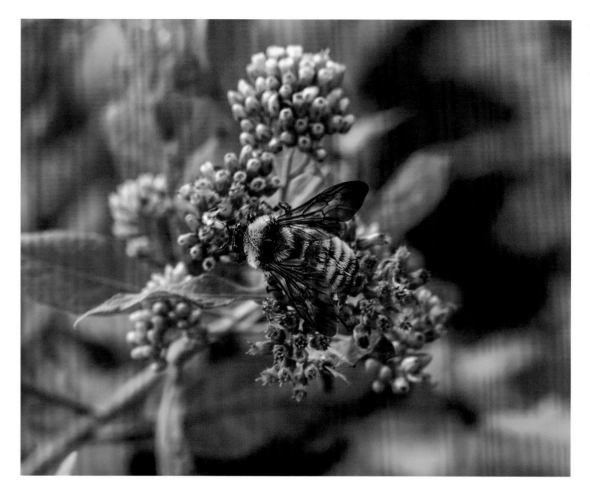

Figure 45. American bumblebee (*Bombus pensylvanicus*). This male bee is feeding on camphor weed (*Pluchea camphorata*) nectar.

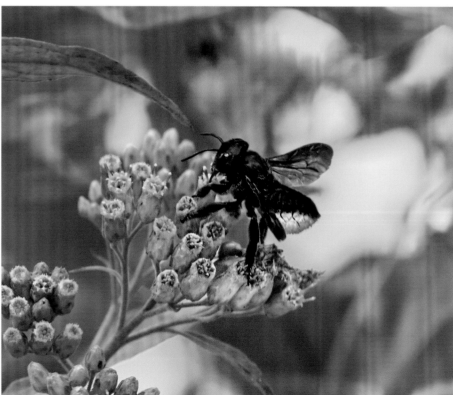

Figure 46. Carpenter-mimic leafcutter bee (*Megachile xylocopoides*). The adults are completely shiny black and resemble carpenter bees (*Xylocopa* spp.). However, they often appear two-toned because they collect pollen and store it on chitinous hairs on their abdomens. Their undersides thus take on the color of the pollen they are feeding on.

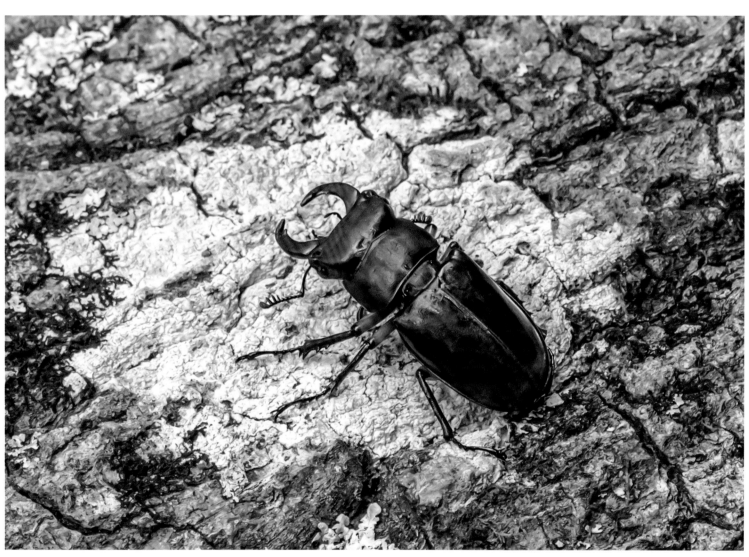

Figure 47. Reddish-brown stag beetle (*Lucanus capreolus*).
Males such as this one have large pincer-like jaws with
which they fight other males as part of their mating rites.
Females have much smaller jaws.

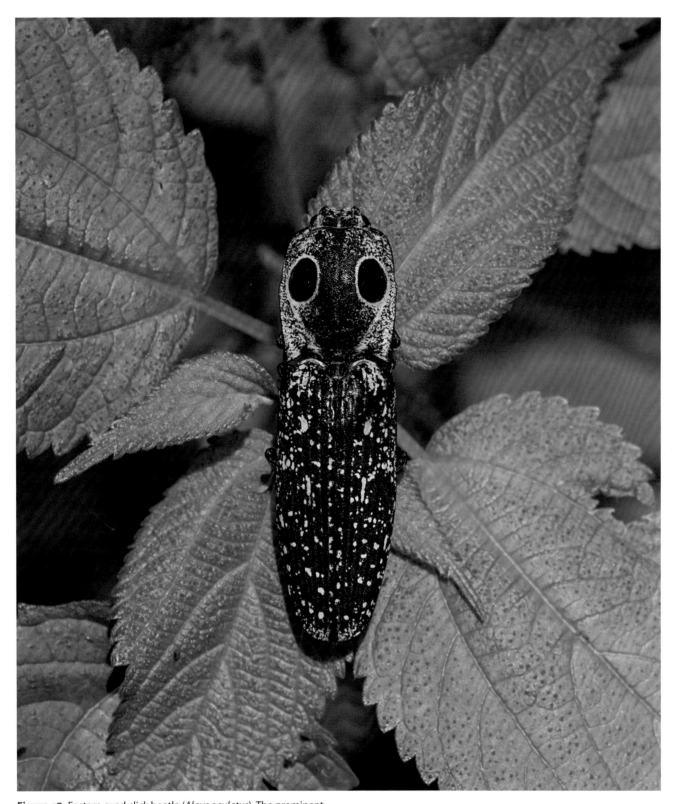

Figure 48. Eastern eyed click beetle (*Alaus oculatus*). The prominent "eyes" of this elongated beetle are deceptions thought to intimidate potential predators. The name *click beetle* comes from an audible sound the beetle makes when righting itself when overturned or when trying to avoid a predator.

Figure 49. Triceratops beetle (*Phileurus truncatus*).

Figure 50. Six-spotted tiger beetle (*Cicindela sexguttata*). Despite its name, not all of these metallic green beetles have six spots: some have more, some have fewer, and some have none. They are commonly seen on the sandy trails, where they hunt small arthropods.

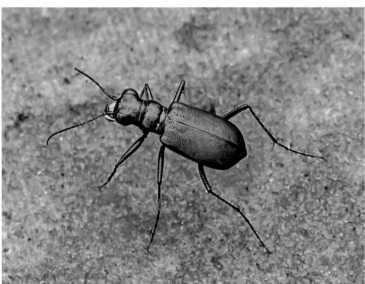

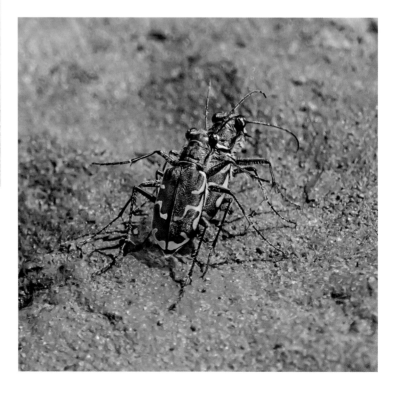

Figure 51. Bronzed tiger beetle (*Cicindela repanda*). A mating pair is shown.

Figure 52. Pipevine swallowtail (*Battus philenor*). The caterpillar of this butterfly feeds on poisonous chemicals from pipevines (*Aristolochia* spp.) that make both the caterpillar and the adult noxious to predators.

Figure 53. Spicebush swallowtail (*Papilio troilus*). Although this species is not poisonous, it is thought to mimic the unpalatable pipevine swallowtail and thereby gain a protective advantage.

Figure 54. Red-spotted purple (*Limenitis arthemis*). Like the spicebush swallowtail, this species is not poisonous but is thought to mimic the unpalatable pipevine swallowtail to gain a protective advantage.

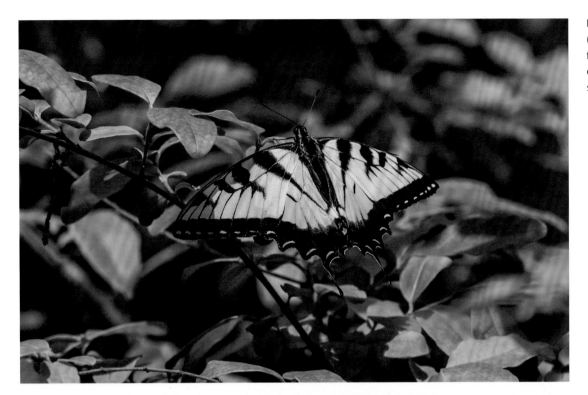

Figure 55. Eastern tiger swallowtail (*Papilio glaucus*). Eastern tigers have four stripes on each wing and feed on the nectar of numerous flower species.

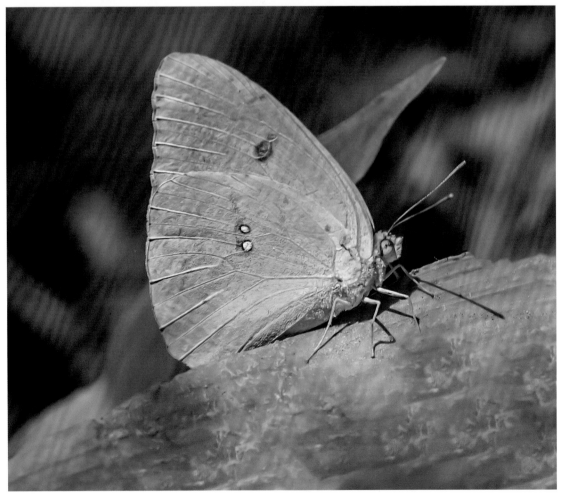

Figure 56. Cloudless sulphur (*Phoebis sennae*). This species feeds on nectar from a variety of plants.

Figure 57. Sleepy orange (*Abaeis nicippe*). This butterfly gets its common name from its "sleepy eye," the small dark spot on the forewing.

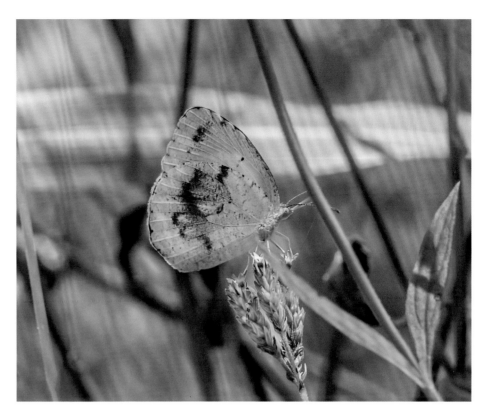

Figure 58. Little yellow (*Eurema lisa*). The adult feeds on nectar from various asters.

Figure 59. Question mark (*Polygonia interrogationis*). When its wings are closed, this butterfly looks like a dead leaf. The silver marks on the upright underwings give the butterfly both its common name and its specific epithet, *interrogationis*.

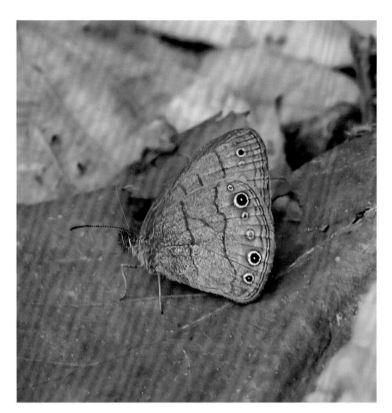

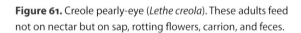

Figure 60. Carolina satyr (*Hermeuptychia sosybius*). These adults feed not on nectar but on rotting fruit and tree sap.

Figure 61. Creole pearly-eye (*Lethe creola*). These adults feed not on nectar but on sap, rotting flowers, carrion, and feces.

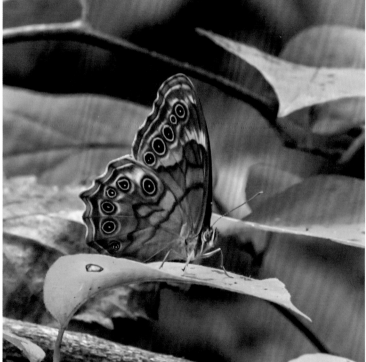

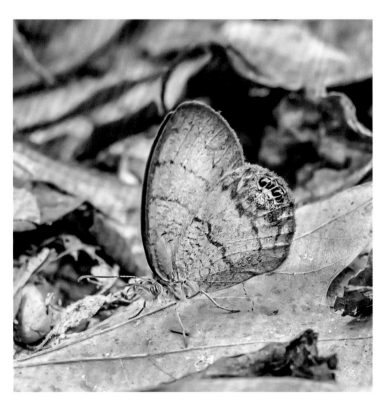

Figure 62. Gemmed satyr (*Cyllopsis gemma*). A close look at the hind wing of this unobtrusive butterfly reveals countershading that outlines the body and legs of a jumping spider. In addition, there are false eyes that have what photographers call a "catch light"—a white glare that makes the jumping spider appear alive. This form of mimicry may deflect a predator strike to a less vital area of the body or intimidate a potential predator.

Figure 63. Monarch (*Danaus plexippus*). Adult monarchs feed on nectar of many flowers. They are believed to be mimics with viceroys: both taste foul as a result of chemicals ingested during the caterpillar stage, and their similar color pattern reinforces predator deterrence. Adult monarchs overwinter in the deep southern United States and Mexico. In the spring, those populations destined for the northeastern United States and Canada begin a northerly migration from Mexico that typically requires three generations to complete. In fall, the fourth generation begins a southerly return migration to Mexico that can cover several thousand miles. Thus, the first generation takes off for a place it will not reach, and the fourth generation takes off for a place it has never been.

Figure 64. Viceroy (*Limenitis archippus*). Both the viceroy and monarch taste foul, and their mimicry is thought to be a reinforcing mutualistic warning signal to potential predators.

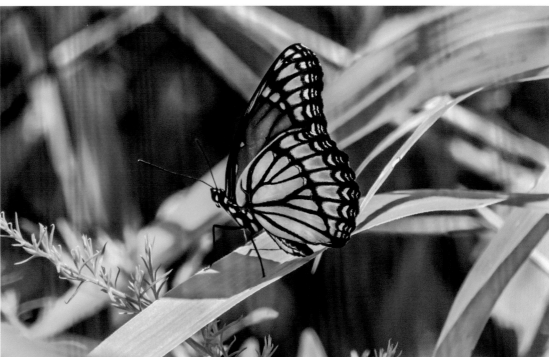

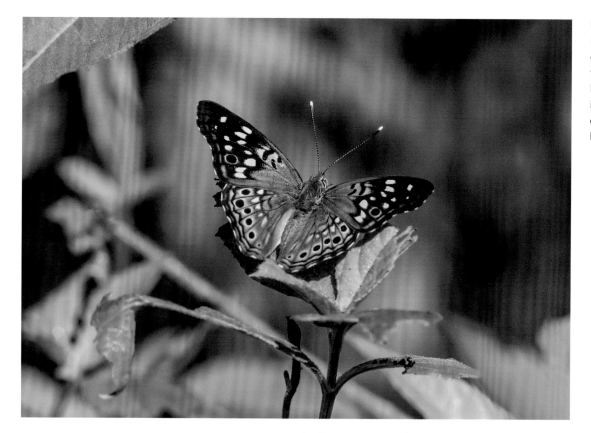

Figure 65. Hackberry emperor (*Asterocampa celtis*). Adults feed not on nectar but on hackberry sap, rotting fruit, carrion, and feces. They are known for landing on humans and ingesting sweat. Adults lay their eggs on hackberry trees, and the caterpillars feed on the leaves.

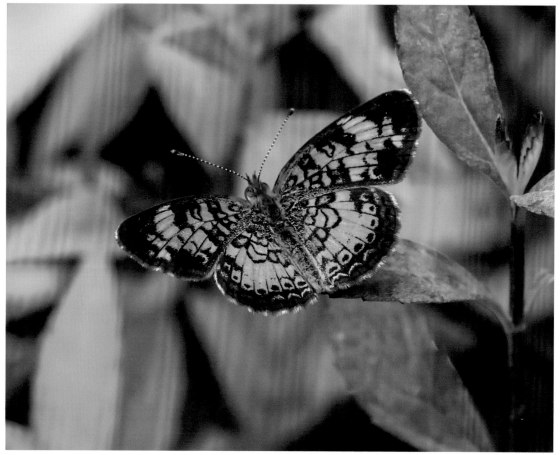

Figure 66. Pearl crescent (*Phyciodes tharos*). Adults nectar on a wide variety of plants.

Figure 67. Gulf fritillary (*Agraulis vanillae*). Adults nectar on a wide variety of plants.

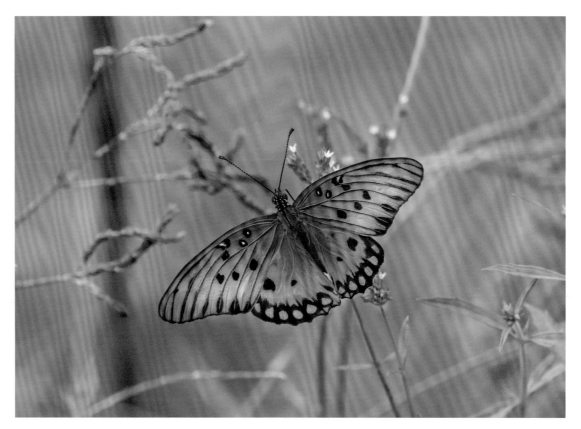

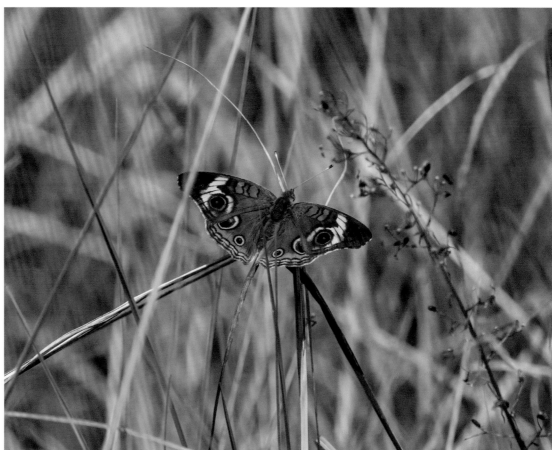

Figure 68. Common buckeye (*Junonia coenia*). Adults nectar on a wide variety of plants. The prominent eyespots are believed to deter predators.

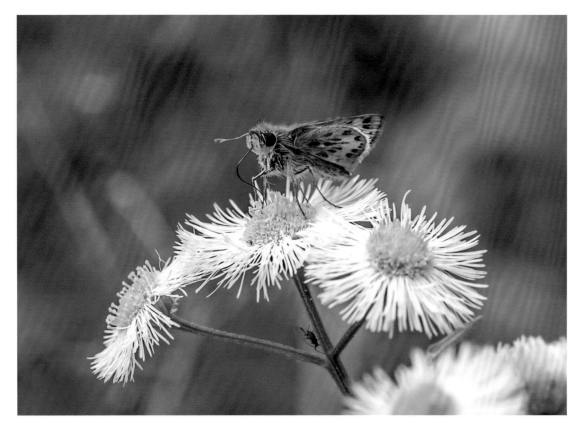

Figure 69. Fiery skipper (*Hylephila phyleus*). In most butterflies, the two sets of wings are held parallel, whereas in the skippers, the hind wings are often held horizontally while the forewings are held vertically. This is thought to aid capture of the sun's heat and is reminiscent of the delta-wing position observed in some birds.

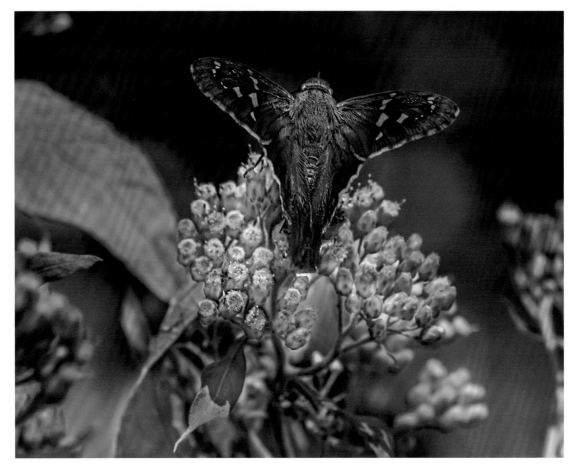

Figure 70. Long-tailed skipper (*Urbanus proteus*).

Figure 71. Zabulon skipper (*Lon zabulon*).

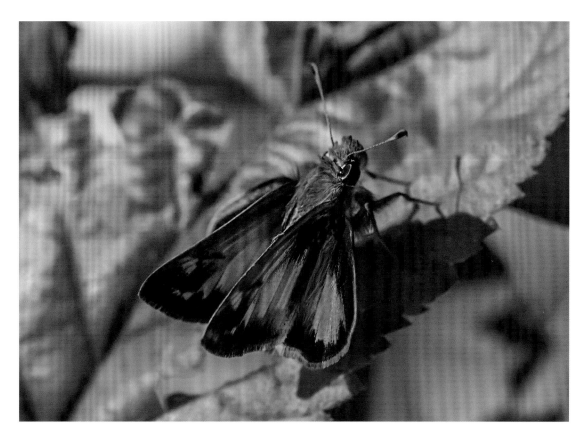

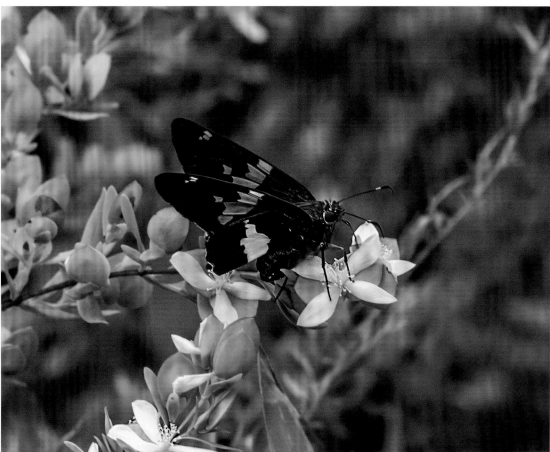

Figure 72. Silver-spotted skipper (*Epargyreus clarus*) gathering nectar on St. Andrew's cross (*Hypericum hypericoides*).

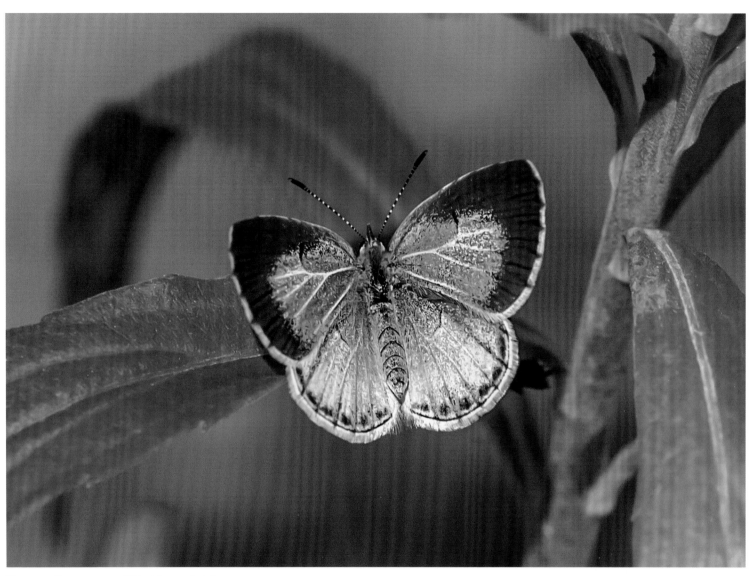

Figure 73. Summer azure (*Celastrina neglecta*).

Figure 74. American snout
(*Libytheana carinenta*).

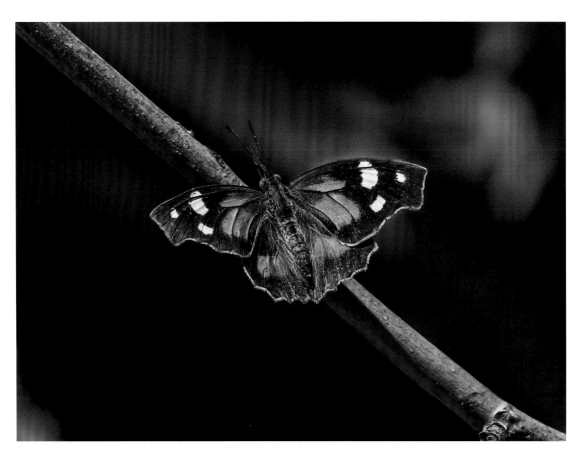

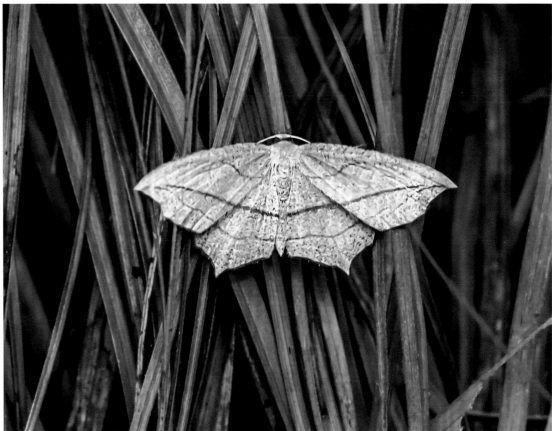

Figure 75. Cross-lined wave
(*Timandra amaturaria*).

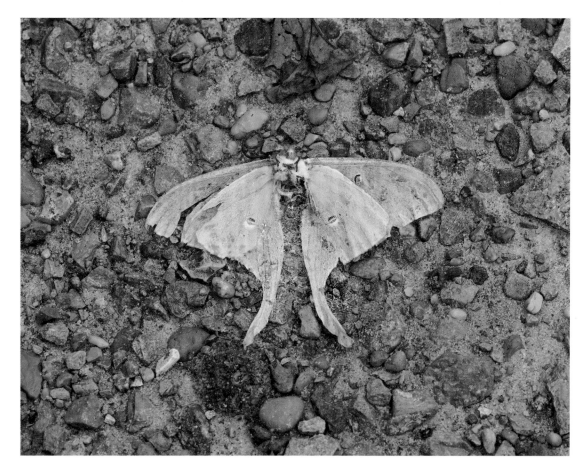

Figure 76. Luna moth (*Actias luna*). These spectacular moths live only a week as adults.

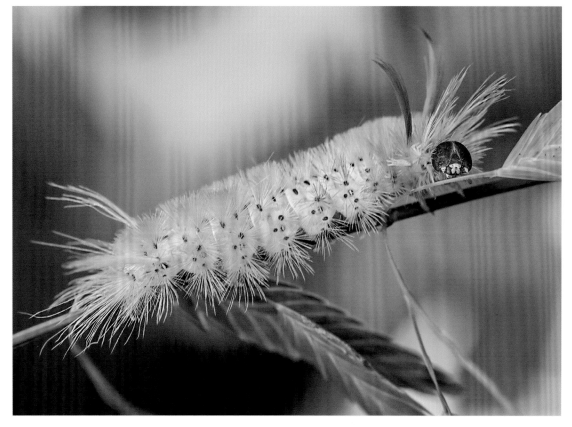

Figure 77. Sycamore tussock moth (*Halysidota harrisii*).

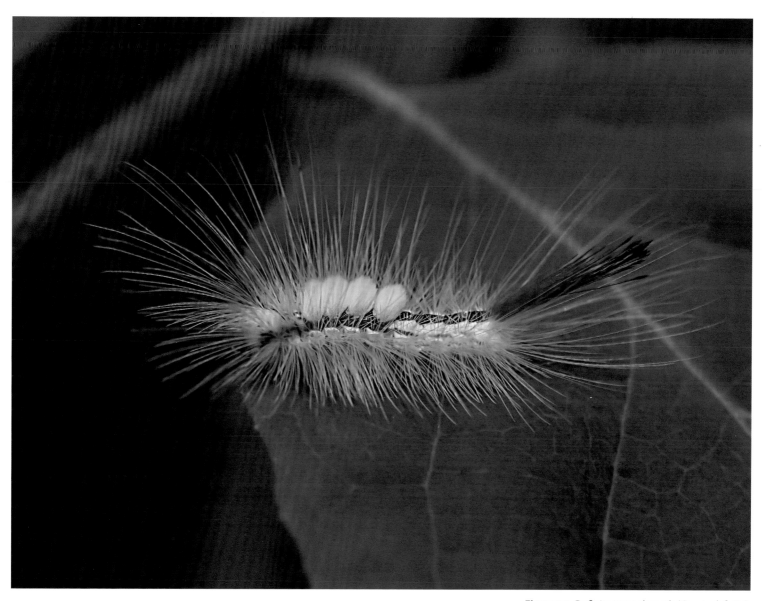

Figure 78. Definite tussock moth (*Orgyia definita*).

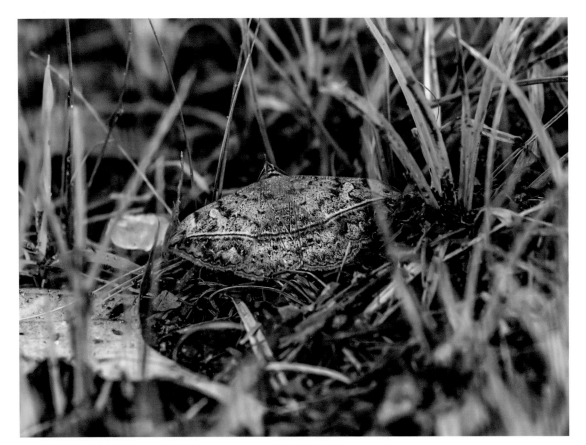

Figure 79. Velvetbean caterpillar moth (*Anticarsia gemmatalis*).

Figure 80. Black bit moth (*Celiptera frustulum*).

Figure 81. Clymene moth (*Haploa clymene*).

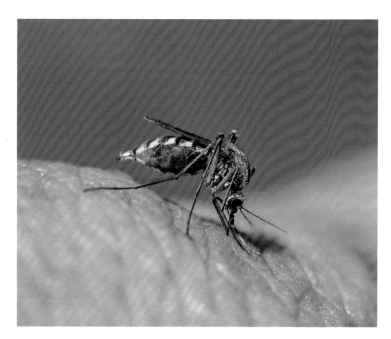

Figure 82. Floodwater mosquito (*Aedes sticticus*). Only the female bites. Males are harmless and feed on nectar. This female is removing some of the author's O+ blood.

Figure 83. Virginia flower fly (*Milesia virginiensis*). This species of hoverfly is a harmless mimic of a yellowjacket. It feeds on nectar and is an important pollinator.

Figure 84. Eastern calligrapher (*Toxomerus geminatus*). Although this flower fly looks superficially like a wasp, the single pair of wings indicates that it is just a fly. It feeds on nectar and pollen and gets its name from the fine detailing on the dorsum.

Figure 85. Robber fly (*Promachus hinei*). This fly has captured and is feeding on a milkweed assassin bug (*Zelus longipes*). Sometimes even an assassin is assassinated.

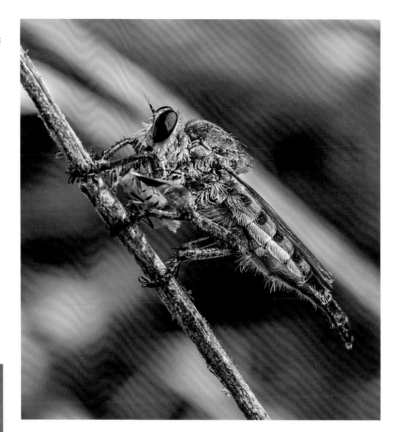

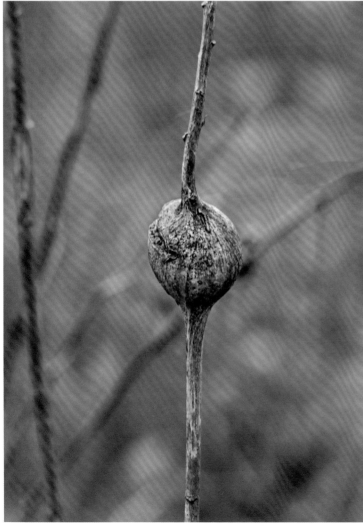

Figure 86. Goldenrod gall fly (*Eurosta solidaginis*). This gall structure in a goldenrod (*Solidago* spp.) is formed in response to the larva of the goldenrod gall fly.

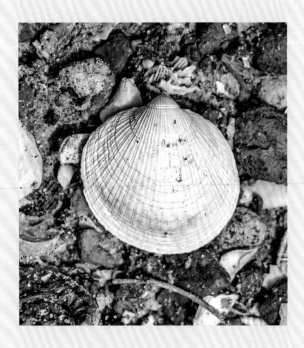

Chapter 3

FOSSILS

Much of Mississippi was under a sea with a coastline roughly from Meridian to Memphis during the Eocene, between 34 and 56 million years ago. During that age, marine life flourished in water where we now build homes and museums. As those ancient marine creatures died, the overwhelming majority were eaten and digested or simply decomposed. Either way, they were lost forever. However, tiny fractions of those marine organisms were buried in poorly oxygenated mud, silt, or sand that slowed or prevented decomposition. Fossilization is a rare event in which part of an organism or its likeness from a previous geologic age is preserved. Species with such things as hard shells, skeletons, or teeth are more likely to leave remnants and thus dominate the fossil strata. Soft-bodied creatures decompose rapidly and are rarely fossilized.

Paleontologists have studied the history of life on our planet and have identified many of the ancient and now-extinct species that inhabited it. Equally important, scientists have developed sophisticated means of determining when those organisms lived. These efforts have led to the construction of what is known as the fossil record—essentially a genealogy of life on our planet. The fossil record has been a key component in understanding how life evolved.

Certain ravines in LeFleur's Bluff State Park expose fossiliferous strata of Mississippi's ancient past. Technically, the darker,

mollusk-rich fossiliferous clays and sands from the bluff are called the Moody's Branch Formation, which is from the upper or late Eocene (generally 34 to 38 million years ago). These areas are subjacent to the better-known Yazoo Clay and superjacent to the Cockfield Formation, representing a time when coral, mollusks, and other marine invertebrates lived in a shallow sea in the middle of what is now Mississippi. As rainwater erodes the present bluff, fossils from the Moody's Branch Formation that have been buried for millions of years are exposed and washed into streams and sloughs. These species are unlike any of the living creatures found in the park or elsewhere in terrestrial Mississippi today. Many, however, are related to species still found in the waters off Mississippi's Gulf Coast.

During the time these fossils were living creatures, there were no humans alive to have seen them. Humans are a young species, something like 200,000 years old. Thus, the exposure of these fossil beds today provides a rare glimpse of a different kind of life that occurred here in the ancient past. The Choctaws and LeFleur himself must have come across some of these fossils during their explorations of Mississippi, and one wonders how they would have understood a rock that looked like an animal that did not exist in their world. Modern paleontology has provided a framework to understand things that were inexplicable in the not-too-distant past.

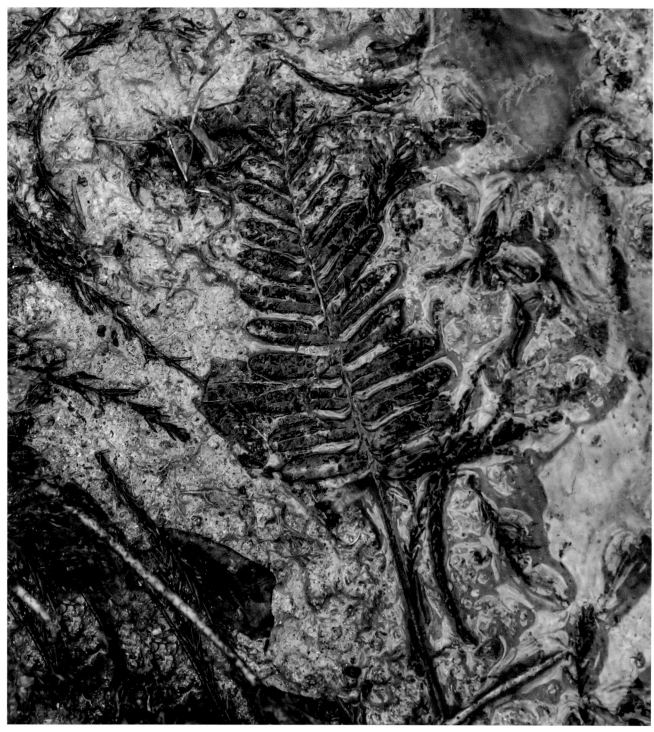

Figure 87. A potential fossil in the making. This stately maiden fern (*Thelypteris kunthii*) has died and fallen into the muddy bottom of a tiny stream. If more mud were to cover the fern, an oxygen-deprived microenvironment could develop and prevent its decomposition. Such a scenario is the end of a life and potentially the beginning of a fossil.

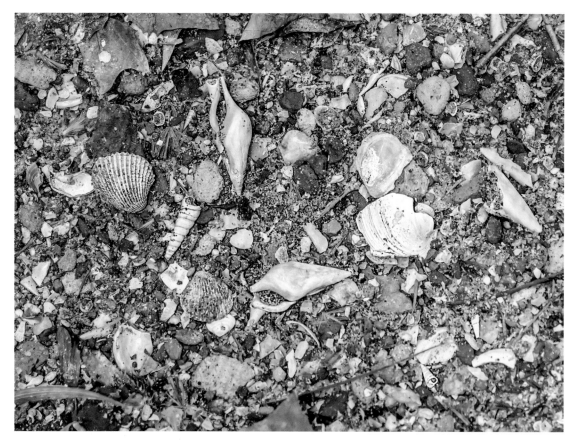

Figure 88. Fossil landscape. After a rain, fossils are washed from the bluffs and carried in small streams to the oxbow sloughs. Along the way, they accumulate in small, temporary pockets.

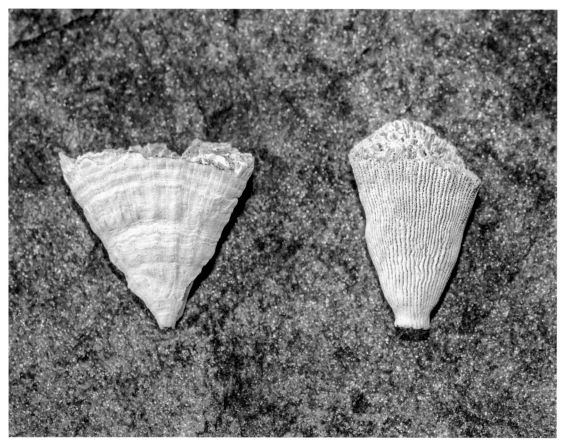

Figure 89. Solitary corals: *Flabellum cuneiforme* (left) and *Balanophyllia irrorata* (right). *F. cuneiforme*: height 23 mm, calyx 22 mm × 12 mm; *B. irrorata*: height 24 mm, calyx 15 mm × 10 mm (1 millimeter ~ 1/32 inch).

Figure 90. Bivalve (*Venericardia diversidentata*). Height 21 mm, width 20 mm (1 millimeter ~ 1/32 inch).

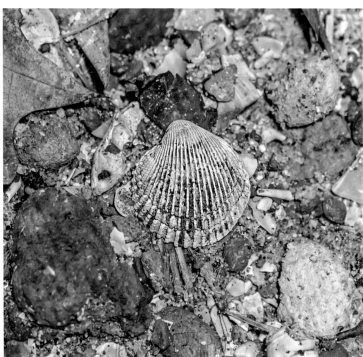

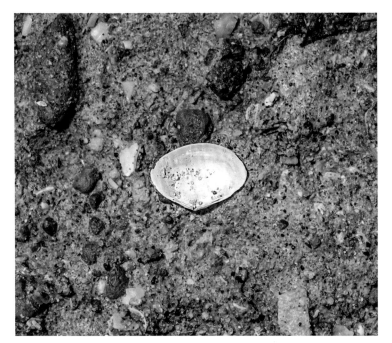

Figure 91. Bivalve (*Spisula jacksonensis*). Height 6 mm, width 7 mm (1 millimeter ~ 1/32 inch).

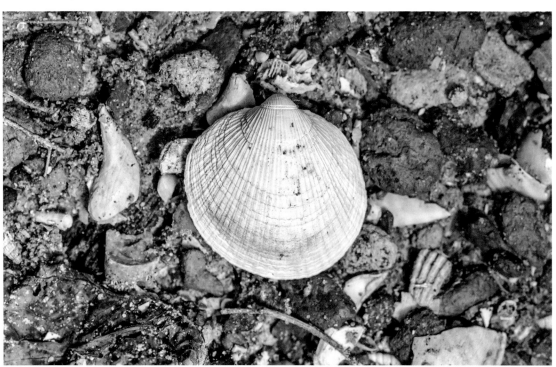

Figure 92. Bivalve (*Glycymeris filosa*). Height 30 mm, width 32 mm (1 millimeter ~ 1/32 inch).

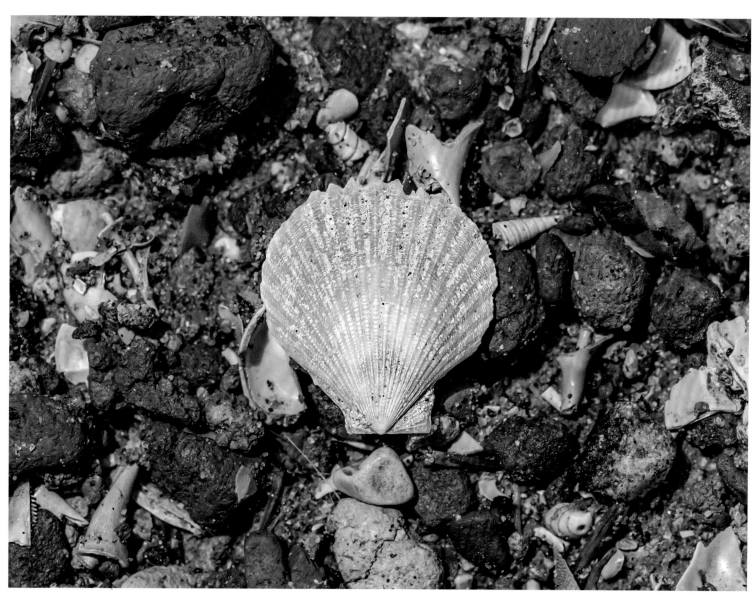

Figure 93. Bivalve (*Chlamys nupera*). Scallop. Height
22 mm, width 21 mm (1 millimeter ~ 1/32 inch).

Figure 94. Bivalve (*Pycnodonte trigonalis*). Oyster right opercular valve. Height 70 mm, width 40 mm (1 millimeter ~ 1/32 inch).

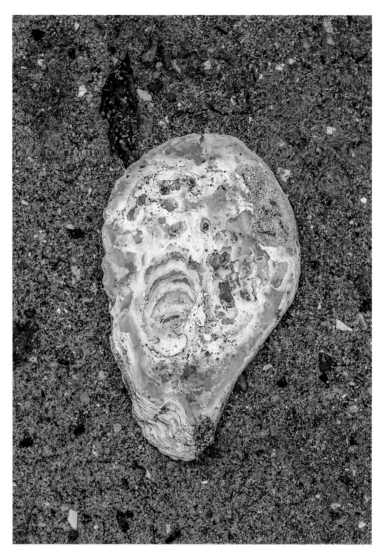

Figure 95. Bivalve tube (*Teredo mississippiensis*). A wood-boring clam. Length 35 mm, width 5 mm (1 millimeter ~ 1/32 inch).

Figure 96. Gastropod (*Calyptraphorus stamineus*). Height 43 mm, width 15 mm (1 millimeter ~ 1/32 inch).

Figure 97. Gastropod (*Clavilithes humerosus*). Height 55 mm, width 22 mm (1 millimeter ~ 1/32 inch).

Figure 98. Gastropod (*Palmerella alveata*). Height 27 mm, width 11 mm (1 millimeter ~ 1/32 inch).

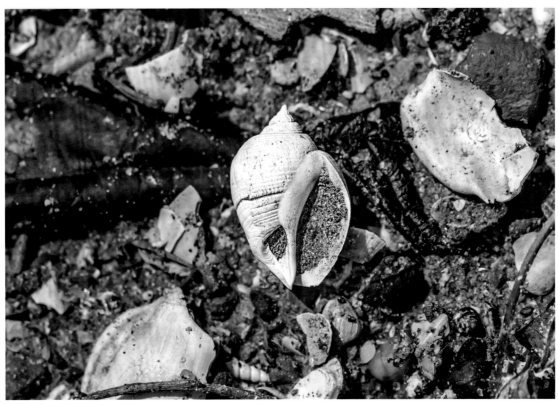

Figure 99. Gastropod (*Pseudoliva vetusta perspectiva*). Height 22 mm, width 15 mm (1 millimeter ~ 1/32 inch).

Figure 100. Gastropod (*Capulus americanus*). Height
10 mm, width 13 mm (1 millimeter ~ 1/32 inch).

Figure 101. Gastropod (*Natica permunda*). Height 15 mm, width 15 mm (1 millimeter ~ 1/32 inch).

Figure 102. Scaphopod (*Dentalium* sp.). Elephant tusk shell. Length 37 mm, width 6 mm (1 millimeter ~ 1/32 inch).

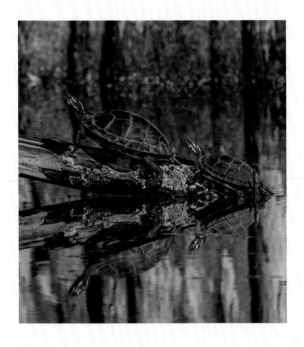

Chapter 4

AMPHIBIANS AND REPTILES

Vertebrates are animals that have backbones. Vertebrates such as amphibians and reptiles have traditionally been placed in separate classes, but both are presently undergoing substantial upheaval. Amphibia as a natural class is in doubt because not a single known characteristic is unique to them and can define them as a related group. Reptiles, too, are problematic: in modern biology, a natural group must not only have a defining character but also contain all the descendants of their common ancestor. Birds, which until recently have enjoyed their own class, are now recognized as the sole surviving member of theropod dinosaurs and thus must now be considered reptiles (see chapter 5). Those arguments are beyond the scope of this chapter, however, and it focuses on the more traditional amphibians and reptiles that naturalists are likely to encounter.

Amphibians, evolutionarily speaking, are believed to be the first vertebrates that colonized land. The name *amphibia* is derived from the Greek words *amphi* (meaning "both") and *bio* (meaning "life"). In other words, they typically have both aquatic and terrestrial phases in their life cycle. Amphibians are four-legged (tetrapodal); have body temperatures that depend on the environment (ectothermic); produce simple, gelatinous eggs; undergo external fertilization; and have water-borne larval stages. Amphibian eggs are

typically deposited in water. Once hatched, the larval stages often require the development of gills to extract oxygen from water and a circulatory system to transport that oxygen to the deeper tissues. The water-borne larvae lose their external gills when they transition to land as adults and develop a pair of internal lungs to extract oxygen from air. Adult amphibians may be terrestrial but often remain closely associated with water. Structurally related to fish fins, the tetrapod limbs of amphibians give them the ability to locomote on land. Together, the air-breathing lung and the development of limbs were among the first adaptations to life on land for vertebrates.

Mississippi in general and LeFleur's Bluff State Park host two groups of amphibians: salamanders (those with tails as adults) and frogs and toads (those without tails as adults).

Reptiles, like amphibians, are ectothermic and tetrapodal (although in snakes and in some lizards, the absence of limbs is a secondary loss due to burrowing). Most of the key reptilian features support the move away from water—internal fertilization; multi-layered amniotic eggs that are deposited on land; lack of an aquatic larval stage; lungs throughout life; and keratinized scales to prevent water loss. The amniotic egg has four membranes (chorion, amnion, allantois, and yolk sac) as well as a calcareous or leathery outer shell that helps prevent desiccation. Each of these adaptations divorced the reptile further from the bondage to water that amphibians have rarely lost.

The reptiles encountered in the park and state include turtles, snakes, lizards, and the apex predator, the American alligator.

Figure 103. Mississippi slimy salamander (*Plethodon mississippi*). This bluish-black salamander and other members of its genus are more terrestrial than many other salamanders. This species has internal fertilization, deposits eggs on land, and lives entirely on land, generally under rotting logs, where it is protected from desiccation.

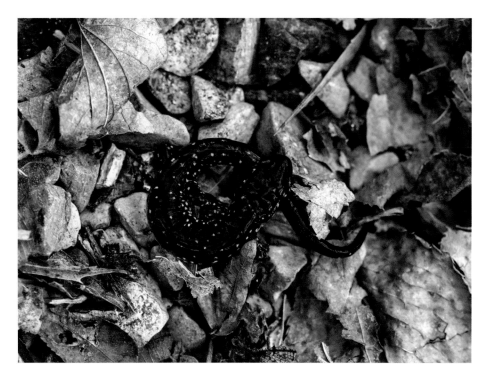

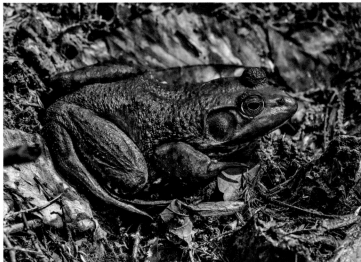

Figures 104 and 105. American bullfrog (*Lithobates catesbeianus*). Male. The bullfrog is the largest frog in Mississippi. The tadpole can reach 18 centimeters (7 inches) in length and grazes on aquatic plants. The adult frog can weigh 0.7 kilograms (1.5 pounds) and will eat essentially anything it can get in its mouth. It is best known for its baritone bellowing, which is thought to sound like a bull bellowing or phonetically as "jug-o-rum." Males have a tympanum (the external ear) that is much larger than the eye, whereas the female tympanum is equal to or smaller than the eye.

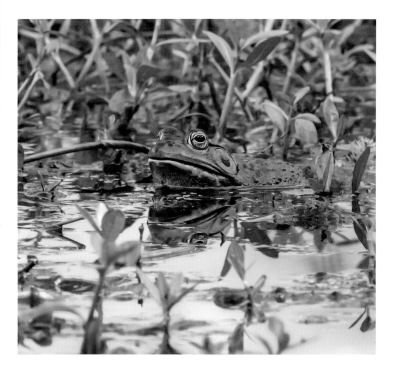

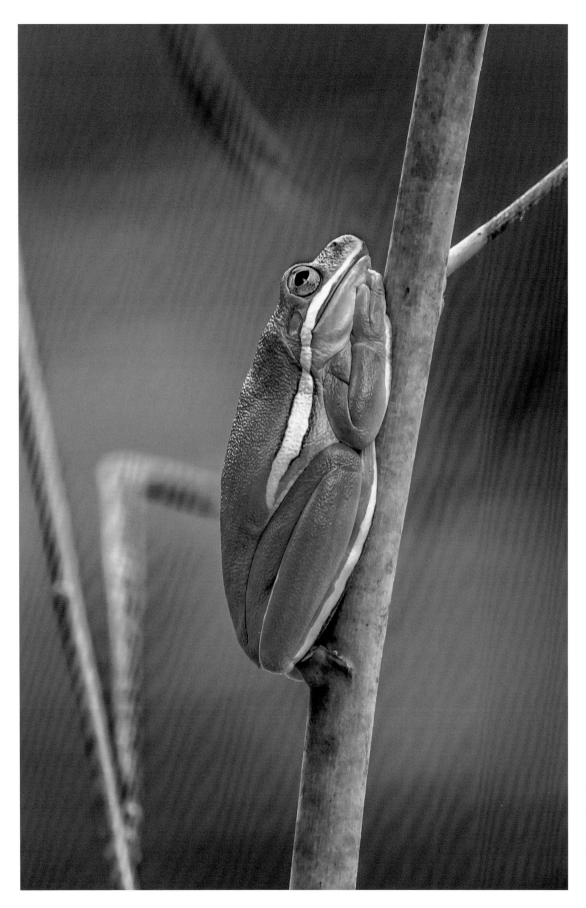

Figure 106. Green treefrog (*Dryophytes cinereus*). At home on plants and small trees, this bright green frog has long digits and distinct toe pads. Some of the frogs have cream-colored lateral lines and/or golden flecks of color on their dorsa.

(Top left) Figure 107. Cope's gray treefrog (*Dryophytes chrysoscelis*). Also known as the southern gray treefrog, the Cope's gray is morphologically indistinguishable from the common gray treefrog, and the species share similar but not identical geographic ranges. The two frogs have different calls, however, and I have heard only that of the Cope's in Mississippi, a finding that buttresses the generally accepted belief that the common gray does not exist in the state. The specific epithet *chrysoscelis* means "golden leg" and refers to the bright yellow flash of the hind leg that can be seen when either species of frog jumps.

(Top right) Figure 108. Bird-voiced treefrog (*Dryophytes avivoca*). Like the Cope's gray, this frog has a white, squarish region below the eye and a mottled gray or green appearance. However, the bird-voiced frog lacks the yellow splash on the hind leg of the Cope's gray and, true to its name, has a birdlike "wit wit wit wit" call that differs from the buzzing trill of the Cope's gray.

(Bottom left) Figure 109. Southern cricket frog (*Acris gryllus*). This small frog is common on the bottomland forest floor and is quite a jumper. It has long limbs and toes but no toe pads. It exists in several color morphs, including orange, green, and black.

(Bottom right) Figure 110. Toad (*Anaxyrus* sp.). Toads in central Mississippi are a conundrum. Many seem to have composite characters of both the American toad (*A. americanus*) and Fowler's toad (*A. fowleri*). This toad had the cranial crest that was in contact with the parotoid gland only via a spur and two or fewer warts per dark patch on the dorsum (not pictured), which are typical characteristics of the American toad, and little if any spotting on the ventral side, typical of Fowler's toad. In addition, both the calls heard in much of central Mississippi and the timing of those calls from spring to late summer are typical of Fowler's toads. So you be the judge: American, Fowler's, or hybrid?

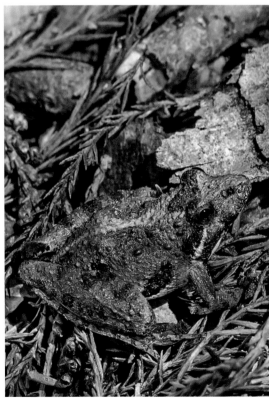

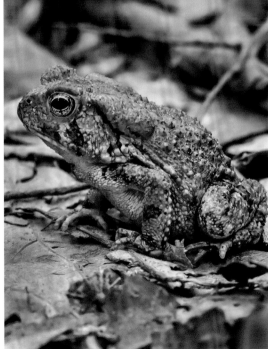

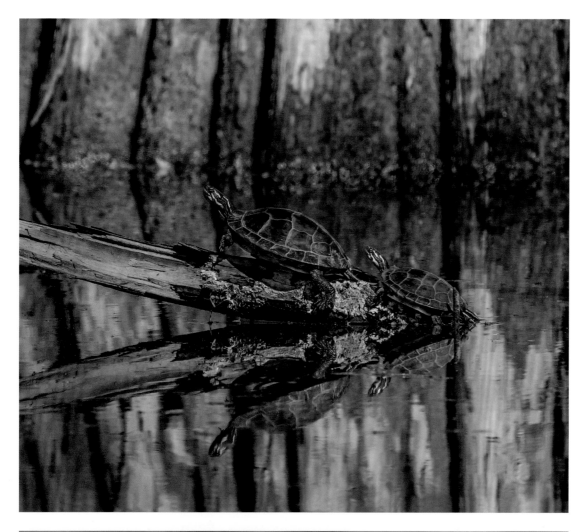

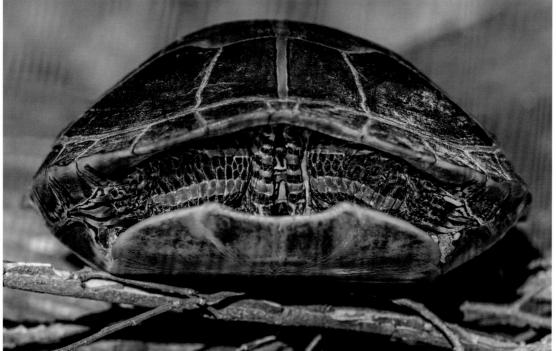

Figures 111 and 112. Southern painted turtle (*Chrysemys dorsalis*). This turtle has a distinct red dorsal stripe on its upper shell, while the margins of the lower shell can be beautifully colored. The southern painted turtle is found in still waters and eats aquatic plants and invertebrates.

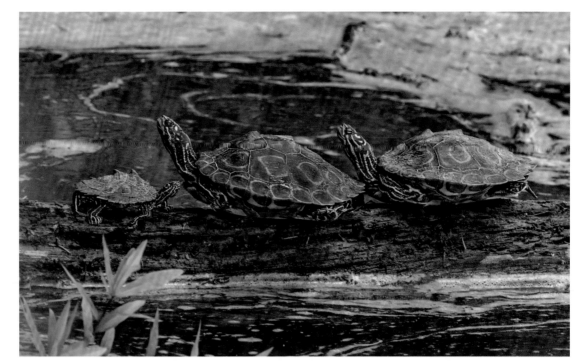

Figure 113. Ringed sawback turtle (*Graptemys oculifera*). This riverine turtle is one of the state's jewels. It is an endangered species found only in the Pearl River system. LeFleur's Bluff State Park has a healthy population in the river as well as in the adjoining oxbows. These turtles may live to be forty years old and nest on sandbars. They feed mainly on insects and mollusks.

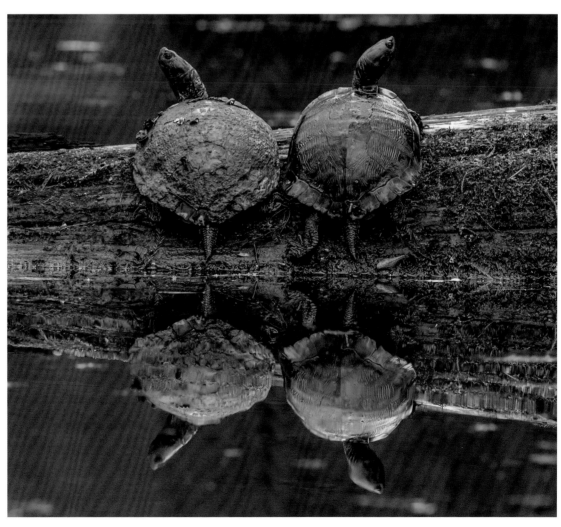

Figure 114. River cooter (*Pseudemys concinna*). This large turtle can reach 30 centimeters (1 foot) in length. It is one of the most common turtles in the park and is seen on all the different waters. It feeds on aquatic plants.

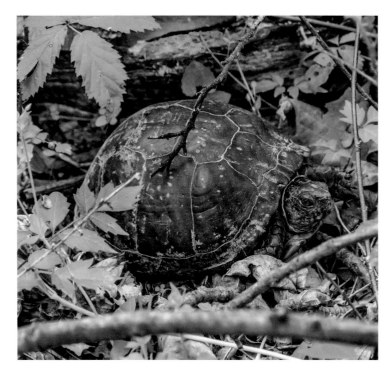

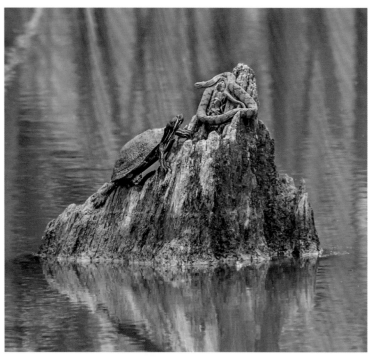

Figure 115. Three-toed box turtle (*Terrapene carolina triunguis*). This terrestrial turtle has a domed upper shell and hinged lower shell, leading to its common name. The turtle can completely withdraw its head and limbs into the shell. Some turtles of this subspecies have three toes on their hind limbs, but others have four toes like the other subspecies of box turtle. They are omnivorous, eating insects, annelids, mollusks, mushrooms, and plants and fruit. Mature males have red irises and orangish-red spots on their heads and necks, whereas females have yellowish-brown irises and generally less coloration.

Figure 116. Red-eared slider (*Trachemys scripta elegans*). This aquatic turtle gets its name from the red stripe behind the eye in young animals, but that red darkens considerably and may disappear in older turtles. This species is native to the southern United States, but its popularity as a pet has led to its wide release, and it may now be the most common turtle in Mississippi. The slider in this photo is challenging a diamondback watersnake (*Nerodia rhombifer*) for top spot on the remains of a bald cypress (*Taxodium distichum*).

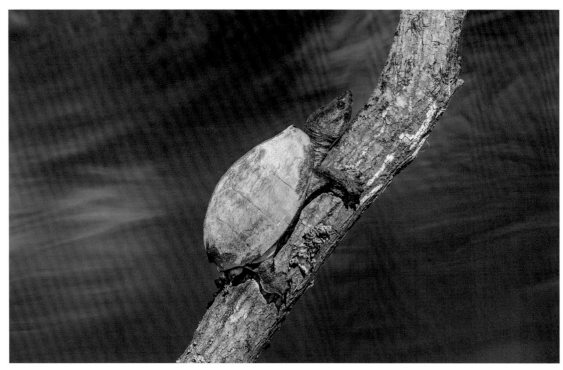

Figure 117. Razor-backed musk turtle (*Sternotherus carinatus*). This distinctive turtle has a high-keeled upper shell unlike any other in the state, while the lower shell is much reduced. Among the musk and mud turtles, this one is most frequently seen basking.

Figure 118. Gulf Coast spiny softshell turtle (*Apalone spinifera aspera*). This aquatic turtle is more flattened and the bone in its shell is greatly reduced relative to other turtle species. When held, the softshell turtle feels flexible because what bone exists is found only in the central region of the shell. In addition, the turtle feels leathery because it lacks horny scales. This turtle is an ambush feeder, often with its body buried in sand, and its head can greatly extend to strike fish, amphibians, large aquatic insects, and crustaceans or to deliver a nasty bite to an unsuspecting handler.

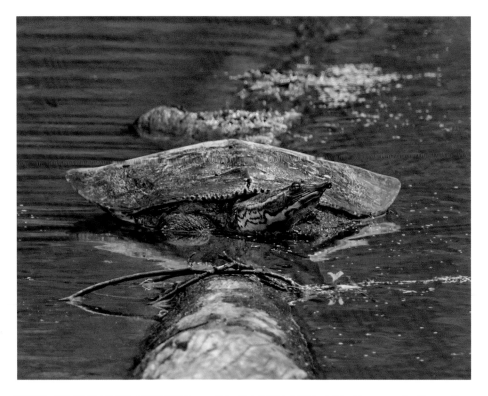

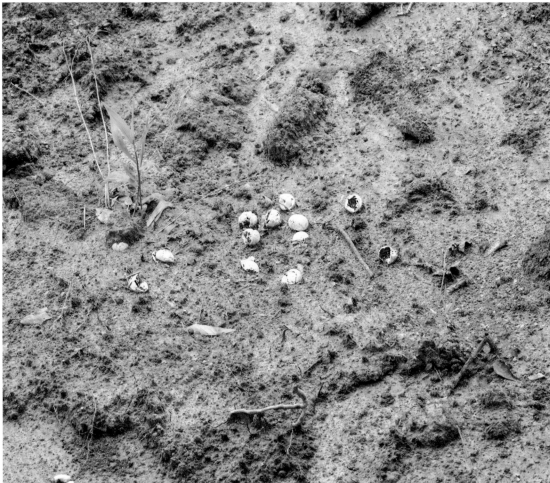

Figure 119. Gulf Coast spiny softshell turtle nest. Turtles bury their eggs in the soil and show no further parental investment. Made in a bank of the Pearl River that collapsed, this nest was exposed to predation from birds and mammals.

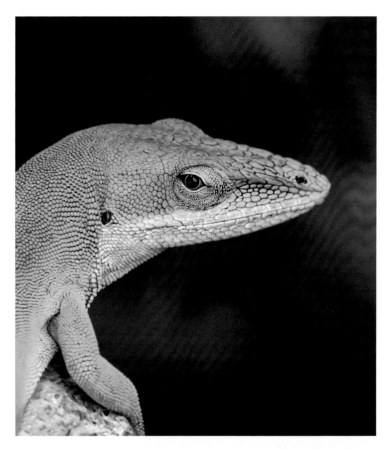

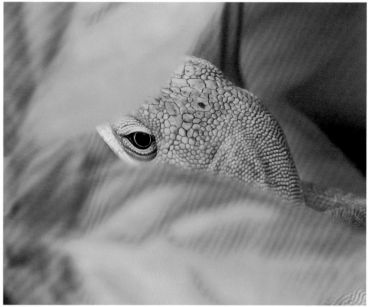

Figures 120, 121, and 122. Green anole (*Anolis carolinensis*). Best known for its ability to change color, these arboreal lizards exist in colors ranging from a brilliant green to a drab brown. Both sexes have dewlaps, but the male's is much larger and bright red and is often displayed as a threat to rival males. Females often have a dorsal white stripe that resembles vertebrae. The parietal eye between the true eyes on the dorsal head detects light and helps set the anole's circadian rhythm based on day length.

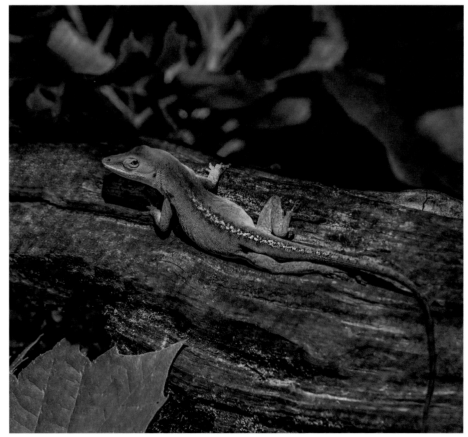

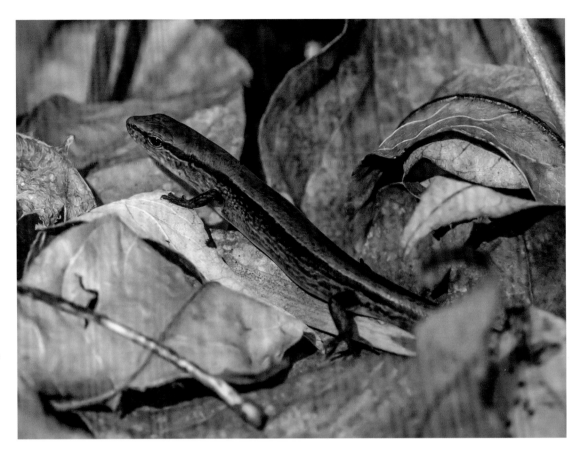

Figure 123. Little brown skink (*Scincella lateralis*). This small, 7–13 centimeter (3–5 inch) skink is copper-brown and most often observed scurrying through leaf litter as it hunts insects and spiders.

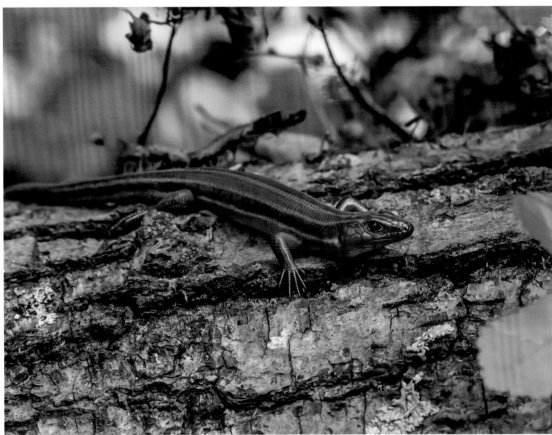

Figure 124. Broad-headed skink (*Plestiodon laticeps*). The largest skink in Mississippi, the broad-headed skink can reach 30 centimeters (1 foot) in length. A mature male has a large, red head and is unmistakable, but the females are smaller and can be mistaken for either of the five-lined skink species. The young have blue tails that also resemble those of the five-lined skinks. The blue tail is thought to draw the attention of potential predators, allowing the more important part of the lizard to escape.

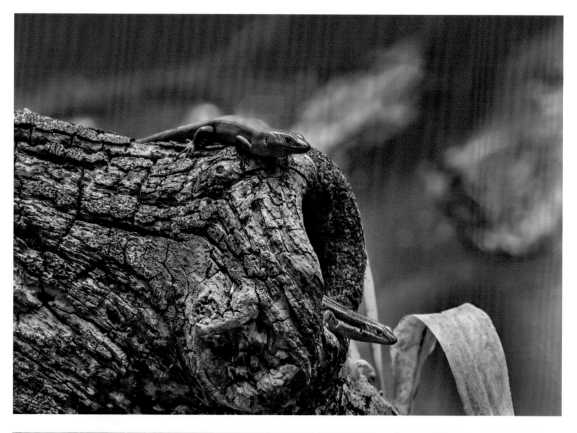

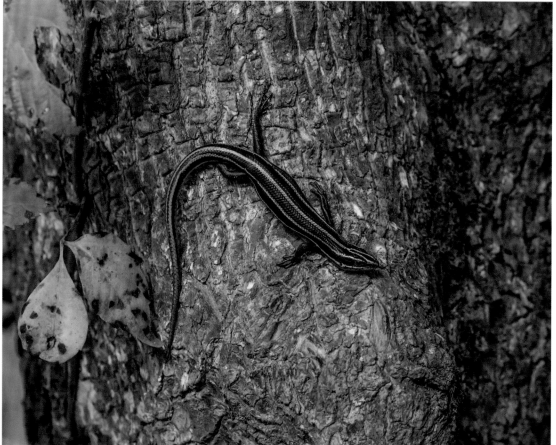

Figures 125 and 126. Common five-lined skink (*Plestiodon fasciatus*). Mississippi has two morphologically similar five-lined skink species, the common five-lined skink (*P. fasciatus*) and the southeastern five-lined skink (*P. inexpectatus*). To distinguish the two requires examining and counting scales on the venter or dorsum. I have found only the common five-lined skink in the park. The young skinks have blue tails, which are thought to deflect predatorial strikes from vital areas. As the animals mature, they generally lose the blue and the five stripes and become a golden brown. Mature males have a reddish head. They are carnivorous and feed largely on insects and spiders.

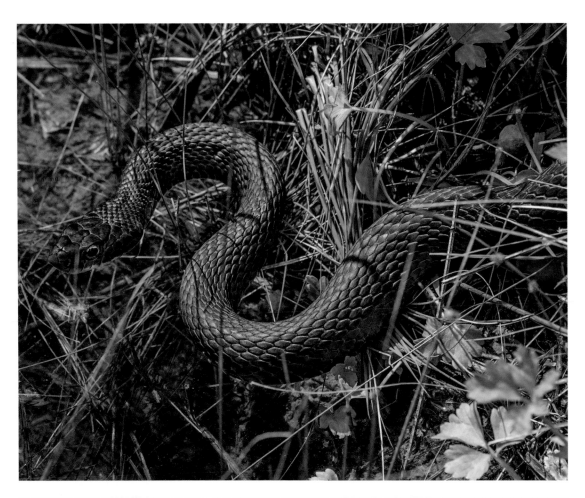

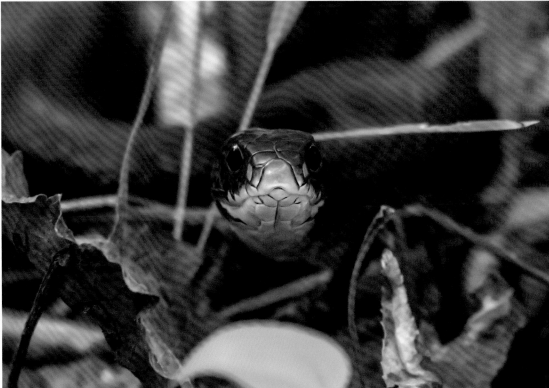

Figures 127 and 128. Southern black racer (*Coluber constrictor priapus*). This snake is built for speed and preys on virtually any vertebrate it can catch. Despite the scientific name, this snake does not constrict its prey but swallows it alive. Although it is considered harmless to humans, anyone who has picked up a black racer will recognize it immediately as one of the most combative snakes.

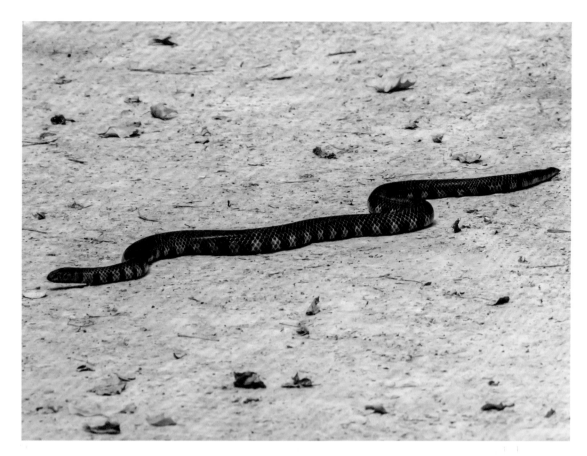

Figure 129. Mudsnake (*Farancia abacura*). This is not a rare snake, but it is rarely seen. It is almost exclusively aquatic and hunts amphiuma (*Amphiuma* spp.) and other amphibians and fish. It is shiny black on the dorsum, while the venter is a beautiful red. They rarely bite when picked up but have an unnerving though harmless habit of hiding their heads and poking their tail spine into handlers.

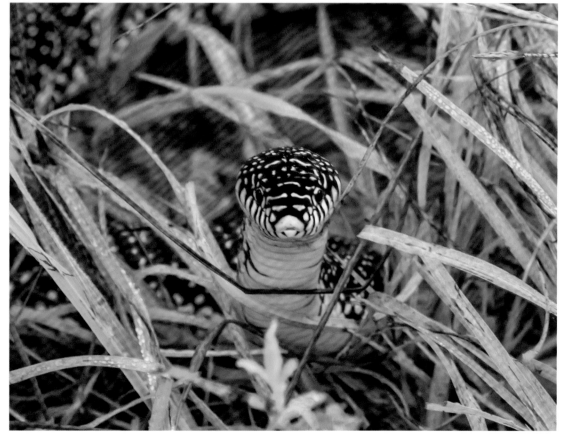

Figure 130. Speckled kingsnake (*Lampropeltis holbrooki*). The kingsnake is shiny black with yellow dots speckled about its dorsum. It is one of the few snakes that enjoys a good reputation because it has a predilection for eating other snakes, including venomous snakes, to which kingsnakes are not susceptible and which are easy to capture. Harmless to humans, kingsnakes may bite when first picked up but readily calm down and are easily held.

Figure 131. Yellow-bellied watersnake (*Nerodia erythrogaster flavigaster*). This harmless watersnake is uniformly brownish-green on the dorsum and pale yellow on the venter. It feeds on frogs, toads, and fish. This species of watersnake is unusual in that it is just as likely to be found away from water as it is near water. When threatened, it will frequently flatten its head. It is often mistaken for a cottonmouth and killed for no reason other than ignorance and fear.

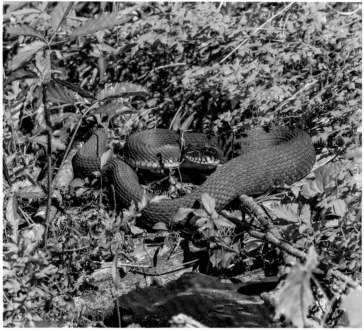

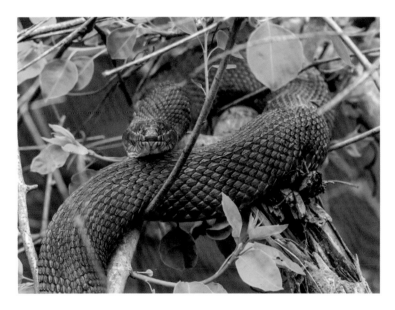

Figures 132 and 133. Diamondback watersnake (*Nerodia rhombifer*). This watersnake has a serial pattern of black rhombi running the length of the brownish-green dorsum. It is one of the largest snakes found in the park, with adults at times reaching 1.2–1.5 meters (4–5 feet) long. However, predation, mainly by American alligators, means that these watersnakes rarely achieve maximal length. They are usually found in or near water and feed largely on fish and to a lesser extent frogs. Although generally harmless to humans, they can give nasty bites. These snakes, too, are often mistaken for cottonmouths and consequently killed.

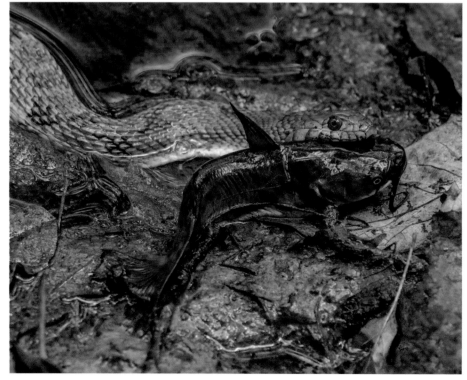

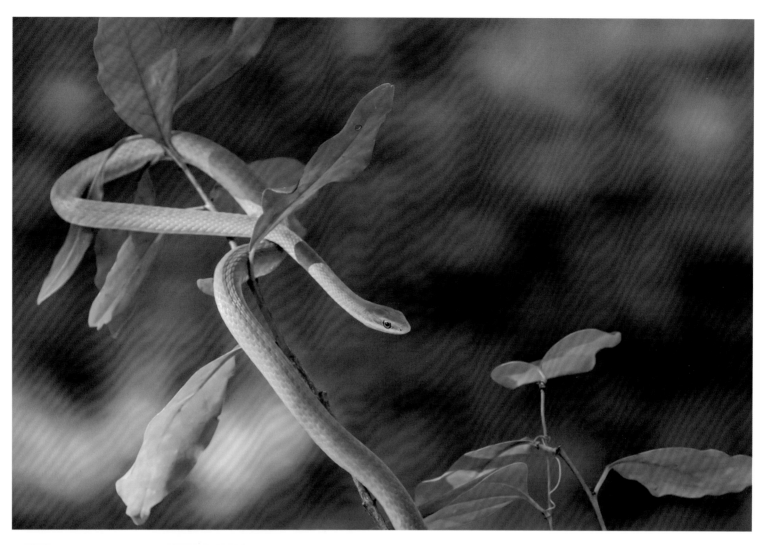

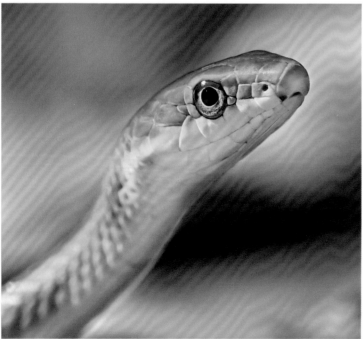

Figures 134 and 135. Rough greensnake (*Opheodrys aestivus*). This slender snake has a vinelike appearance that allows it to hide in plain sight. They can move their bodies back and forth to mimic small tree limbs caught by a breeze. This snake primarily hunts invertebrates but will take small frogs if available. They are harmless to humans and rather docile and unlikely to bite.

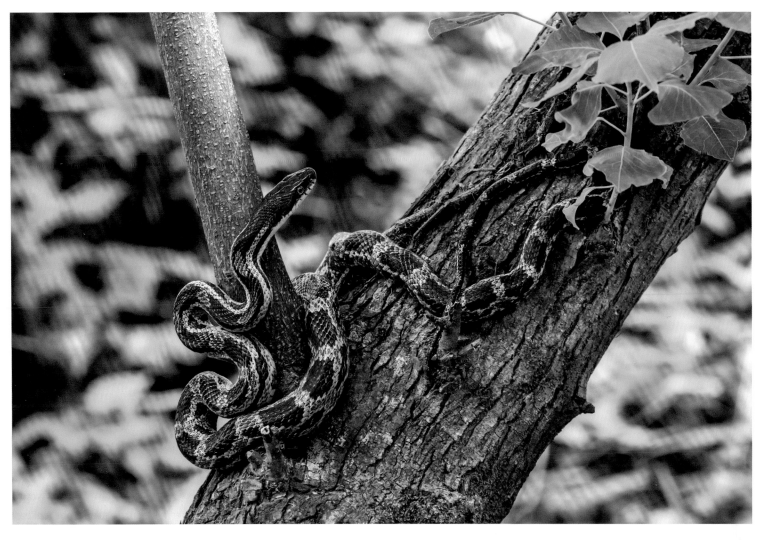

Figures 136 and 137. Gray ratsnake (*Pantherophis spiloides*). A common snake that feeds on rodents, birds, and their eggs, the gray ratsnake kills its live prey by constriction. This snake can reach 2 meters (6 feet) in length and was historically referred to as a chicken snake because of the frequency with which it was found near penned chickens and the eggs that it was after. It is an excellent climber, just as comfortable in trees as on the ground. It is harmless but can inflict a substantial bite.

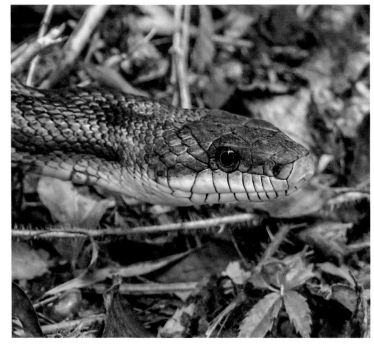

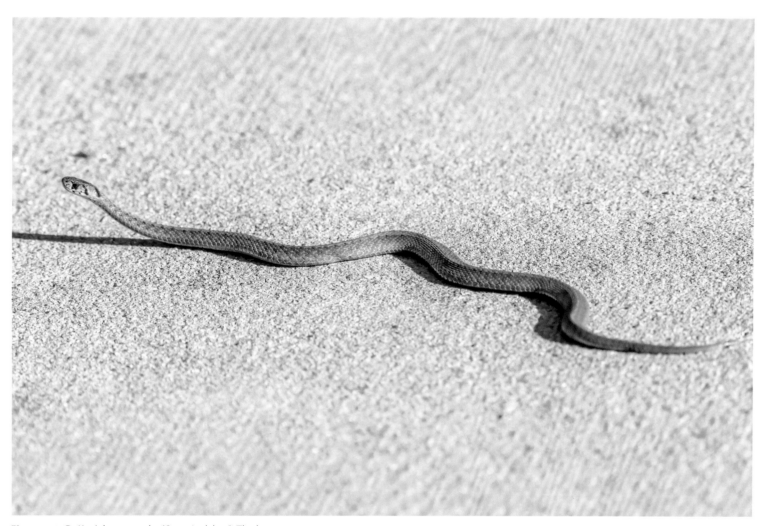

Figure 138. DeKay's brownsnake (*Storeria dekayi*). The brownsnake is one of the smallest snakes found in the park. An adult is typically 30 centimeters (1 foot) long. Occasionally seen in the open, this snake is more often at home in leaf litter and feeds mainly on slugs, snails, and earthworms.

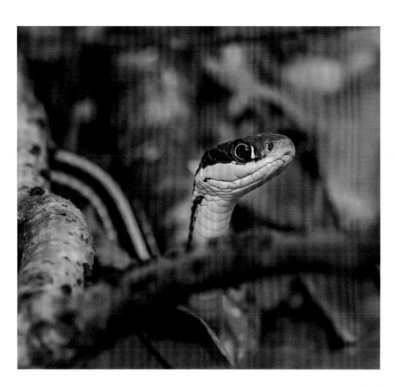

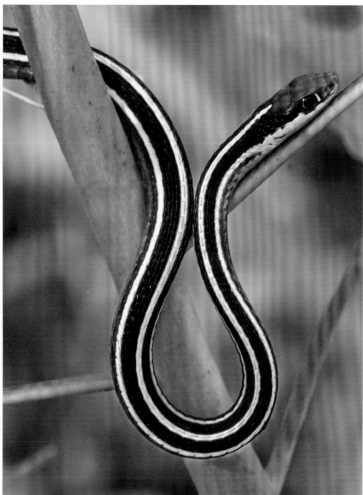

Figures 139, 140, and 141. Eastern ribbonsnake (*Thamnophis saurita saurita*). This harmless snake is frequently encountered on the park trails in the vicinity of water, where it feeds largely on frogs, toads, and small fish. It will strike if picked up and will defecate a musky and extremely unpleasant discharge. A small white spot is seen in front of the eye.

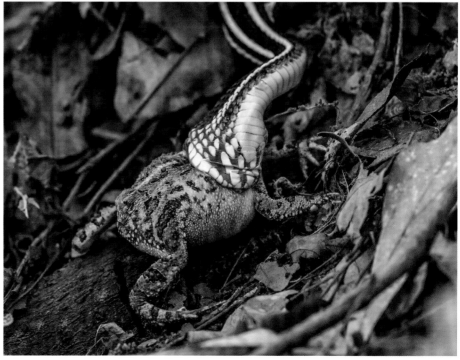

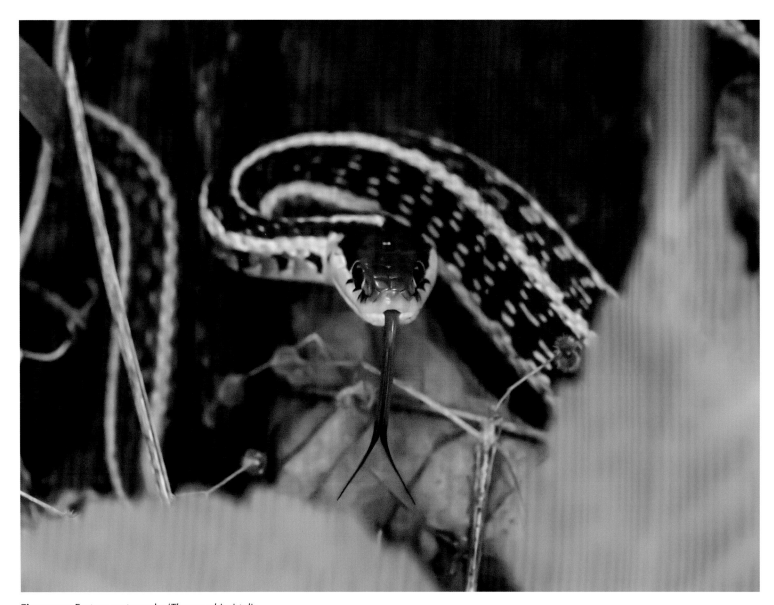

Figure 142. Eastern gartersnake (*Thamnophis sirtalis sirtalis*). The eastern garter can be distinguished from the eastern ribbonsnake by dark vertical markings on the labial (lip) scales and a distinctive red and black tongue. The garters are also shorter and stockier, but assessing that distinction requires naturalists to have either great memories or examples of the two snakes for comparison.

Figure 143. Western cottonmouth (*Agkistrodon piscivorus*). The cottonmouth is the only semiaquatic pit viper in the United States. It gets its name from its behavior when threatened: it elevates its head, opens its mouth, and exposes the white epithelial lining. As the young cottonmouth in this photo matures, its shape, banding, and coloration will give way to a dark and heavy-bodied look. Like the closely related copperheads, cottonmouths have infrared detecting pits between their nostrils and eyes as well as hollow fangs that can deliver tissue-degrading venom. Their reputation is far worse than reality: I have encountered dozens of cottonmouths, stepping next to them on several occasions, and have never experienced a strike, let alone a bite. A naturalist who comes across a cottonmouth should simply step back and leave it alone. Ignorance and fear leads humans to kill many cottonmouths and other unrelated and completely harmless snakes.

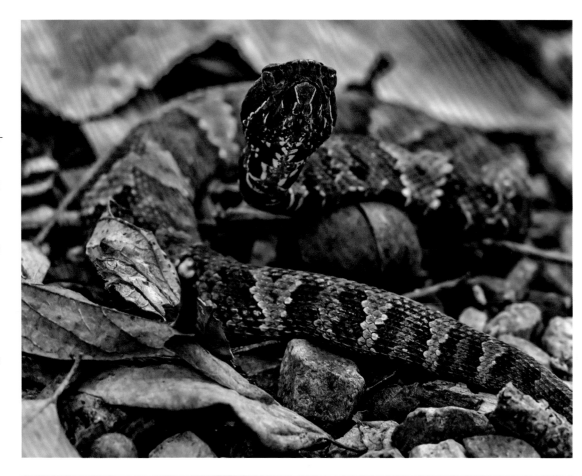

Figure 144. Eastern copperhead (*Agkistrodon contortrix*). The copperhead is a beautiful snake whose pattern and coloration is perfectly suited for leaf litter. This snake hunts primarily rodents but will take birds, amphibians, and cicadas. As pit vipers, they have sensory pits between their nostrils and eyes that detect infrared heat given off by a rodent or bird. They possess hollow fangs that inject tissue-degrading venom from modified salivary glands. They hunt by ambush and allow the venom to dispatch the prey. For many Mississippians who suffer venomous snakebites, copperheads are the most likely culprits, though the bites are painful but rarely fatal to humans. As with the cottonmouth, the best strategy to follow if encountering a copperhead is to leave it alone and step away.

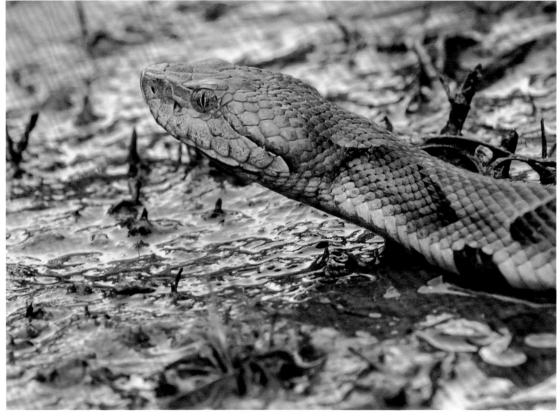

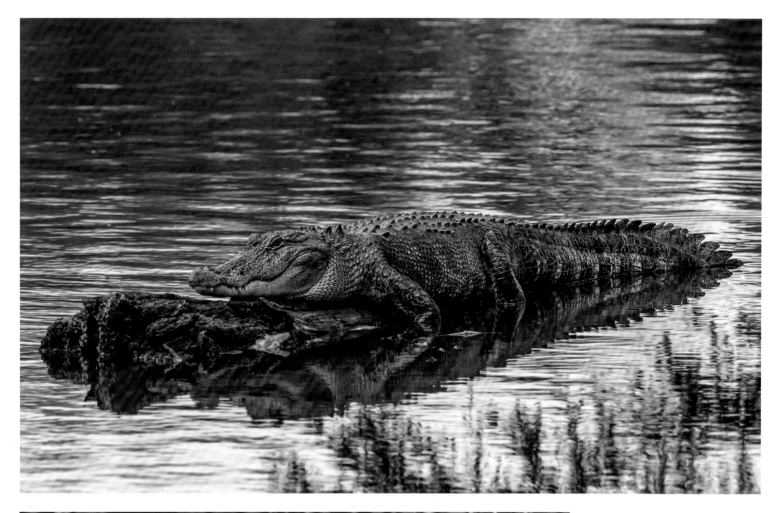

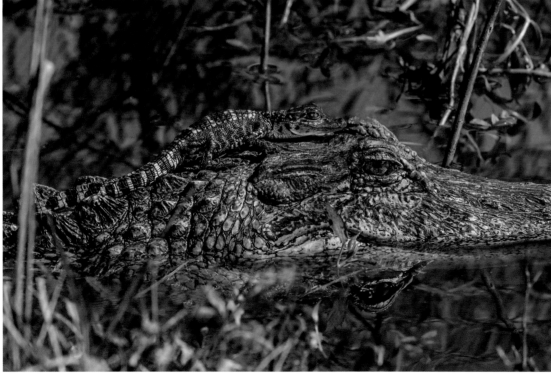

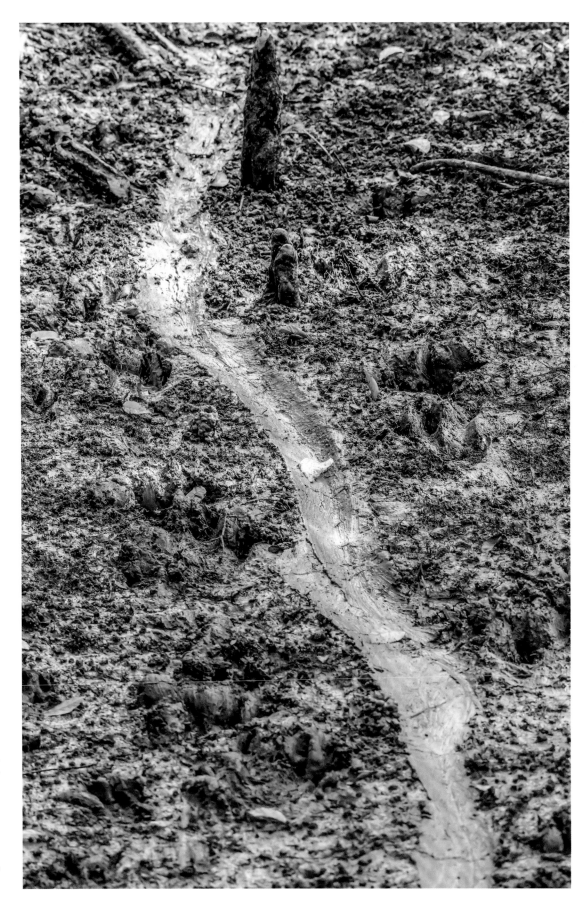

Figures 145, 146, and 147. American alligator (*Alligator mississipiensis*). The state's apex predators, American alligators in the park have reached 4 meters (13–14 feet) in length and an estimated 225 kilograms (500 pounds). Female American alligators are one of the few reptiles that show maternal care. Alligator tracks often include a conspicuous tail drag, and they feed on anything they can catch, meaning that humans should exercise caution regarding them- selves and their pets along any body of water in the park.

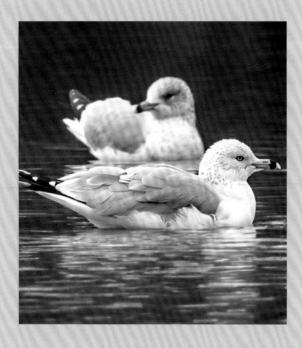

Chapter 5

BIRDS

Birds are now recognized as the lone remaining group of theropod dinosaurs that survived the Cretaceous extinction some 65 million years ago. Dinosaurs are often thought of as an extinct group of reptiles that would not be known at all except for the fossil record. Indeed, most—but not all—dinosaurs are extinct. We have long known that birds and reptiles were related because birds lay amniotic eggs and have scales on their legs, but the big similarities have been found in fossils.

Paleontologists have unearthed and studied thousands of fossilized dinosaurs, including ancient and now extinct genera such as *Archaeopteryx* and *Confuciusornis*. Virtually all characteristics of modern birds—amniotic eggs, scales, feathers, wings, hollow bones, wishbones, bipedalism, toothless beaks, among others—have now also been found in theropod dinosaur fossil remains. For example, small and likely insulating feathers have been found in several therapod dinosaur fossils, not only demonstrating that they had feathers but suggesting they had the beginning of warm-bloodedness (homeothermy), both of which are found in birds. Feathers themselves have been traditionally thought to be modified reptilian scales, but current evidence suggests that they have an independent origin that occurred in the therapod line of dinosaurs. Birds appear different from modern reptiles for two reasons. First, all the close

reptile kin of modern birds are extinct, effectively erasing the similarities linking the two. They would have remained erased if paleontologists had not discovered them via fossils. Second, modern birds have radiated into an aerial niche, focusing and magnifying specific characteristics unique to powered flight and to which no other present-day reptile has come close.

Most animal, plant, and fungal species pictured in this book reside in the state throughout the year, mainly because they lack the ability to migrate. During winter, many species hibernate or go dormant, but they are still here. For many of the birds, however, flight and homeothermy have given them the extraordinary ability to migrate at all times of the year, and they take full advantage of that ability. Some bird species breed in the state during the summer, migrate during the fall to wintering grounds in Central and South America, and return during the spring. Other species, conversely, overwinter in the state, migrate during the spring to upper North America and Canada, where they breed before returning south to Mississippi in the fall.

Few groups of animals can rival birds for sheer beauty, both in coloration and song. Although some birds may have drab coloration for camouflage, many possess striking patterns, especially during mating season. Male and female birds often have quite different colorations, with males typically more colorful. Birds' songs are similarly differentiated. Many biologists see sexual dimorphism in color and song as a case of sexual selection. Charles Darwin noted two types of selection, natural and sexual. In the far-better known natural selection, nature selects traits and the organisms that bear them by culling the maladaptive and allowing only those that best fit the environment to pass on their genes. This selective carving of the genome tailors the population to its environment. In sexual selection, however, one sex selects traits of the other sex, a process that can lead to a trait that may not fit the environment at all. The ostentatious colors or elaborate songs of some male birds have no environmentally useful purpose other than to please the female. In many cases, these traits appear maladaptive in that they expose the male bird to predators. It is no surprise that most males mute their coloration and song following breeding season. Some biologists have argued that females select these traits in males simply because they are beautiful. Conversely, other biologists believe that garish coloration or an intricate song may prove to the female that a male is an extraordinarily fit mate because he can bear these dangerous traits. No matter the purpose, females select these traits,

producing male birds that are some of the most strikingly beautiful and sonorous creatures on the planet, and this phenomenon certainly holds true in this LeFleur's Bluff State Park and throughout the state.

More than 200 species of birds have been recorded in the park. This chapter features many of the yearlong, winter-only, and summer-only birds that are commonly found in the state and the park as well as some migrant and rarer species.

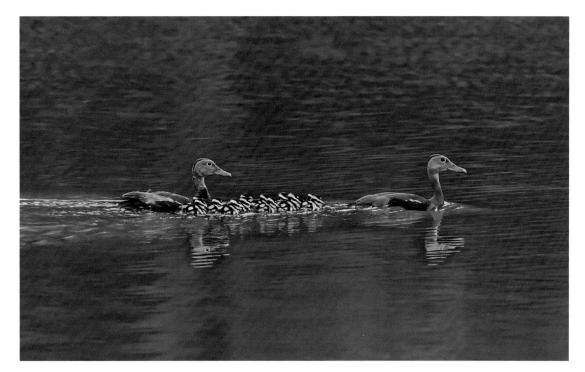

Figure 148. Black-bellied whistling duck (*Dendrocygna autumnalis*). This duck is found throughout South and Central America, with Mississippi at the extreme northern end of its range. Until recently, sightings of this duck were rare in the park: this photo captures the first time they nested and raised ducklings there.

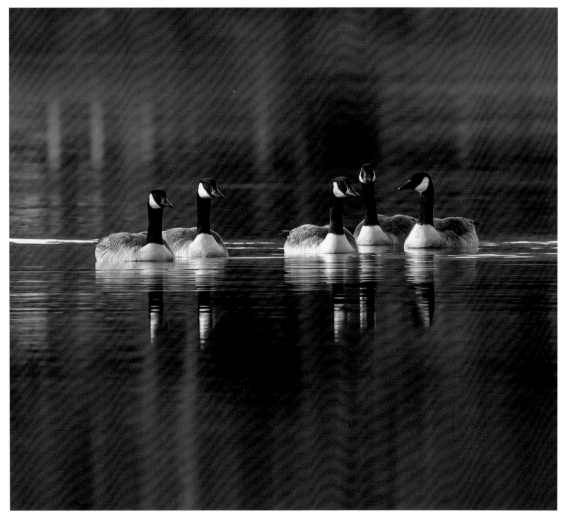

Figure 149. Canada goose (*Branta canadensis*). Year-round residents, the Canada goose has become so numerous that many humans regard it as a pest.

Figure 150. Wood duck (*Aix sponsa*). Woodies are a year-round icon. They are cavity nesters in trees or nest boxes, and their major food source is acorns.

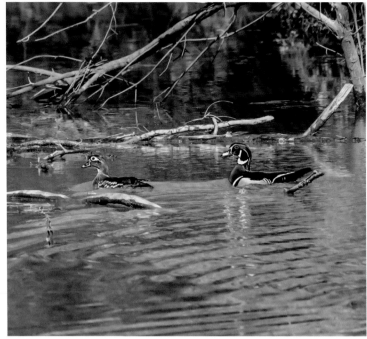

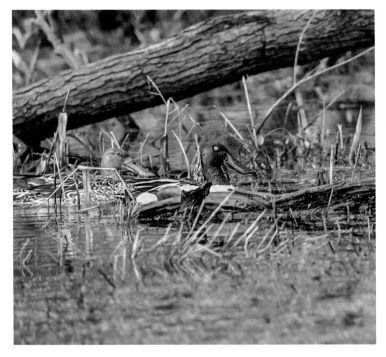

Figure 151. Northern shoveler (*Spatula clypeata*). Though northern shovelers are commonly found in the state during the winter, they are only sporadically sighted in the park. The wide spatulate bill is used to great effect when it dabbles for aquatic plants and invertebrates. Its summer breeding grounds are in the north-central United States and Canada.

Figure 152. Mallard (*Anas platy-rhynchos*). These birds frequent the state and the park only occasionally in the summer but are much more frequently found during the winter. They are one of the dabbling ducks that feed on plant material and invertebrates.

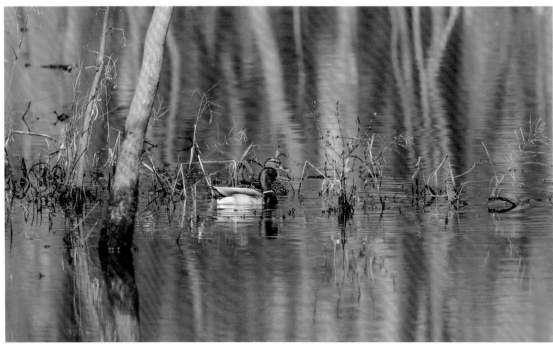

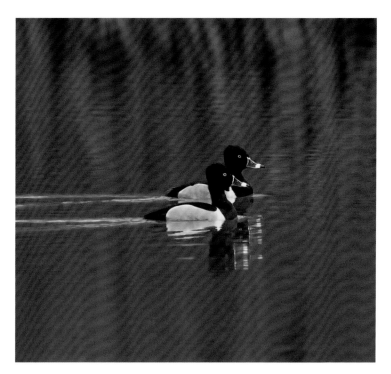

Figure 153. Ring-necked duck (*Aythya collaris*). Like the northern shoveler, the ring-necked duck spends the summer breeding in the northern United States and Canada and overwinters in Mississippi. The common name of this diving duck reflects the male's purplish collar.

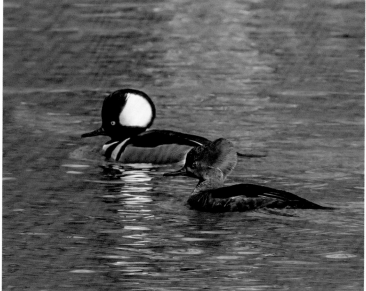

Figure 154. Hooded merganser (*Lophodytes cucullatus*). Another bird that summers in the northern United States and Canada and winters in Mississippi, the hooded merganser is a diver for fish and crawfish.

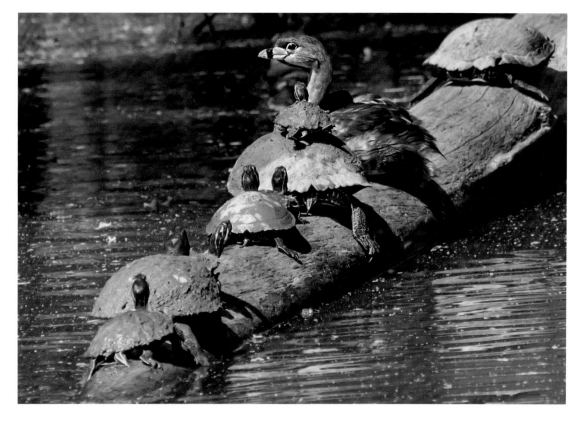

Figure 155. Pied-billed grebe (*Podilymbus podiceps*). A permanent resident of the state but is common in the park only during the winter, this diving bird often catches crawfish and small fish.

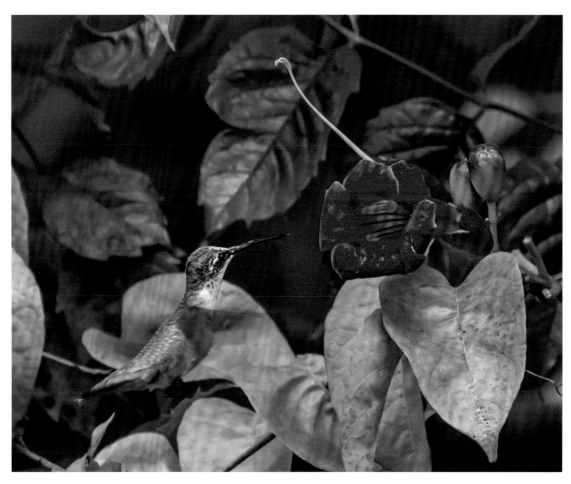

Figures 156 and 157. Ruby-throated hummingbird (*Archilochus colubris*). A common sight in the state as well as the park during the summer, these hummingbirds spend the winter in Central America. I initially thought this bird was part of the American trumpet vine (*Campsis radicans*).

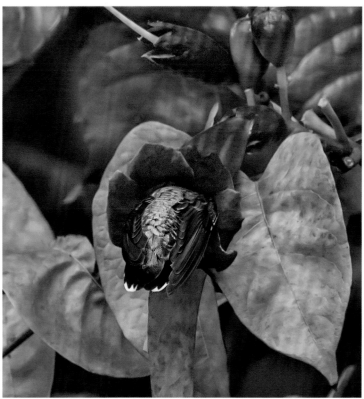

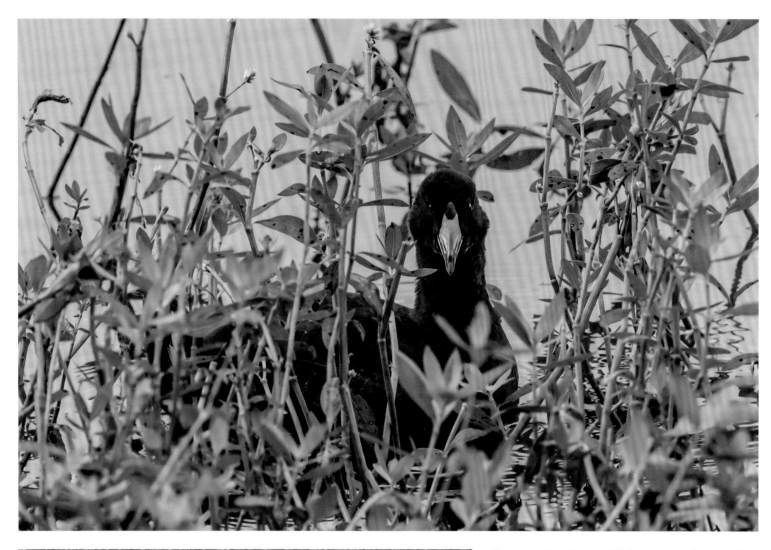

Figure 158. American coot (*Fulica americana*). During the winter months, the American coot is common in the state but only sporadically sighted in the park. Its breeding grounds are in the US Upper Midwest and Canada.

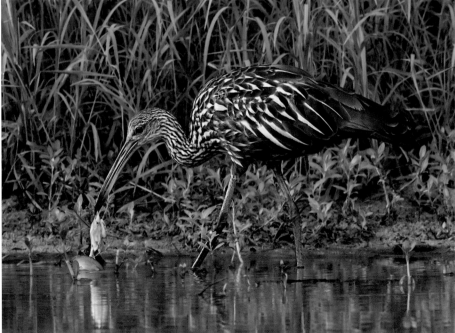

Figure 159. Limpkin (*Aramus guarauna*). Rarely seen in Mississippi and LeFleur's Bluff State Park, this large wading bird with drab plumage is named for its limping gait. It feeds largely on mollusks but will take amphibians and crawfish. In the United States, it has historically been seen primarily in Florida, where it feeds predominantly on apple snails (*Pomacea* spp.), but individuals have recently been reported across the eastern United States. This bird is feeding on a mussel.

Figure 160. Solitary sandpiper (*Tringa solitaria*). Often seen in Mississippi and the park during the spring and the fall, this bird is typically seen without companions, as its name suggests. It feeds along the shorelines of sloughs and rivers, foraging for invertebrates, frogs, and fish while bobbing the posterior half of its body—one of its identifying characteristics. It breeds in Canada during the summer and migrates to Central and South America during the winter.

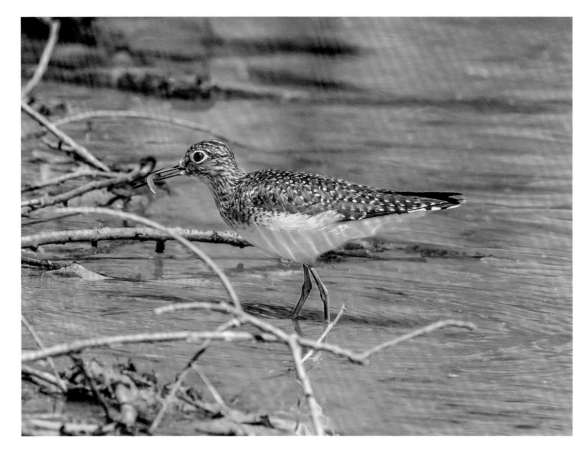

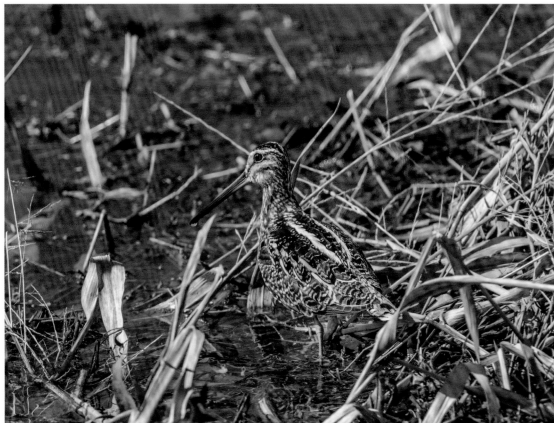

Figure 161. Wilson's snipe (*Gallinago delicata*). During the winter, Wilson's snipes are common in the state but rare in the park. Despite the popular perception of snipe hunts as pranks, the snipe is actually a game bird. It breeds in the northern United States and Canada during the summer and has a winter range that extends from the southern United States to northern South America.

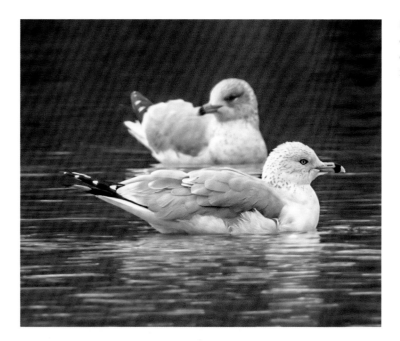

Figure 162. Ring-billed gull (*Larus delawarensis*). These gulls spend their winters in LeFleur's Bluff and the rest of Mississippi and their summers in the northern United States and Canada.

Figure 163. Wood stork (*Mycteria americana*). The only stork in the United States, these birds feed in shallow water on fish, amphibians, and crawfish. Wood storks winter in South Florida, the Caribbean, and Central and South America and can be seen sporadically in the park and the rest of Mississippi during the summer and early fall.

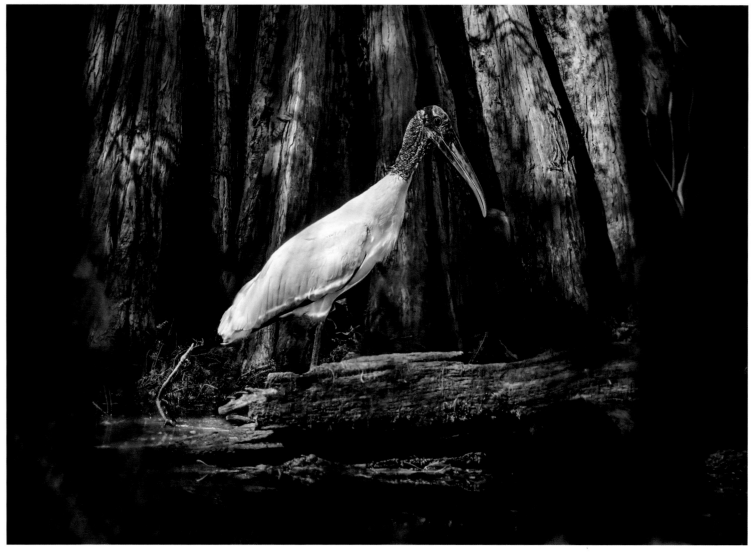

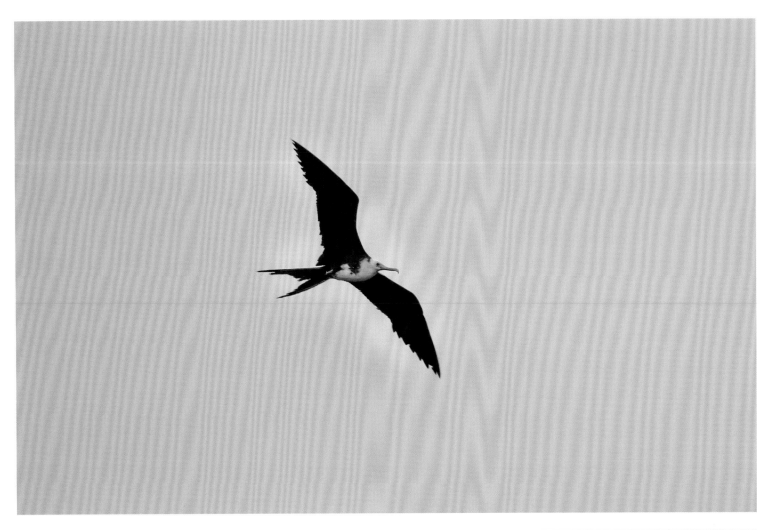

Figure 164. Magnificent frigatebird (*Fregata magnificens*). Primarily a seabird, the magnificent frigatebird is typically seen during the summer on the islands in the Mississippi Sound. However, two juveniles (only one is shown) were blown into the park during Hurricane Ida in 2021, the only time the species has been recorded there. Adult birds may have a wingspan of 2.5 meters (8 feet) and will hunt for fish on the wing over Caribbean or West Coast waters.

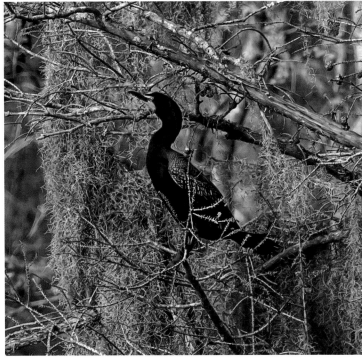

Figure 165. Double-crested cormorant (*Phalacrocorax auritus*). Very common in the state and the park during the winter and occasionally sighted in the summer, these cormorants are fantastic pursuit divers for fish. However, their outer feathers are not waterproof, so following a dive, they retire to trees and stumps to spread their wings and dry their feathers. Their summer breeding grounds are in upper-central North America.

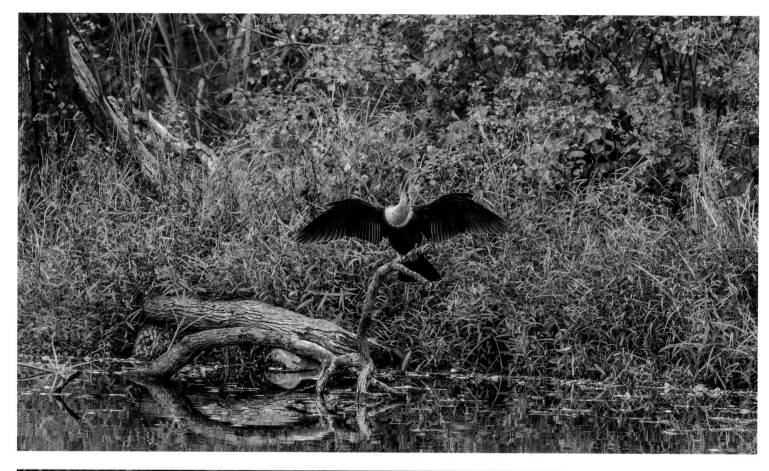

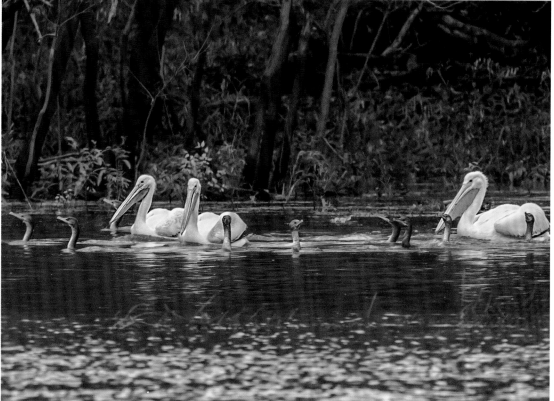

Figure 166. Anhinga (*Anhinga anhinga*). A year-round resident of Mississippi and the park, the anhinga is often confused with the double-crested cormorant. A piscivorous bird, the anhinga swims with only its head and neck above the waterline, leading to its nickname, snakebird. The bill is straight as a spear, and the anhinga does spear its prey. Like the double-crested cormorant, the anhinga lacks waterproof outer feathers and follows a dive by extending its wings to dry its feathers.

Figure 167. American white pelican (*Pelecanus erythrorhynchos*). These birds are found in the state's inland and coastal waters during the winter but only rarely sighted in the park. The few times I have seen pelicans there, they have been surrounded by actively diving double-crested cormorants.

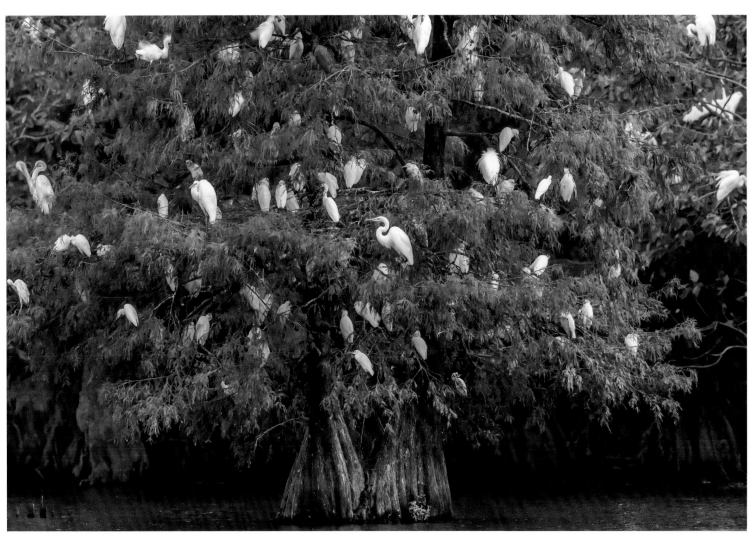

Figure 168. Hundreds of cattle egrets (*Bubulcus ibis*), snowy egrets (*Egretta thula*), great egrets (*Ardea alba*), and little blue herons (*Egretta caerulea*) roost in the bald cypresses (*Taxodium distichum*) on Lake Mayes near dusk during the late summer and early fall.

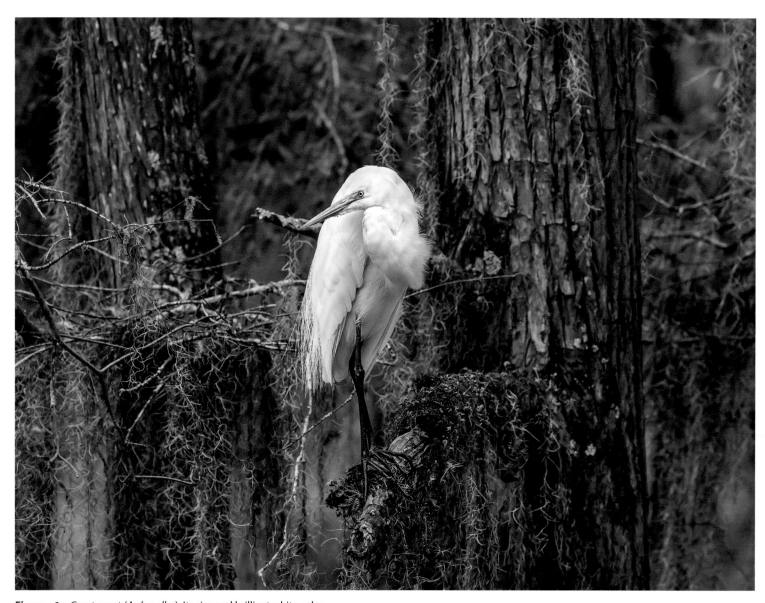

Figure 169. Great egret (*Ardea alba*). Its size and brilliant white color, combined with its year-round residence in Mississippi, make the great egret one of the most frequently seen birds in the park. A white heron, the great egret is placed in the same genus as the great blue heron (*Ardea herodias*) and thus is more closely related to it than to the snowy egret (*Egretta thula*) or cattle egret (*Bubulcus ibis*). Great egrets can reach 1 meter (3 feet) in height but weigh only 1.5 kilograms (3 pounds).

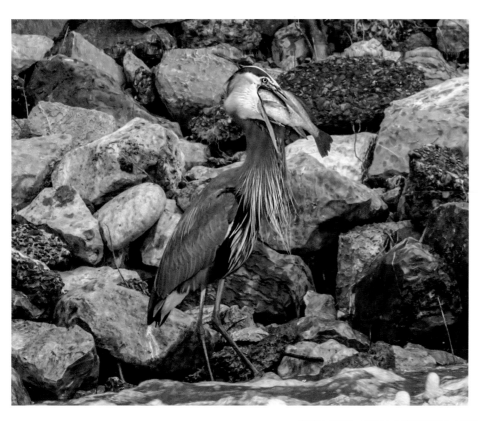

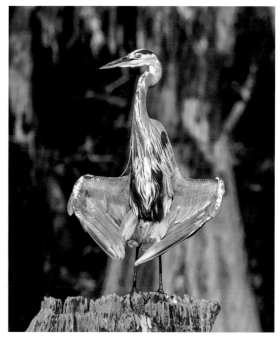

Figures 170, 171, and 172. Great blue heron (*Ardea herodias*). The largest heron in the United States (1 meter [3 feet] tall and weighing between 2.2 and 3.6 kilograms [5–8 pounds]) is a year-round resident of the park and will take fish from small minnows to large freshwater drum (*Aplodinotus grunniens*) that would seem too big for the bird to swallow. The delta-wing position helps the bird thermoregulate on sunny days.

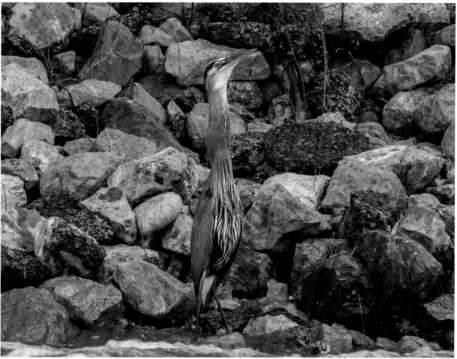

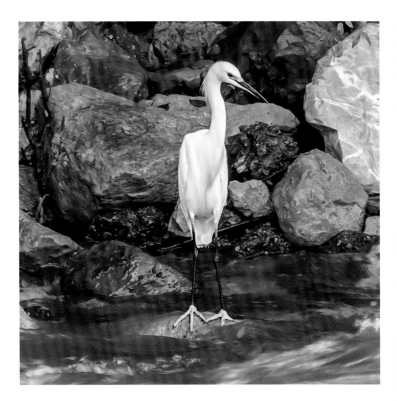

Figure 173. Snowy egret (*Egretta thula*). Very common summer residents of Mississippi and occasionally of the park, snowy egrets migrate south during the fall to the coastal parts of the United States, Mexico, and Central America. These birds have bright yellow feet and were hunted mercilessly in the past for their feathers.

Figure 174. Little blue heron (*Egretta caerulea*). Like the snowy egret, the little blue heron is frequently found in the state and occasionally in the park during the summer months. Other similarities exist as well: early in its first year, the little blue heron is all-white and is often mistaken for an egret. By the time of its first birthday, the heron transitions to a mix of blue and white feathers before getting its full blue plumage. They are occasionally seen foraging with white ibises (*Eudocimus albus*). The little blue heron breeds in the south-central United States during the summer and migrates to Central America to spend the winter.

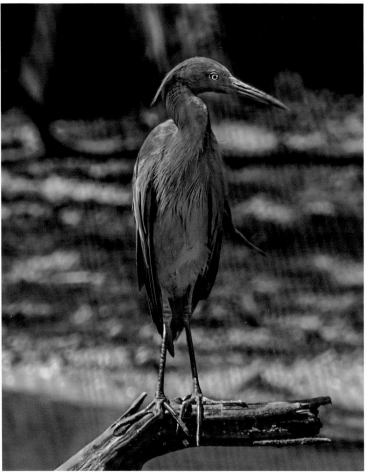

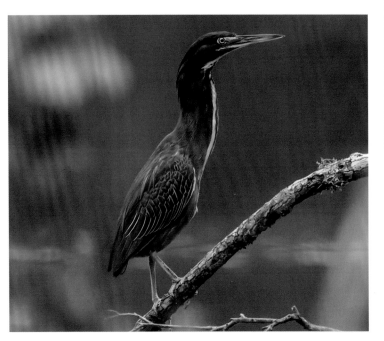

Figure 175. Green heron (*Butorides virescens*). Whereas many of the herons and egrets stand out conspicuously, the green heron is relatively small and can easily conceal itself in vegetation near the water's edge. It summers in Mississippi and winters between the far southern United States and northern South America.

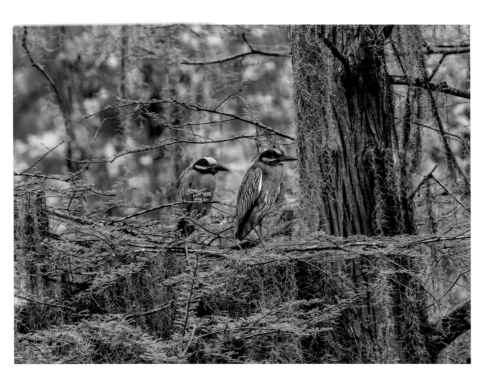

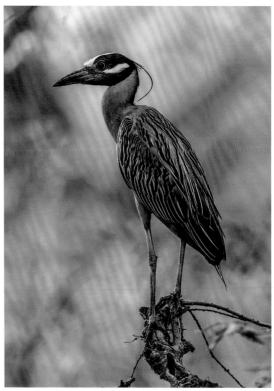

Figures 176, 177, and 178. Yellow-crowned night heron (*Nyctanassa violacea*). This bird breeds in LeFleur's Bluff State Park, where naturalists can observe gawky chicks in stick nests—and vice versa. The adults hunt in shallow sloughs, primarily for crawfish, and small piles of crunched crawfish shells may be a telltale sign of a nest above. These herons winter in Central and South America.

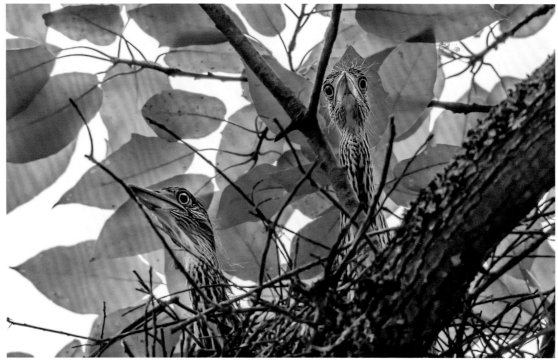

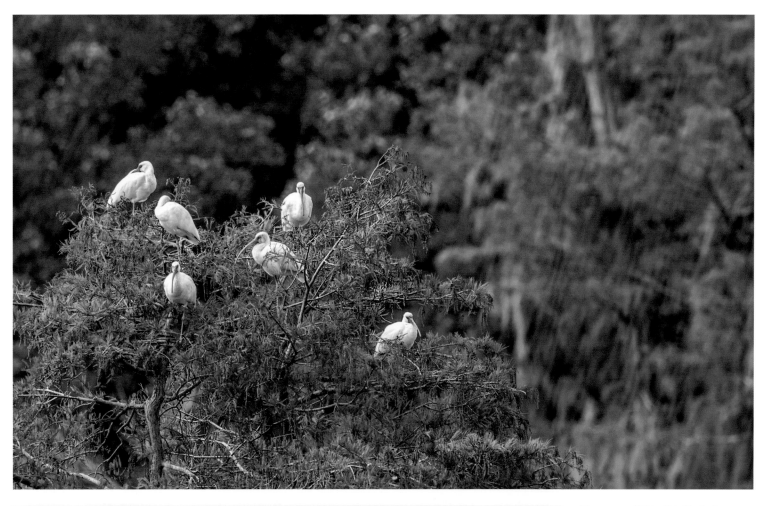

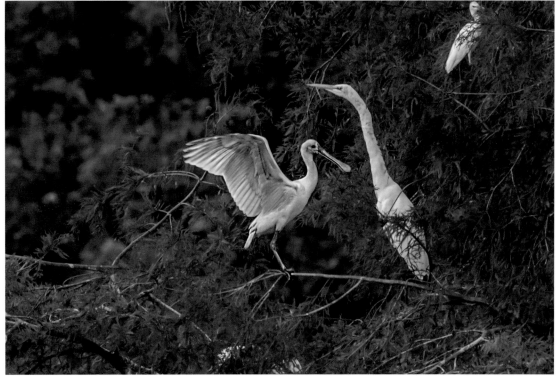

Figure 179. White ibis (*Eudocimus albus*). This beautiful white bird with a pink face, bill, and legs has jet-black wingtips visible only when flying. The bird forages at the edges of lakes and in wetlands, using its distinctive bill to probe for invertebrates and small fish and often accompanied by little blue herons. It is found year-round along the Gulf Coast.

Figure 180. Roseate spoonbill (*Platalea ajaja*). This bird is one of the more exotic visitors to the park, where it can be seen sporadically in the late summer and fall before heading to its winter home in Central and South America. Its color comes from carotenoid molecules absorbed from its crustacean diet. It catches a variety of invertebrates and small vertebrates by swinging the spoonbill back and forth in shallow water.

Figure 181. Osprey (*Pandion haliaetus*). Ospreys can be found year-round on the Mississippi coast, where they breed in the summer. Some spend the winter further south, in Central America.

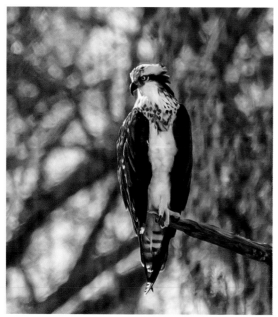

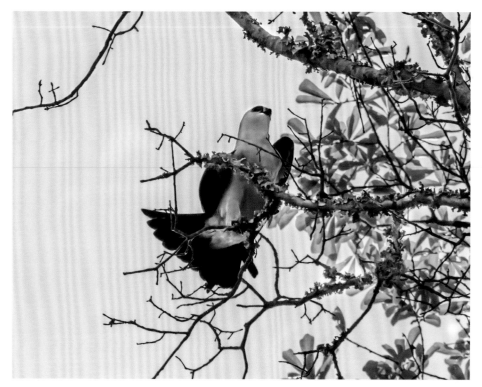

Figure 182. Mississippi kite (*Ictinia mississippiensis*). This iconic gray hawk is frequently sighted soaring high over the park during the summer; it occasionally can be seen landing in a tree or sitting on a nest. It feeds by catching large insects such as dragonflies, cicadas, and grasshoppers as well as other birds. During mating, the male will often extend his wings forward and completely enclose the female. They winter in South America.

Figure 183. Cooper's hawk (*Accipiter cooperii*). Found in the state year-round and in the park during the cooler months, this agile hawk uses its long tail as a rudder when flying through the woods to hunt smaller birds.

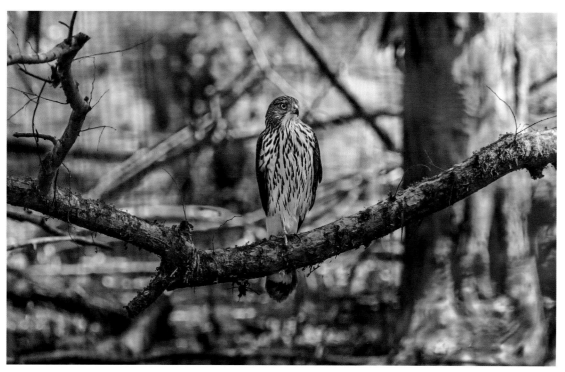

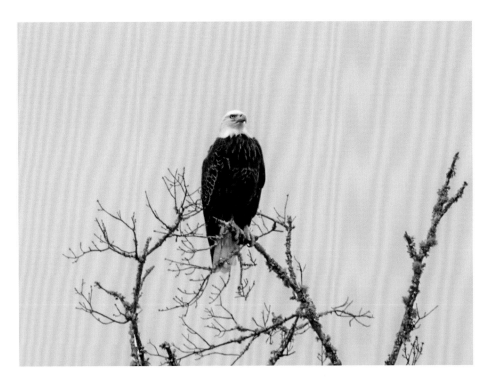

Figure 184. Bald eagle (*Haliaeetus leucocephalus*). Though this bird is commonly sighted in winter throughout the state and occasionally in the park, its scream as it crosses an open body of water is unmistakable.

Figure 185. Red-tailed hawk (*Buteo jamaicensis*). A resident of the park and Mississippi throughout the year, this large raptor is identified by its rufous-colored tail, which can be seen when the bird is either perched or flying overhead. It feeds primarily on rodents but can take almost any small vertebrate.

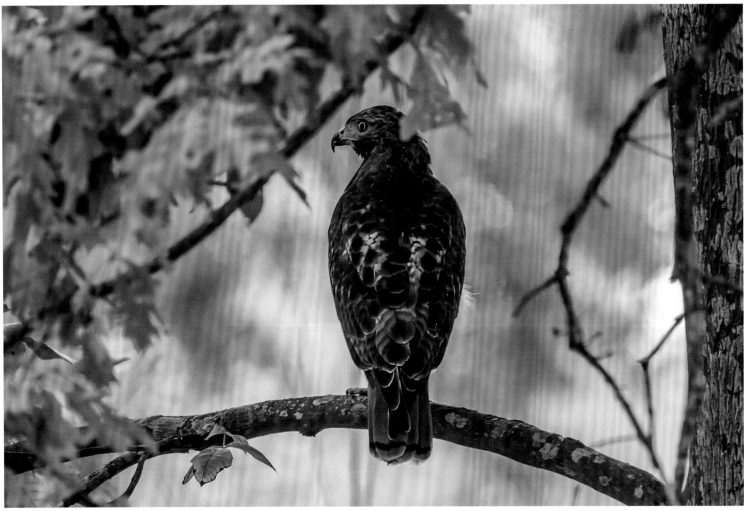

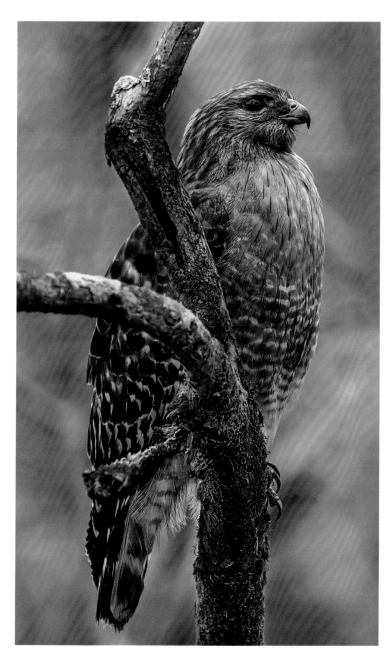

Figures 186 and 187. Red-shouldered hawk (*Buteo lineatus*). A year-round resident of both the state and the park, the red-shouldered hawk is the most commonly encountered raptor in LeFleur's Bluff. Naturalists often hear it even when they cannot see it because it is one of the noisiest hawks. It feeds on small mammals and birds but will also take frogs and snakes, temporarily storing its kill in its crop, an area of the esophagus that becomes distended when full.

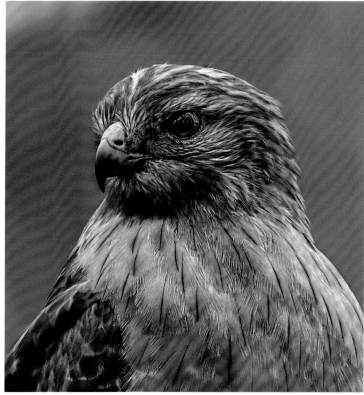

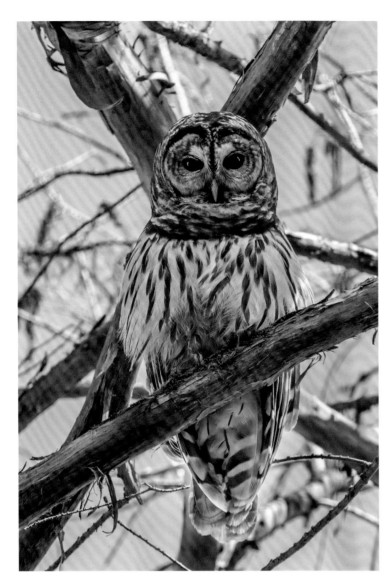

Figure 188. Barred owl (*Strix varia*). This is the most common owl in the park year-round, with a distinctive call that sounds like, "Who cooks for you, who cooks for you all."

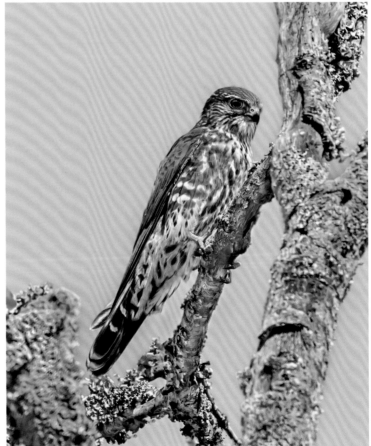

Figure 189. Merlin (*Falco columbarius*). Merlins occasionally can be seen in the state during the winter and have been spotted in the park during the spring and fall. Once known as pigeon hawks, they are fast fliers and adept hunters of small birds, a quality that has for centuries made them favorites of falconers. Merlins breed in Canada during the summer and winter in between the far southern United States and South America.

Figure 190. Belted kingfisher (*Megaceryle alcyon*). Both male and female kingfishers have a blue belt across the chest. However, reversing the typical bird pattern, female kingfishers have extra coloration— a brown band below the blue strip. The reason for this extra coloration is not known, but some observers believe it distinguishes females from combative males during mating battles. Kingfishers are plunge divers that feed mainly on fish. The birds nest in riverbanks, and their rattling calls can be heard along the state's various waterways year-round.

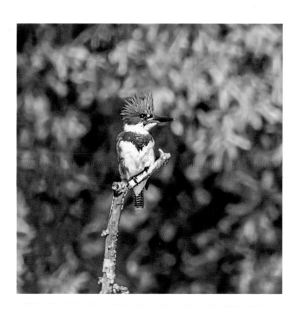

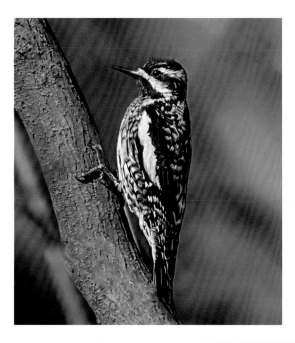

Figures 191 and 192. Yellow-bellied sapsucker (*Sphyrapicus varius*). A winter resident of the state and the park, this bird is believed to be Mississippi's only migratory woodpecker and the only woodpecker that does not breed in the state. This bird drills horizontal bands of holes in trees and then spends several days drinking the sap and eating any insects it attracts. The sapsucker heads to its breeding grounds in the northern United States and Canada in the spring.

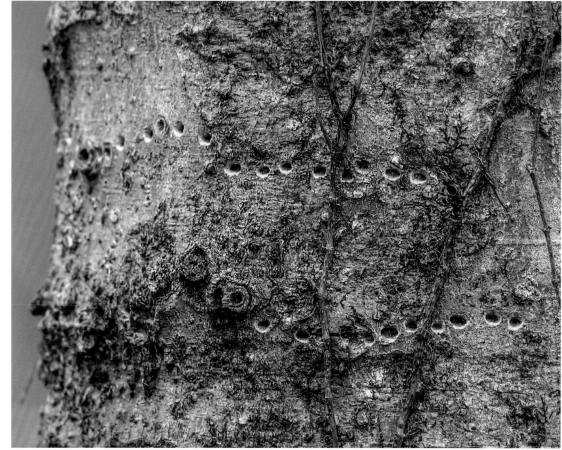

Figure 193. Red-headed woodpecker (*Melanerpes erythrocephalus*). A year-round resident, this woodpecker feeds on insects on trees and the ground but will readily take acorns and berries in winter. This bird is closely related to the red-bellied woodpecker (*Melanerpes carolinus*), with which it shares a genus.

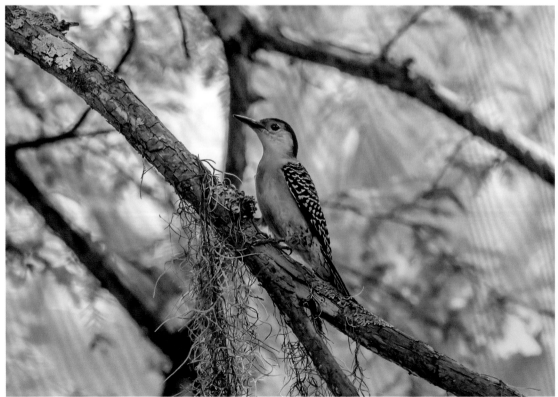

Figure 194. Red-bellied woodpecker (*Melanerpes carolinus*). Like its red-headed cousin, this bird is a year-round resident of the state and the park.

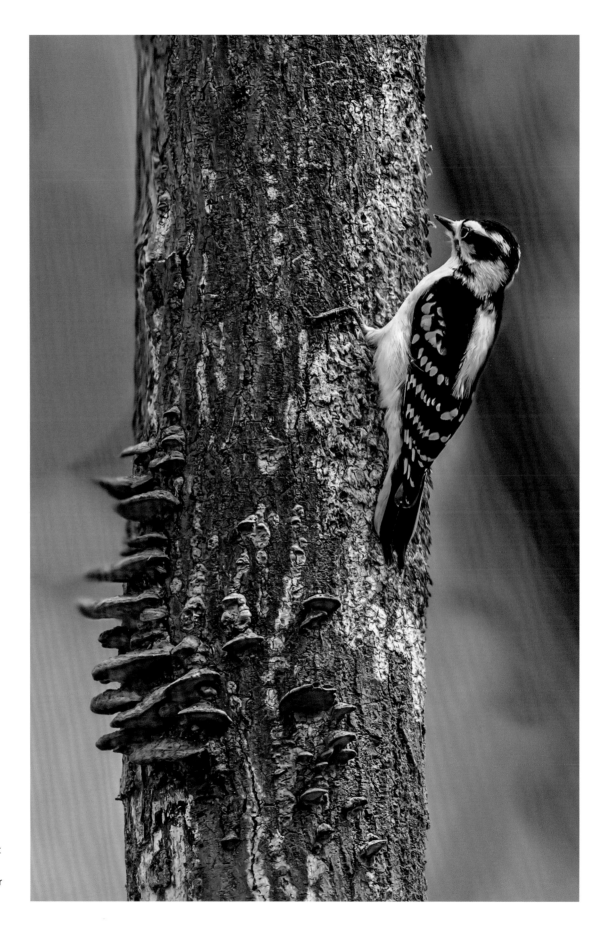

Figure 195. Downy woodpecker (*Dryobates pubescens*). This year-round resident weighs only about 25 grams (1 ounce) as an adult, making it the smallest woodpecker in North America.

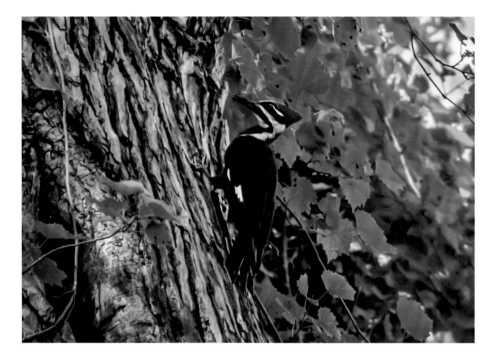

Figure 196. Pileated woodpecker (*Dryocopus pileatus*). The pileated is by far the state's largest woodpecker and can be seen here during all four seasons. The birds' prehistoric-sounding calls and drumming can be heard throughout the park. They are insectivorous but will also take berries.

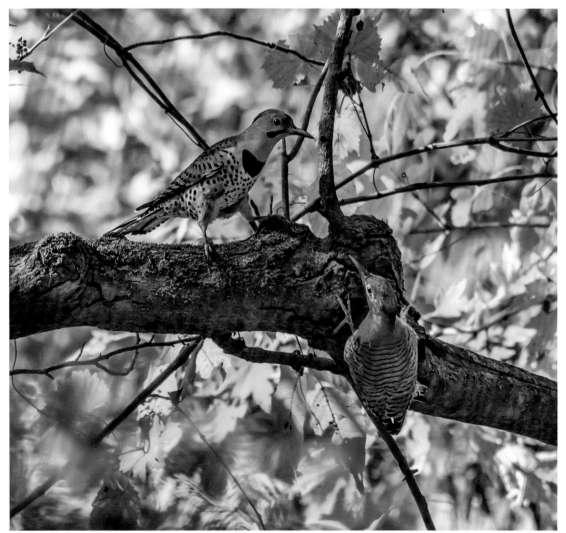

Figure 197. Northern flicker (*Colaptes auratus*). Although the flicker resides in the park throughout the year, sightings diminish in the summer. Males have a black mustache that the female lacks. They feed primarily on insects but will take all manner of plant products.

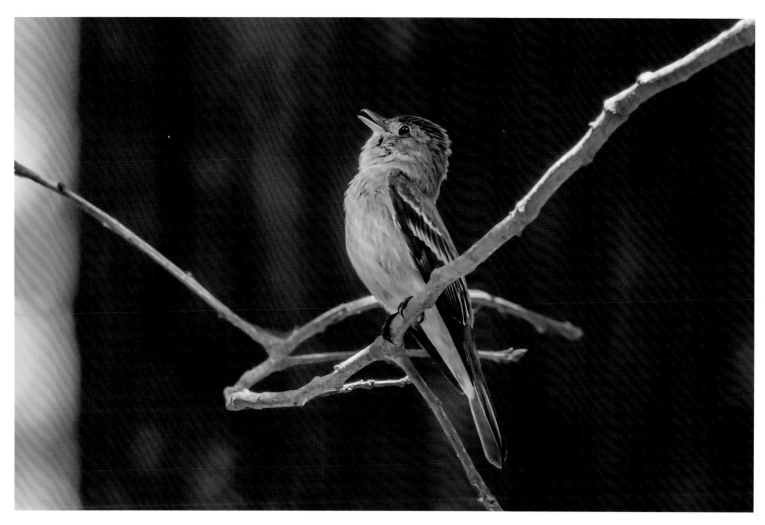

Figure 198. Eastern wood pewee (*Contopus virens*). The eastern wood pewee summers in Mississippi and winters in South America. A small flycatcher that feeds on insects by catching them in the air, this bird can be confused with the phoebe, but the former has stronger wing bars.

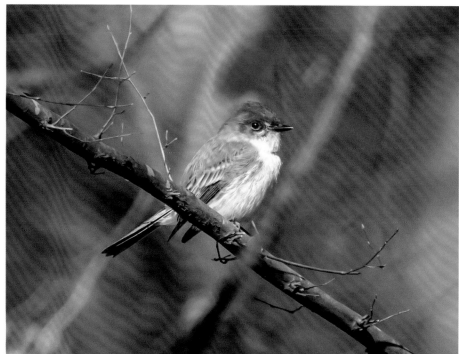

Figure 199. Eastern phoebe (*Sayornis phoebe*). This bird gets its name from the sound of its call. The phoebe is a flycatcher, and although some breed in the state in summer, others migrate to breeding grounds in the northern United States and Canada, returning in the fall to the southern United States and Mexico.

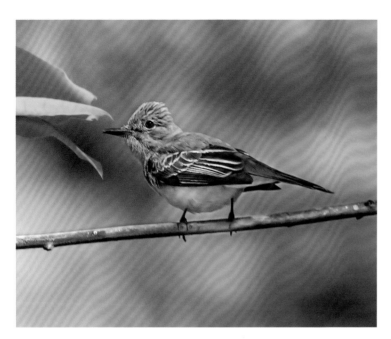

Figure 200. Great crested flycatcher (*Myiarchus crinitus*). A large flycatcher with a substantial crest, as its name indicates, this bird feeds high in the canopy and is not easily seen. It is a cavity nester that breeds in Mississippi before overwintering in the Yucatan and Central America.

Figure 201. Eastern kingbird (*Tyrannus tyrannus*). Elegant in its dark gray and white, this flycatcher has a red crown that it displays only rarely—for example, flashing it when aggressively attempting to drive off a larger bird. They breed in North America in the summer and migrate to South America for the winter.

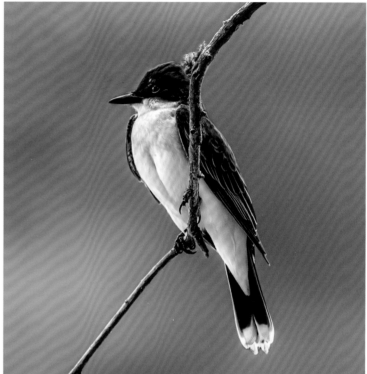

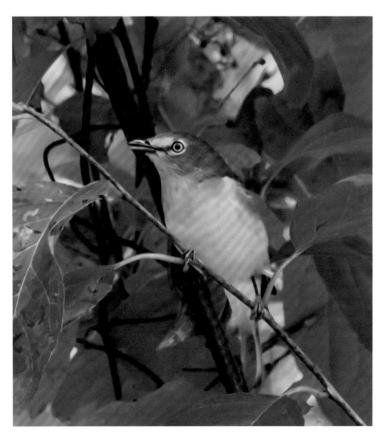

Figure 202. White-eyed vireo (*Vireo griseus*). A summer resident, the adult vireo has a distinctive white eye but is more easily heard than seen. "Chick, what's your major, chick" is one of several mnemonics for its song, which is audible throughout the day. The vireo hunts insects, largely caterpillars, in the brush, thickets, and small trees.

Figure 203. Blue-headed vireo (*Vireo solitarius*). This bird is warbler-like except that it has a robust bill, which it uses to capture its primary prey, insects; it also eats berries. It winters in Mississippi and breeds in the northern United States and Canada.

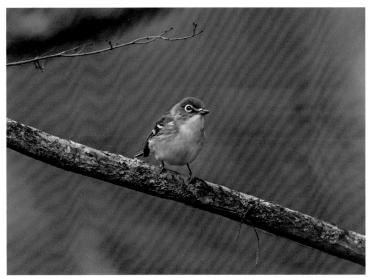

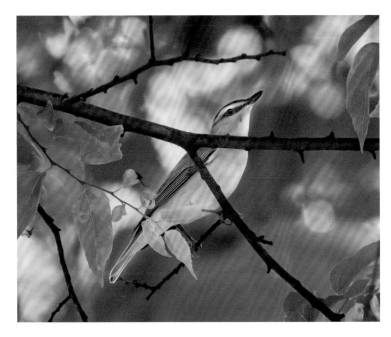

Figure 204. Red-eyed vireo (*Vireo olivaceus*). This aptly-named bird feeds on insects, fruits, and berries. It breeds throughout the eastern United States and Canada but heads to South America for the winter.

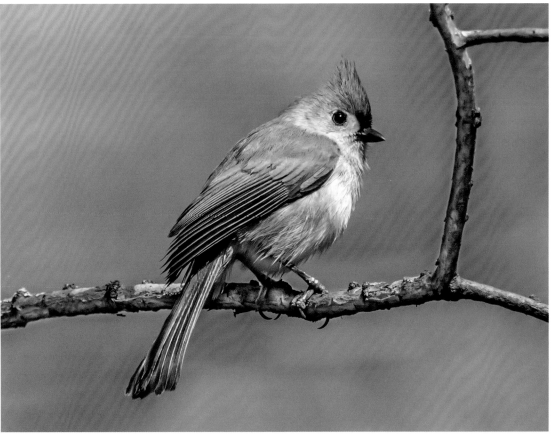

Figure 205. Tufted titmouse (*Baeolophus bicolor*). This bird's "peter-peter-peter" call can be heard year-round throughout the park.

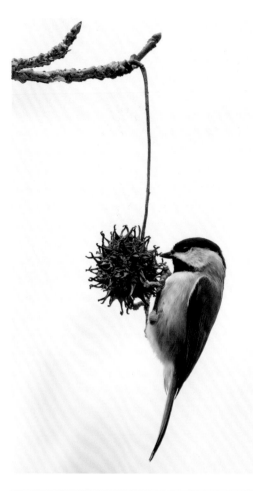

Figure 206. Carolina chickadee (*Poecile carolinensis*). This bird's common name reflects one of its calls. Chickadees are just as comfortable feeding upside down as right side up and eat insects during the summer and berries and seeds during the colder months. The birds make their nests in tree cavities. It is a year-round resident of the park and state.

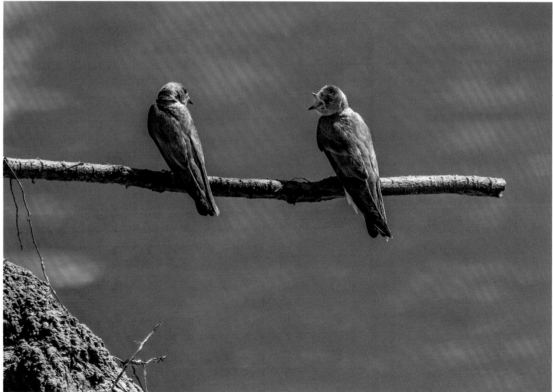

Figure 207. Northern rough-winged swallow (*Stelgidopteryx serripennis*). Naturalists can see these birds from the park's trails overlooking the Pearl River during the warmer months, though it migrates to southern Mexico and Central America during the winter. A graceful flier, it hunts insects low over the water.

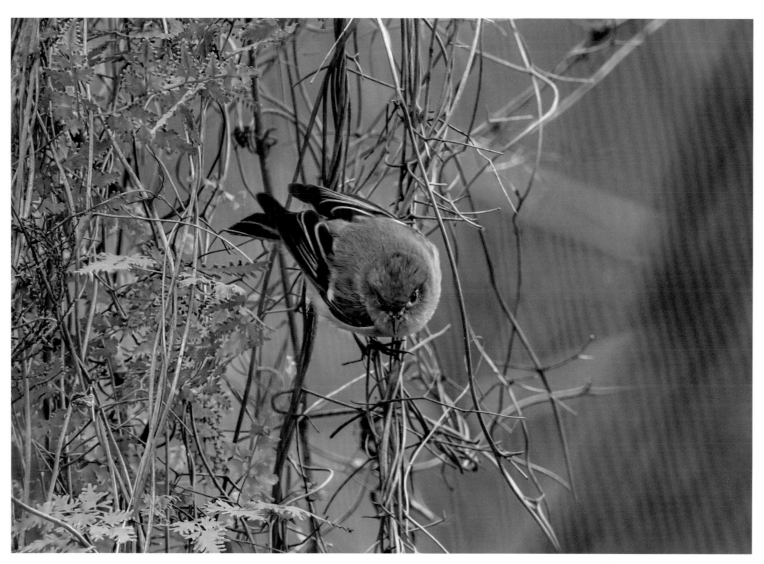

Figure 208. Ruby-crowned kinglet (*Regulus calendula*). The male kinglet's ruby crown is rarely seen and constitutes a major prize for bird photographers. The female lacks a crown. The kinglet summers in the northern United States and Canada and winters in Mississippi.

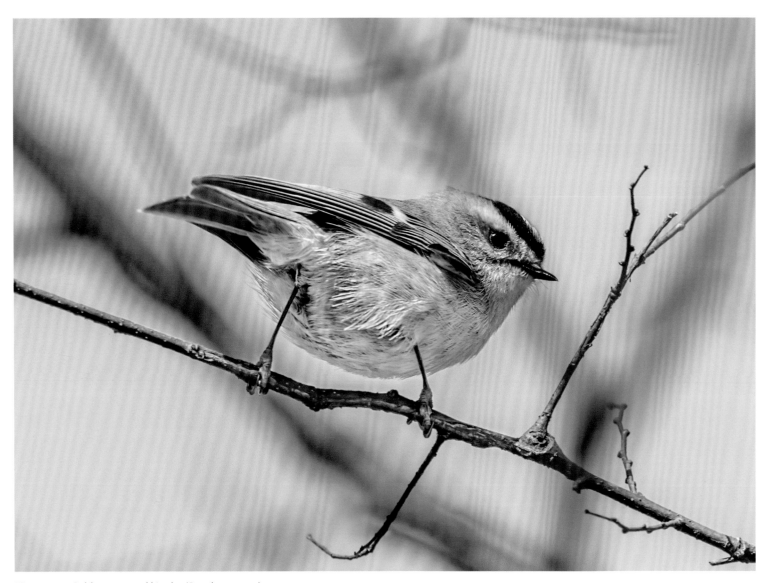

Figure 209. Golden-crowned kinglet (*Regulus satrapa*). Unlike the ruby-crowned kinglet (*Regulus calendula*), both sexes of this species possess the crown, although the male has an additional orange stripe in the center. This kinglet summers in northern United States and Canada and winters in Mississippi.

Figure 210. White-breasted nuthatch (*Sitta carolinensis*). A year-round resident, this distinctive bird is unusual in that it can move both up and down tree trunks in search of insects.

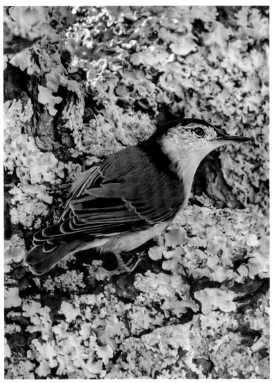

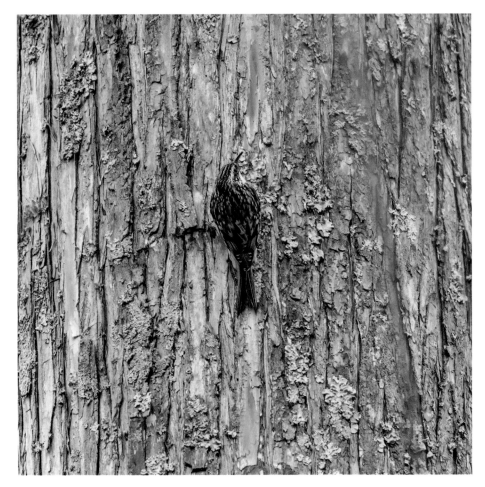

Figure 211. Brown creeper (*Certhia americana*). Blending perfectly into the tree bark, these birds forage upward, using their curved bills to ferret out insects and then flying back down to start again. Similar to woodpeckers, creepers use their tail feathers for support. They summer in the northern United States and Canada and winter in Mississippi.

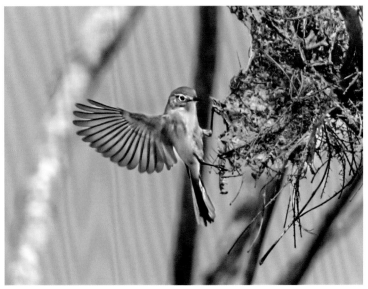

Figure 212. Blue-gray gnatcatcher (*Polioptila caerulea*). Despite the name, this small and active bird feeds on a variety of insects. They fly to Mexico to overwinter and return to Mississippi in the spring.

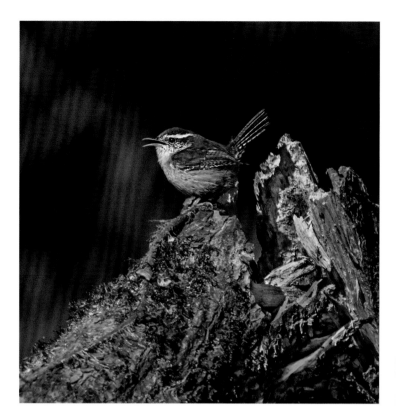

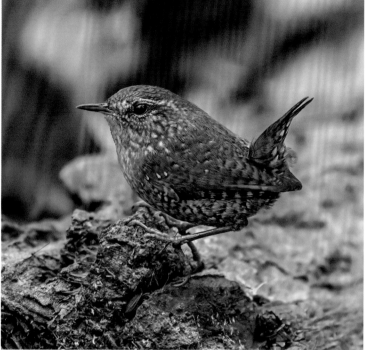

Figure 213. Carolina wren (*Thryothorus ludovicianus*). Frequently seen and heard, the wren is an insectivore that feeds largely on the ground, particularly on downed trees. It is a year-round resident of the park and state.

Figure 214. Winter wren (*Troglodytes hiemalis*). This tiny mouselike bird is found mostly on the swamp floor, where it investigates the cracks and crevices of cypress knees and logs for insects. The wren winters in the state but moves north to breed in the upper United States and Canada.

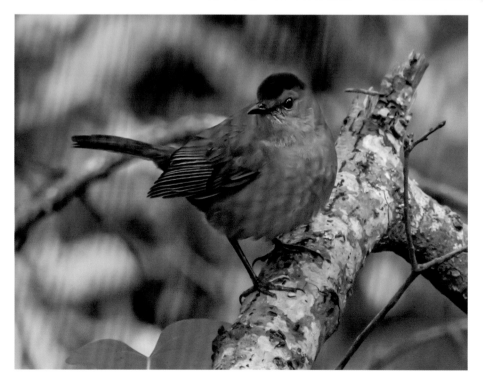

Figure 215. Gray catbird (*Dumetella carolinensis*). The largely gray bird has a black cap and rusty-colored feathers (coverts) on the underside of the body. It derives its name from its catlike sound. It is a member of the family Mimidae, and its relatives are the mockingbird and brown thrasher. The catbird breeding grounds include much of temperate North America, and it winters in Mexico and Central America.

Figure 216. Northern mockingbird (*Mimus polyglottos*). This bird's scientific name means "many tongued mimic," a reference to its song repertoire. Males sing as many as two hundred different songs, many of which are other bird's songs. It is the Mississippi state bird, medium-sized and gray, with white wing bars that are easily discernible in flight. It is feisty and will aggressively defend its nest against any intruder.

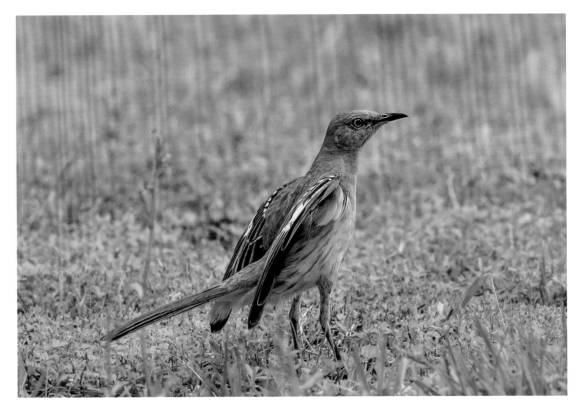

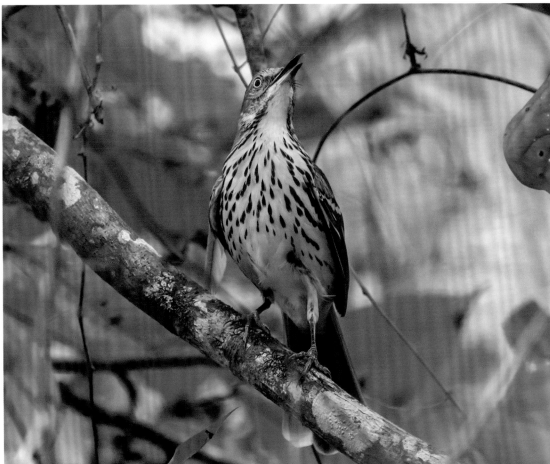

Figure 217. Brown thrasher (*Toxostoma rufum*). Mainly seen in thickets, brush, and small trees, this rufous-colored bird has bright yellow eyes and a curved bill. It is a generalist feeder and a member of the Mimidae family, which also includes mockingbirds and catbirds.

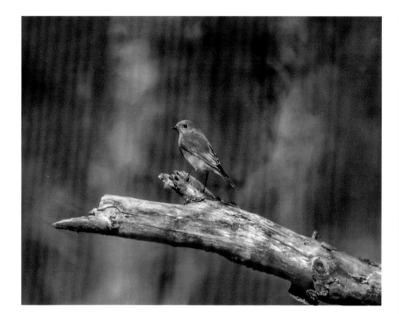

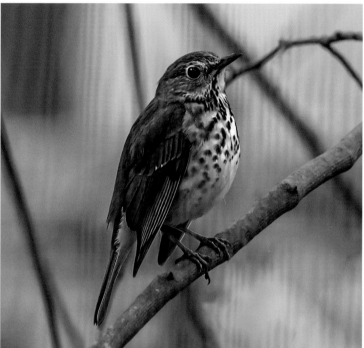

Figure 218. Eastern bluebird (*Sialia sialis*). These birds are found throughout the year in the more open parts of the park. They are omnivorous but prefer insects.

Figure 219. Hermit thrush (*Catharus guttatus*). During the winter, this bird is found low in the forest and often feeds on the ground on insects and berries. Its summer breeding grounds are in the northern United States and Canada.

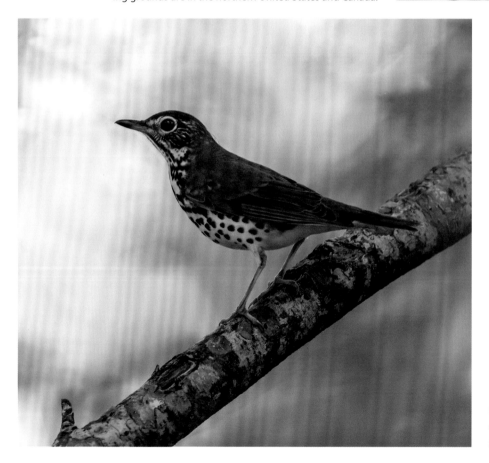

Figure 220. Wood thrush (*Hylocichla mustelina*). This bird winters in Mexico and Central America and spends the rest of the year in Mississippi.

Figure 221. Cedar waxwing (*Bombycilla cedrorum*). This bird's crest, mask, red wingtips, and yellow-tipped tail feathers make it particularly beautiful. Its summer breeding grounds are in Canada.

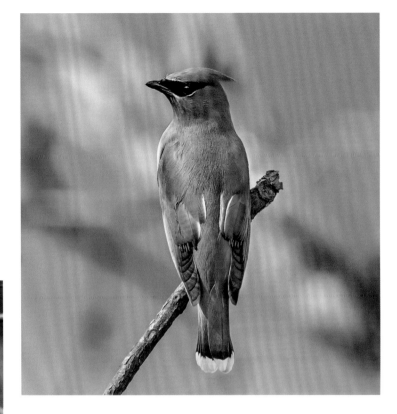

Figure 222. Lincoln's sparrow (*Melospiza lincolnii*). These birds have crisp dark streaks down the sides of their chests. They breed in summer in Canada and migrate to overwinter in the far southern United States and Mexico.

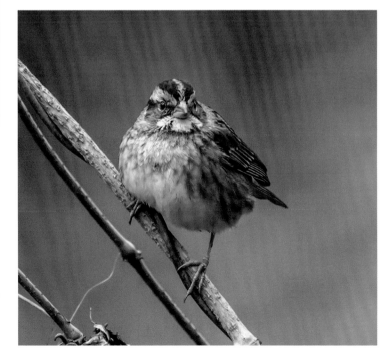

Figure 223. White-throated sparrow (*Zonotrichia albicollis*). A beautiful sparrow that feeds on seeds on the ground, this bird winters in the state but migrates north to its breeding grounds in Canada for the summer.

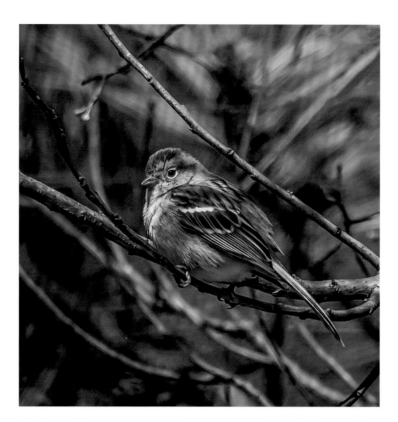

Figure 224. Field sparrow (*Spizella pusilla*). The park lacks the open bushy fields that this bird prefers, so these birds are only rarely seen in the park despite their year-round presence in the state.

Figure 225. Eastern towhee (*Pipilo erythrophthalmus*). This sparrow forages on the ground for plant material, insects, and spiders. Common year-round in the state.

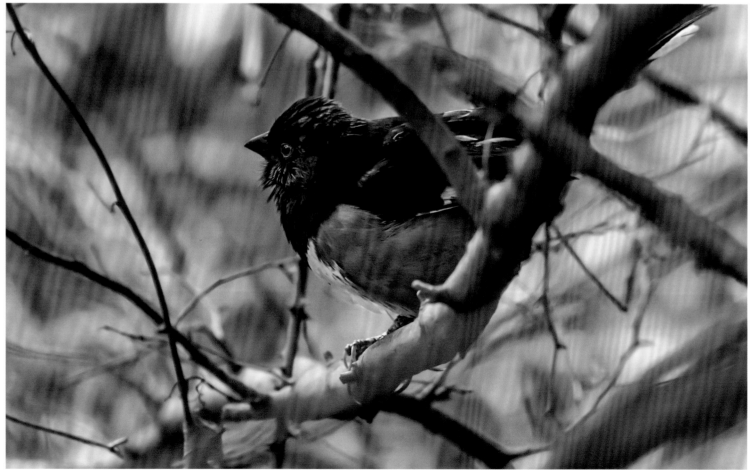

Figure 226. Dark-eyed junco (*Junco hyemalis*). These sparrows can be seen foraging on the ground throughout the drier parts of the park during the winter. They migrate north to breed in the northern United States and Canada.

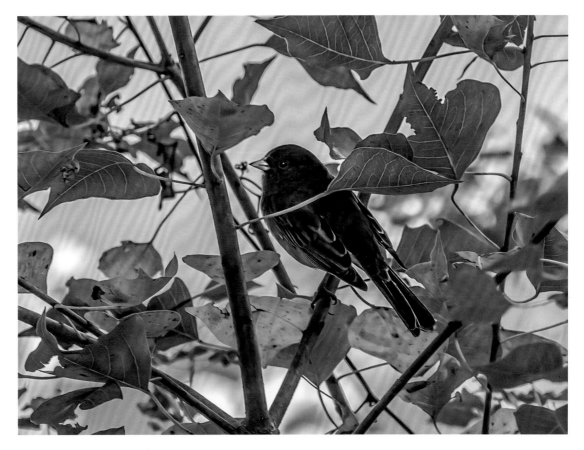

Figure 227. American goldfinch (*Spinus tristis*). After wintering in Mississippi, these birds molt in the spring, often looking disheveled. Some then remain in the state, while others head to summer breeding grounds in the northern United States and Canada.

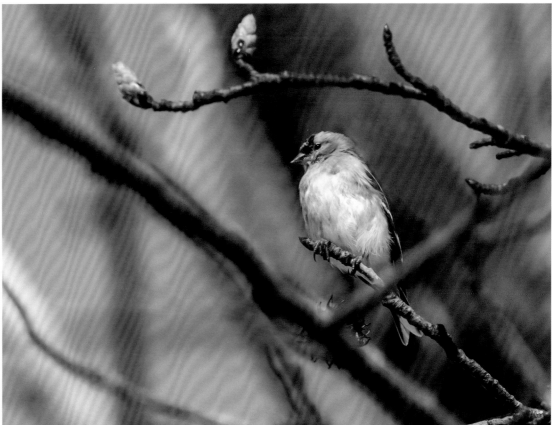

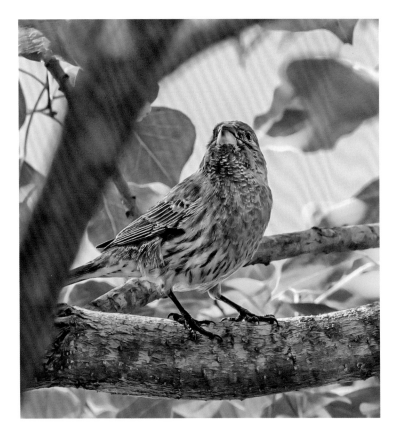

Figure 228. House finch (*Haemorhous mexicanus*). It is unusual for birds to feed their offspring plant material, but house finch parents do just that. It has been conjectured that this strategy deters nest parasitism by brown-headed cowbirds (*Molothrus ater*), whose chicks do not thrive without animal protein. It is a common resident year-round in state and park.

Figure 229. Orchard oriole (*Icterus spurius*). These birds winter in Central America and are known for their pouch-like nests.

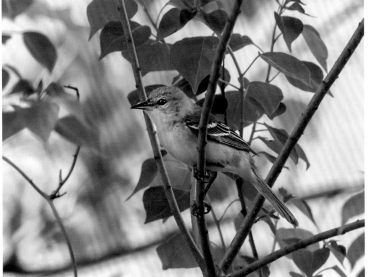

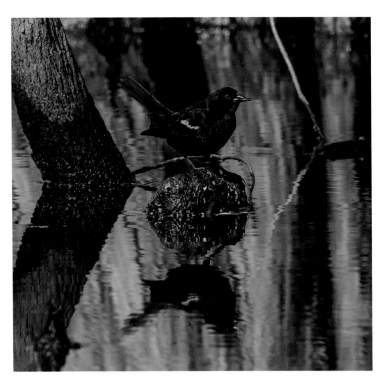

Figure 230. Red-winged blackbird (*Agelaius phoeniceus*). Red-and-yellow epaulets make males of this species unmistakable. Raucous omnivores, these blackbirds favor wetland areas and reside in Mississippi year-round but are less frequently sighted in the park during the summer.

Figure 231. Brown-headed cowbird (*Molothrus ater*). Cowbirds do not make their own nests but lay their eggs in those of other birds—more than one hundred different species—and let them raise the chicks. Some species recognize and expel the foreign eggs, but other birds spend precious resources feeding these nest parasites.

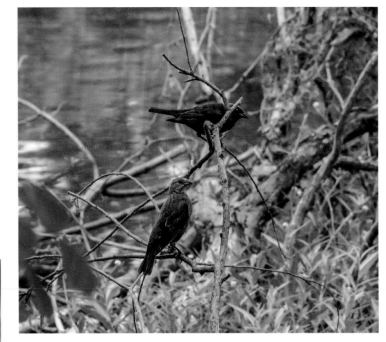

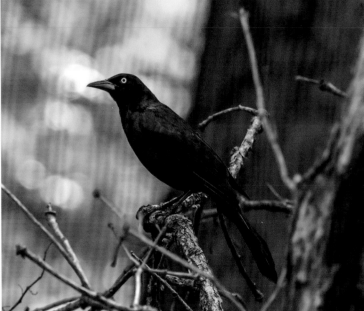

Figure 232. Common grackle (*Quiscalus quiscula*). Grackles do not elicit the love that many other birds get, as is epitomized by the fact that a group of grackles is called a plague. Nevertheless, the bird is beautifully iridescent and has brilliant yellow eyes.

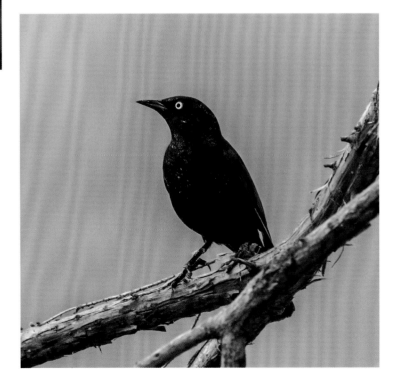

Figure 233. Rusty blackbird (*Euphagus carolinus*). Populations of this blackbird have plummeted since the 1980s as a consequence of habitat loss, mercury poisoning, and indiscriminate poisoning by people who consider them pests. It is occasionally seen in the park during the winter before it flies north to breed in Canada.

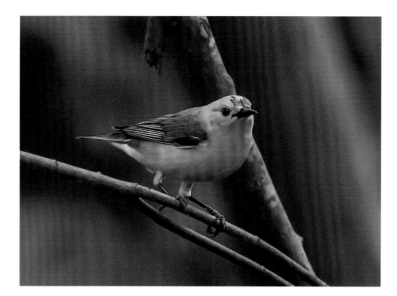

Figure 234. Prothonotary warbler (*Protonotaria citrea*). This stunning bird, sometimes referred to as a swamp canary, is a jewel of LeFleur's Bluff State Park. The males arrive in March, a few weeks before the females, after traveling over the Gulf of Mexico from wintering grounds in Colombia. They are cavity nesters, mainly in trees, but will readily take human-constructed boxes. They are occasionally seen with brown stains on their foreheads: ornithologists believe that the stains result when the birds plunge into fruit when chasing insects. By late September, these warblers head back to South America.

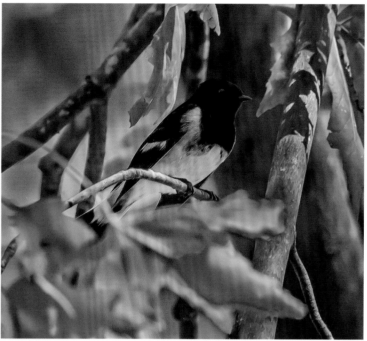

Figure 235. American redstart (*Setophaga ruticilla*). Some redstarts breed in Mississippi, while others migrate to breeding grounds in the northern United States and Canada. These warblers winter in Central and South America.

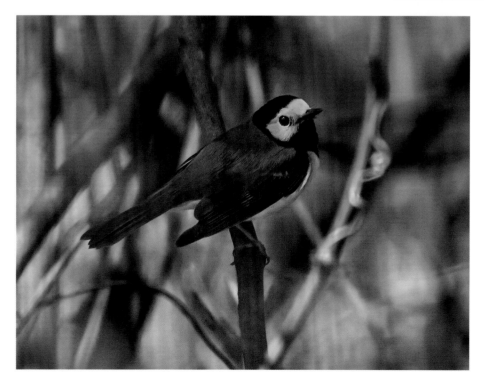

Figure 236. Hooded warbler (*Setophaga citrina*). The park is in this warbler's breeding range, but sightings are most likely to occur in the spring and fall, as the bird passes through on its way further north or to its wintering grounds in the Yucatan.

Figure 237. Pine warbler (*Setophaga pinus*). Usually sighted in the park during the winter, the pine warbler forages insects on the ground and on tree trunks and will also eat seeds.

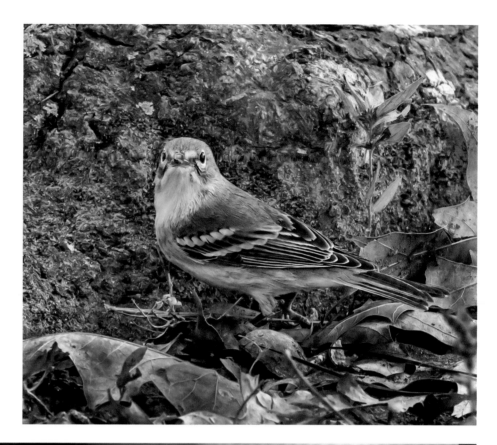

Figure 238. Magnolia warbler (*Setophaga magnolia*). This species was collected from a magnolia in Mississippi in the early 1800s, leading to the derivation of both its common name and its specific epithet. These warblers feed primarily on insects, augmenting their diet with fruits and berries. These birds breed in the summer in the northern United States and Canada and overwinter in Central America, which means they are present in Mississippi for only a few weeks in the spring and fall.

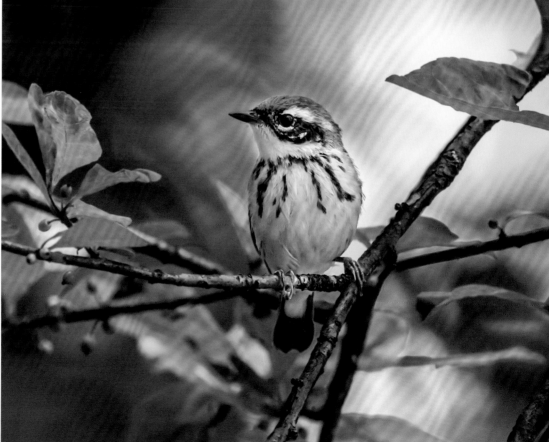

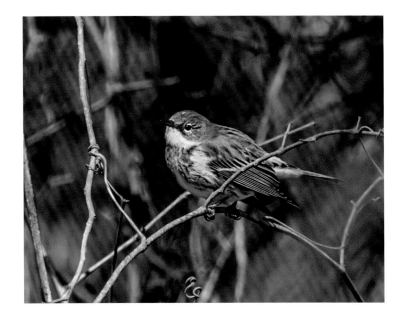

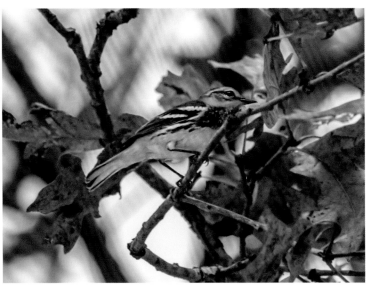

Figure 239. Yellow-rumped warbler (*Setophaga coronata*). The yellow-rumped warbler is found across the United States, with subspecies in the East and West. Many ornithologists believe these subspecies should be elevated to separate species. Mississippi is home to the eastern subspecies, which is often called the myrtle warbler after its winter habit of expanding its insect diet to include berries from such plants as the wax myrtle. Prior to their spring migration to their Canadian breeding grounds, the males' coloration intensifies.

Figure 240. Black-throated green warbler (*Setophaga virens*). This migrant graces Mississippi with its presence as it travels between its summer breeding grounds in the northeastern United States and Canada and its winter haunts in Cuba, Mexico, and Central America.

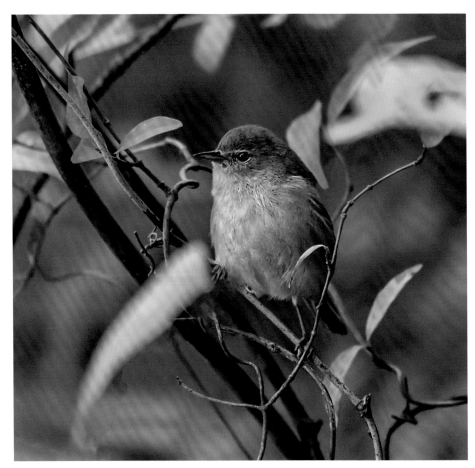

Figure 241. Orange-crowned warbler (*Leiothlypis celata*). This is an elegant olive-green bird with few distinctive characteristics and a faint orange crown that is rarely visible. It nests on the ground, where it feeds on insects. These birds breed in the northern United States and Canada and overwinter in the southern United States.

Figure 242. Common yellowthroat (*Geothlypis trichas*). This bird is a warbler and like its fellow warblers is primarily insectivorous. The male bird is masked and looks like a yellow bandit; the female is less showy but elegant.

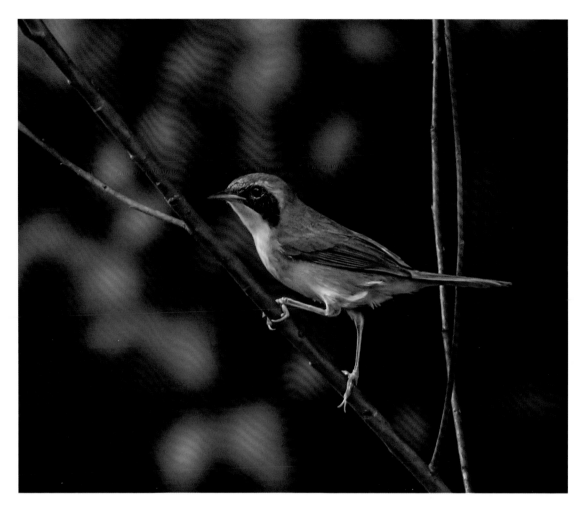

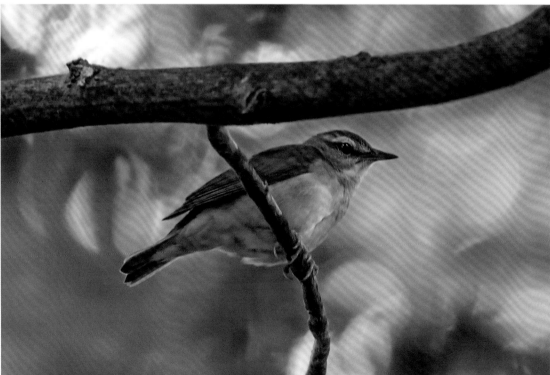

Figure 243. Swainson's warbler (*Limnothlypis swainsonii*). Less colorful than other warblers, this bird nonetheless has a simple beauty. It breeds in swamplands in the southeastern United States and winters in Cuba and the Yucatan.

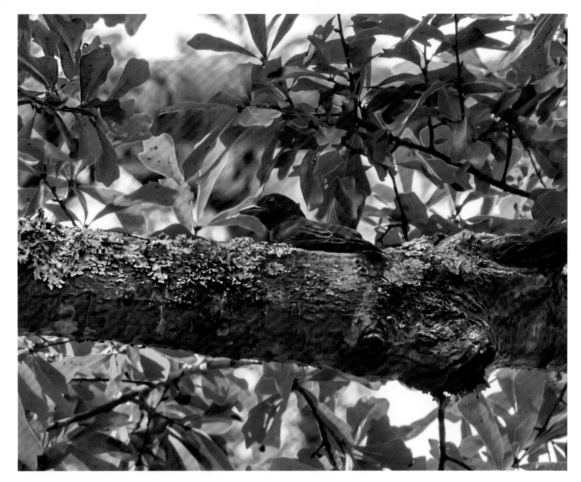

Figure 244. Summer tanager (*Piranga rubra*). Male tanagers are red, while females are more of a mustard yellow. These birds feed high in oak trees, largely on insects, and winter in Central and South America.

Figure 245. Northern cardinal (*Cardinalis cardinalis*). One of the most striking of the backyard birds, the cardinal gets its name from the resemblance of its coloration to the robes of Catholic Church officials. It feeds primarily on seeds and grain. It is a year-round resident of the park and state.

Figure 246. Rose-breasted grosbeak (*Pheucticus ludovicianus*). These birds breed in the northern United States and overwinter in the Yucatan and Central America, passing briefly through Mississippi twice each year.

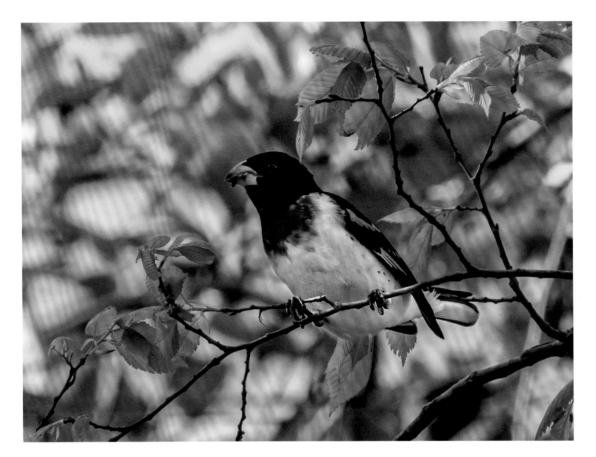

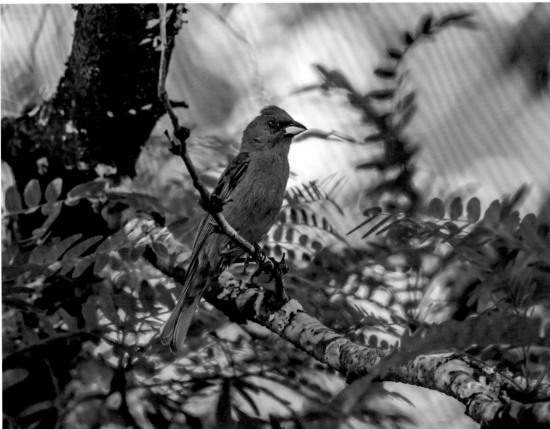

Figure 247. Indigo bunting (*Passerina cyanea*). This species flies directly over or around the Gulf of Mexico as it migrates between its winter home in northern South America and its breeding range, which includes Mississippi.

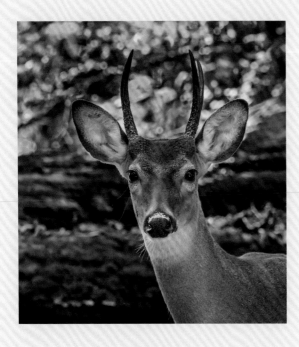

Chapter 6

MAMMALS

Mammals are defined uniquely by the presence of mammary glands and hair. In fact, the name *mammal* comes from the Latin word *mamma*, which means "breast" or "teat." The female mammary gland and its associated tissues are the lifeline of every neonatal mammal; as a result, milk is the only common food of every species of mammal. Male mammals have mammary glands, but they remain rudimentary because the necessary hormone signals are not turned on at the appropriate times. Hair has numerous functions, including providing insulation from cold and heat, waterproofing, providing sensory input, offering protection from dust around the eyes and in the nose, offering protection from predators in the form of spines and quills, enabling color displays for mating and warning flashes, providing camouflage, and preventing chafing in axillary and pubic areas.

Mammals share the trait of warm-bloodedness (homeothermy) with birds, but this trait evolved independently in the two groups. Homeothermy allows mammals and birds to be active at all times of the day and all seasons of the year. Although some mammals hibernate, they do so largely because their food sources disappear during the winter. Virtually all chemical reactions occur faster with heat. Homeothermy provides the continuous heat that life-sustaining biochemical reactions, mainly enzymatic, require for peak efficiency irrespective

of outside temperature. This has allowed mammals to grow in size and move into and remain active in environments where cold-blooded animals (ectotherms) cannot.

Mammals, birds, and other reptiles share the presence of an amniotic egg, or at least the amniotic membrane, and are often included in the Amniota superclass. As discussed in previous chapters, the amniotic egg provides additional membranes around the developing embryo and an outer leathery or calcareous shell that allows these groups to separate from water to a greater extent than other vertebrates can. Traditionally classified reptiles produce eggs that are laid on land, although some reptile species maintain the egg within the female and give birth to live young. Birds, as reptiles, produce amniotic eggs but invariably expel them from the body early as a requirement for flight. They compensate by intensive postpartum parental investment. All mammals have amniotic membranes, but with one exception, they lack calcareous or leathery eggshells because females maintain embryos/fetuses in their bodies for extended periods of time. The exception is monotremes, which lay leathery eggs. Monotreme fetuses, such as those of the platypus or echidna, hatch from eggs in about a week, and the neonates drink milk from their mothers. Members of this group are rare and are not found in Mississippi.

The overwhelming majority of mammals bear live young and fall into two groups, marsupials and placentals. The only marsupial in Mississippi is the Virginia opossum. Marsupials possess amnions, but they also have fully functioning choriovitelline placentas that are fusions of embryonic chorions and yolk sacs and serve as a bridge to the female uterus. However, the developing opossum fetus does not reside in the mother for very long and breaks through the amnion at about the second week of gestation; it is born alive when it is the size of a bean. An opossum neonates crawls and attaches to one of thirteen teats in its mother's marsupium (pouch). There the neonate carries out the rest of its development to adolescence. The presence of the marsupium makes this group unique.

Placental mammals not only have amnions but also have well-developed chorioallantoic placentas that are the fusion of two membranes, the chorion and allantois, and act as a bridge to exchange gases, nutrition, and waste between embryos/fetuses and their mothers' uteri. This type of placenta allows the developing fetus to remain inside the female for a prolonged period of time, meaning that placental mammals are generally born at a more advanced stage of development than are marsupials.

Other than the opossum, all of Mississippi's mammals are placental.

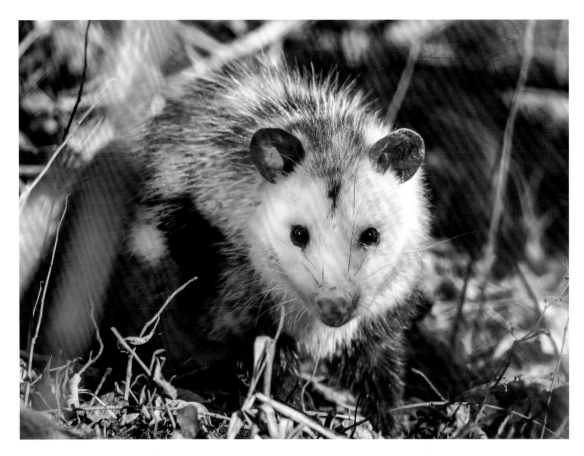

Figures 248 and 249. Virginia opossum (*Didelphis virginiana*). This arboreal marsupial is more closely related to kangaroos than to any of our placental mammals. Possums have a grasping (prehensile) tail that can help them maneuver in trees, and when cornered, these animals do in fact play "possum." They are omnivorous scavengers who eat large numbers of ticks. They are also unusual in that they are not affected by pit-viper venom and rarely get rabies. They have more teeth than any other US land mammal, and males may have surprisingly large canines. The photo with the opossum skull also shows a question mark butterfly (*Polygonia interrogationis*).

Figure 250. Nine-banded armadillo (*Dasypus novemcinctus*). Anatomy students used to learn that the synsacrum (a fusion of sacral and caudal vertebrae) was found only in birds and extinct dinosaurs, but Professor Frank Hensley (Mississippi College) informed me that armadillos are the only North American mammal with this structure.

Figures 251 and 252. American beaver (*Castor canadensis*). The largest rodent in Mississippi, beavers are best known for using their ever-growing incisors to take down trees, building dams and wooden lodges, and possessing flat, paddle-like tails. Beavers eat primarily plant material and build dams to provide water deep enough that it will not freeze, allowing them to continue their aquatic activity outside their lodges during the winter. Beavers' reengineering of waterways often brings them into conflict with landowners, who may consider the animals pests.

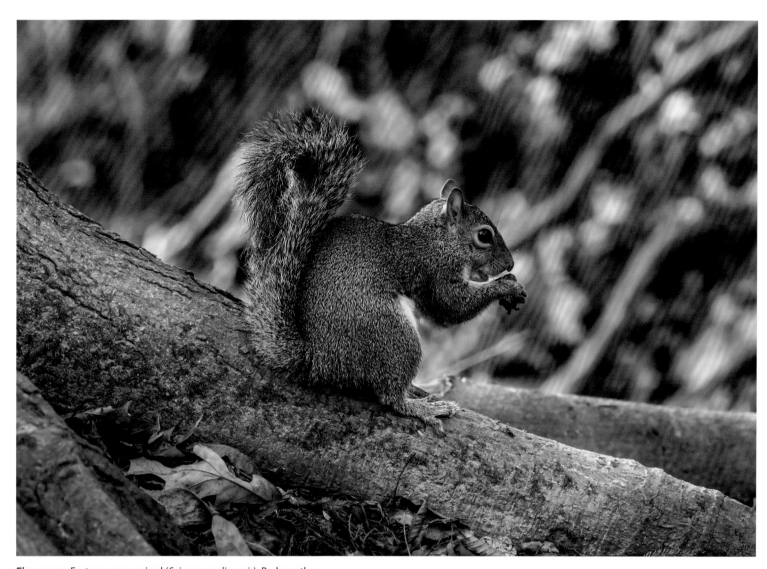

Figure 253. Eastern gray squirrel (*Sciurus carolinensis*). Perhaps the most commonly observed mammal in the park, these arboreal rodents are continually collecting acorns, nuts, and the like and storing them in caches to which the animals return when food is scarce, sometimes months later. Each squirrel may have several hundred caches and are thus prodigious spreaders of plant and tree seeds. They also eat the young cambium under tree bark: substantially grazed areas of tree bark can often be observed on bald cypresses (*Taxodium distichum*).

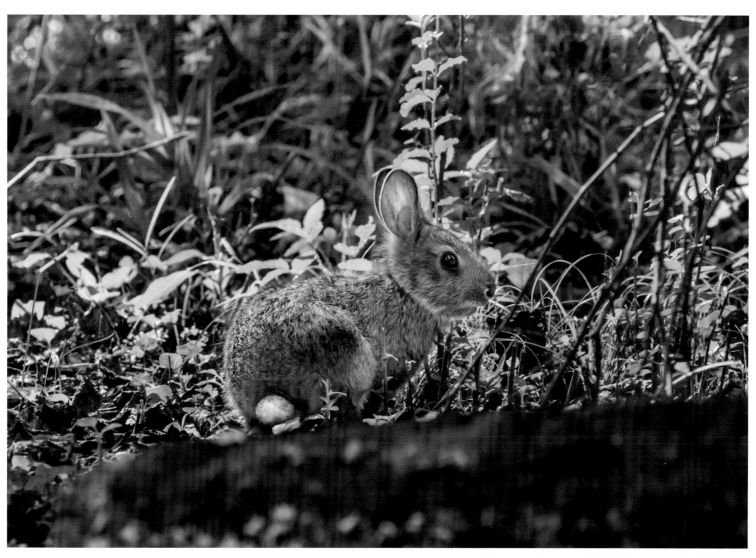

Figure 254. Swamp rabbit (*Sylvilagus aquaticus*). The canecutter is distinguished from the cottontail by several features, including a cinnamon-colored eye ring. This rabbit is at home in floodplains and swamps and is a surprisingly good swimmer.

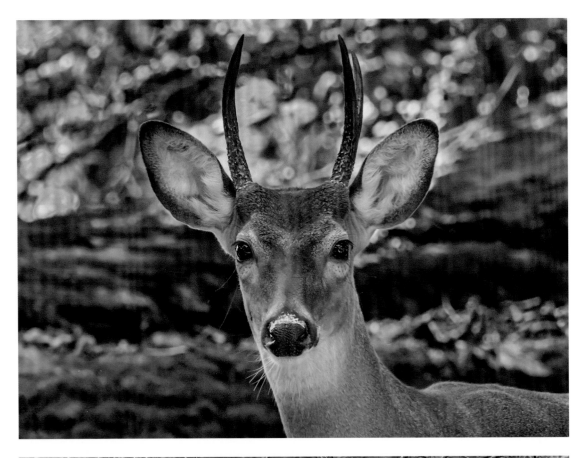

Figures 255 and 256. White-tailed deer (*Odocoileus virginianus*). Like many species at the end of the 1800s and early 1900s, this animal was nearly hunted to extinction in the United States. But managed hunting, a reduction in the number of large predators, and the deer's ability to thrive near humans have enabled the deer to make a comeback to the point of being a pest. The park has a healthy population, and naturalists may come upon what look like abandoned fawns: in reality, however, the mother often leaves them bedded down while she feeds, and she will return, so it is best to leave the fawn alone.

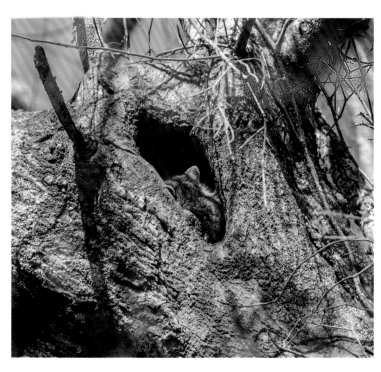

Figures 257, 258, and 259. Common raccoon (*Procyon lotor*). Although nocturnal, the raccoon is one of the most recognized mammals in the state. The generic name *Procyon* means "early dog" and reflects the erroneous belief that the raccoon was closely related to the dog. The specific epithet, *lotor*, means "washer" and reflects the animal's hunting behavior near water. The raccoon uses its highly tactile paws to search for food items in the water and only appears to be washing its food. They are incredible climbers and often make their dens high in trees. Their skulls can be identified by knowing their dental formula: three incisors, one canine, four premolars, and two molars on each upper and lower side of the skull.

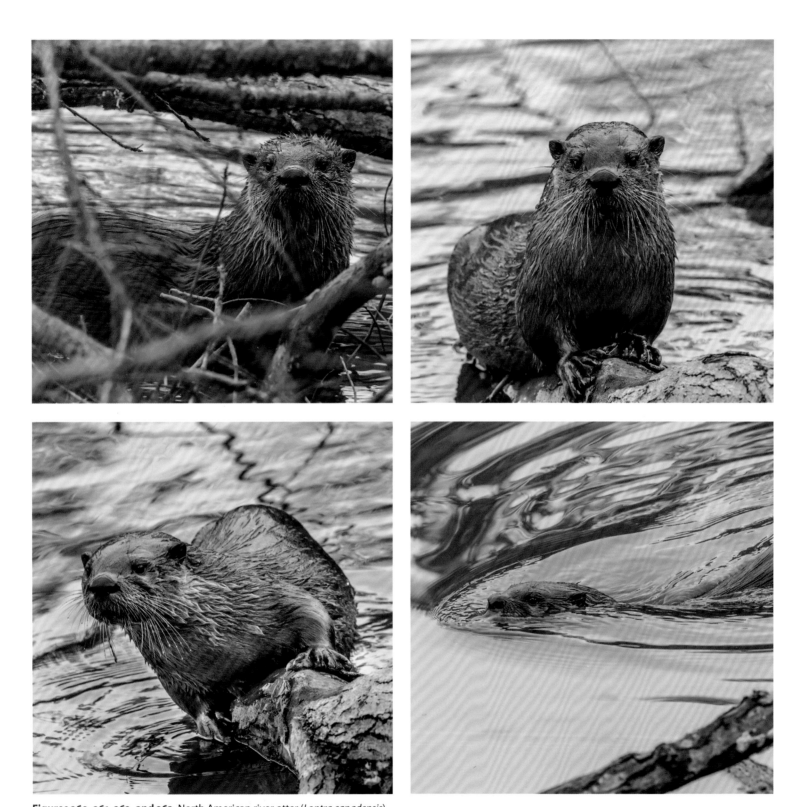

Figures 260, 261, 262, and 263. North American river otter (*Lontra canadensis*). The river otter is a rarely seen semiaquatic carnivore that is related to weasels, minks, and other members of the family Mustelidae. Accomplished swimmers that are very playful, otters feed largely on fish but will take a wide variety of prey, including crustaceans and mollusks.

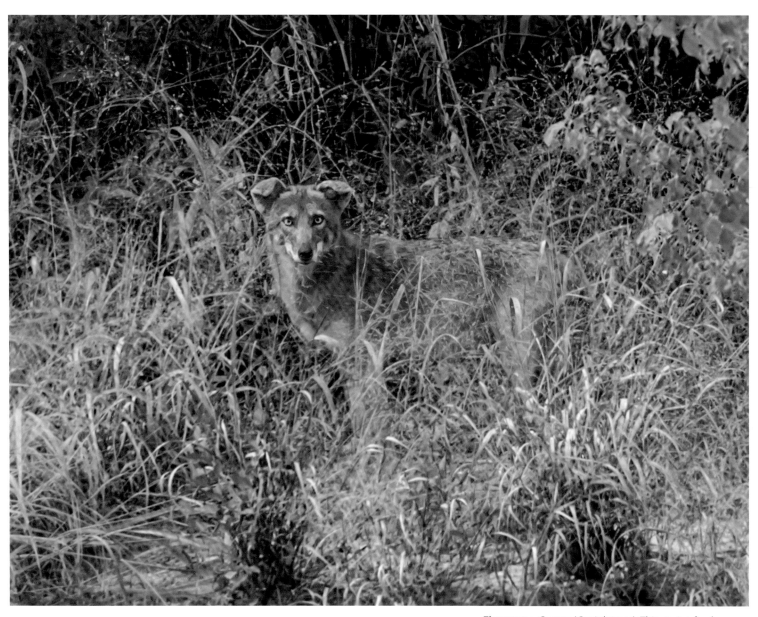

Figure 264. Coyote (*Canis latrans*). This canine feeds largely on small mammals such as rabbits, rodents, and deer but is incredibly adaptable and can also take a wide variety of invertebrate prey as well as fruits and berries. Coyotes are quite wily, and visitors to the park are not likely to get more than a glimpse of one.

Chapter 7

PLANTS

Plants are multicellular organisms that have cellulose in their cell walls and photosynthesize. Photosynthesis is a chemical reaction powered by light energy from the sun that converts carbon dioxide and water to sugars and oxygen. These chemical reactions occur in structures called chloroplasts located within each of the plant's cells. Conversion of sun energy into plant matter is the base of our food web, and chloroplasts make possible the herbivore and carnivore food chains. Without plants and their chloroplasts transforming energy from the sun, life on this planet would be possible only in the deep ocean, where hydrothermal vents provide just enough energy to sustain life forms such as mollusks, arthropods, and fish until the existing oxygen is depleted. At that point, only anaerobic bacteria would survive.

Chlorophyl is the molecule found in chloroplasts that captures sunlight and converts its energy to sugars. The chlorophyl molecule is chemically closely related to hemoglobin, which is the oxygen-carrying molecule in our blood. Within the center of the chlorophyl molecule, a single atom of magnesium gives the molecule a green color. The center of the hemoglobin molecule contains a single atom of iron, which gives that molecule a red color. These vital and structurally similar molecules are responsible for plants being green and vertebrate blood being red, two of the most ubiquitous colors in life.

The significance of plants, chloroplasts, and photosynthesis to life on Earth cannot be overstated, and chemists have conducted intensive research on the molecular processes. However, biologists have written one of the great detective stories on the evolution of plants and their chloroplasts. Chloroplasts are about 3 micrometers (1/8,000 of an inch) long, are surrounded by a double membrane, have their own DNA separate from the nuclear DNA of the plant itself, and replicate by binary fission. Analysis of DNA relationships has shown that the DNA of chloroplasts is most closely related to cyanobacteria (sometimes referred to as blue-green algae) and not at all closely related to the DNA in the nucleus of the plant cell in which the chloroplast lives. It is now widely accepted that chloroplasts are the descendants of cyanobacteria that were ingested by plant ancestors approximately 2 billion years ago.

How is this explained? Modern cyanobacteria also are about 3 micrometers in size, are free-living, are blue-green (because they have chlorophyll and photosynthesize), have their own DNA, and replicate by binary fission (as do most bacteria). Scientists believe the ancestral plant cell's ingestion of the ancestral cyanobacteria resulted in a double membrane that consisted of the normal cell membrane of the cyanobacterium as well as part of the plant's own cell membrane that had pinched off to form a food vacuole around the bacterium. Although some of those ingested bacteria were likely digested by the ancestral plant cells, some were not. Those that survived within the ancestral plant continued photosynthesizing and making sugars and were able to reproduce because they had their own DNA. At some point, the symbiotic relationship between the surviving cyanobacteria and the ancestral plants became genetically fixed, with the plants providing protection and the cyanobacteria providing food in the form of sugar. Thus, the chloroplast found in every plant cell and responsible for photosynthesis was/is a bacterium.

The *was/is* semantic shuffle is interesting because over the eons of the relationship, much of the cyanobacterial genome has been transferred to and taken over by the host cell's nucleus. Many biologists have consequently concluded that the bacterium no longer exists as its own entity and has become just a part of the host cell. However, one of the most important theories in biology, cell theory, states that the fundamental unit of life is the cell and that only cells give rise to cells. Thus, the alternative view is that because the cyanobacterium retains its own cell membrane, has its own (albeit reduced) DNA, still gives rise to other cells via binary fission, and is the only part of the host cell that the nucleus does not have instructions to make, it is alive and its

own entity. Regardless of which side you might support, this mutualistic relationship between two species is called endosymbiosis, and it represents a significant milestone in the evolution of life on this planet.

The organelle known as the "powerhouse" of both plant and animal cells, the mitochondrion, also has a double membrane and possesses its own DNA separate from that of the cell's nucleus. This is now understood to also be the result of ancestral plant and animal cells ingesting bacteria, and a process similar to what occurred with the chloroplast is believed to be at work. These evolutionary partnerships have been incredibly successful, with the host plant and animal cells providing protection and receiving food and energy in return. These symbiotic relationships have coevolved so long and are now so closely integrated that it is not possible for either partner to live without the other, leading to the question of whether a plant is one organism or a colony of organisms. The same question can be asked of animals, including humans.

Much recent systematic work on plants and other groups has been done using cladistic analysis—that is, a search for monophyletic groups that include a unique common ancestor and all descendants which are defined by traits unique to them. By that definition, all multicellular organisms, including humans, become problematic, since endosymbiosis means they have more than one common ancestor. The current classification system requires overlooking the fact that chloroplasts and mitochondria are really bacteria. Even if these bacteria have been degraded to nothing more than an organelle, they remain ancestors.

Plants comprise angiosperms (flowering plants), gymnosperms (conifers and cycads), ferns, hornworts, liverworts, and mosses. Approximately 600 species of plants have been identified in the LeFleur's Bluff State Park. Just under 90 percent of the world's plants are angiosperms, with that percentage even higher in Mississippi. The park has about 570 species of flowering plants, 3 conifers, 14 ferns, several mosses, and one liverwort. No hornworts have yet been found in the park, but that doesn't mean they aren't there. Some biologists include green algae as a plant, but naturalists rarely encounter microscopic organisms. Nevertheless, I have included one green alga that a naturalist might actually be able to see.

Figure 265. Resurrection fern (*Pleopeltis michauxiana*).

Figure 266. Stately maiden fern (*Thelypteris kunthii*).

Figure 267. Bald cypress (*Taxodium distichum*) and Spanish moss (*Tillandsia usneoides*).

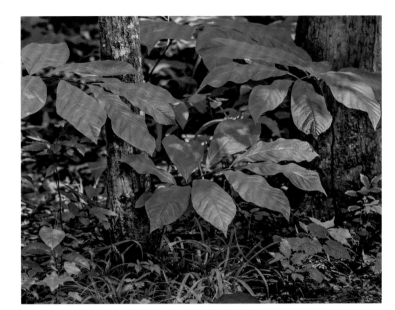

Figure 268. Common pawpaw (*Asimina triloba*).

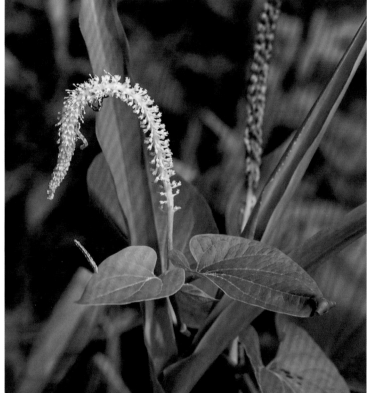

Figure 269. Lizard's tail (*Saururus cernuus*).

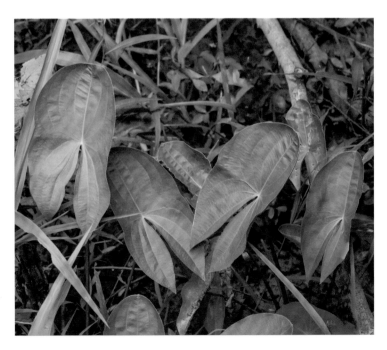

Figure 270. Broadleaf arrowhead (*Sagittaria latifolia*).

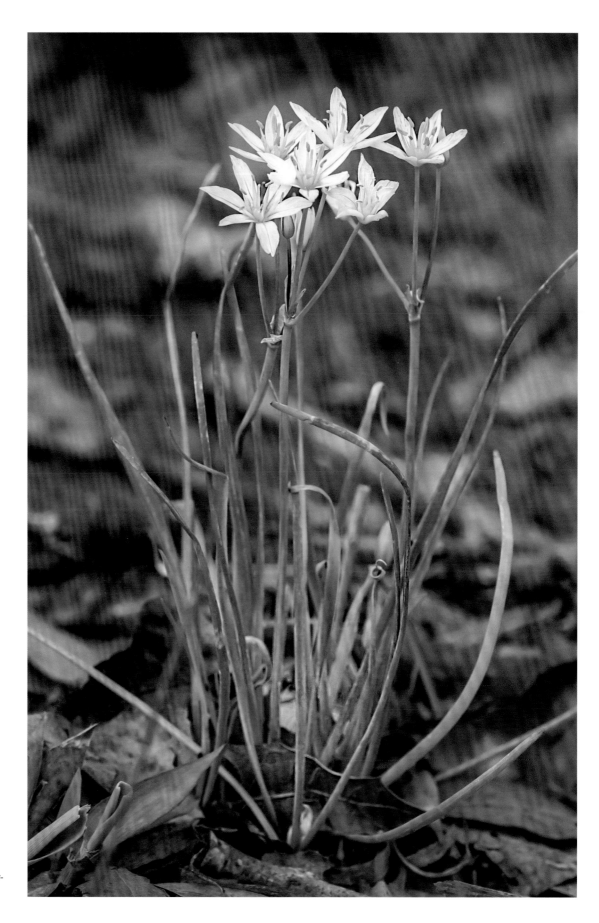

Figure 271. Crow poison (*Nothoscordum bivalve*).

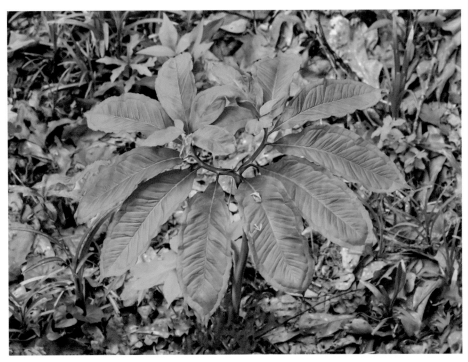

Figures 272 and 273. Green dragon (*Arisaema dracontium*).

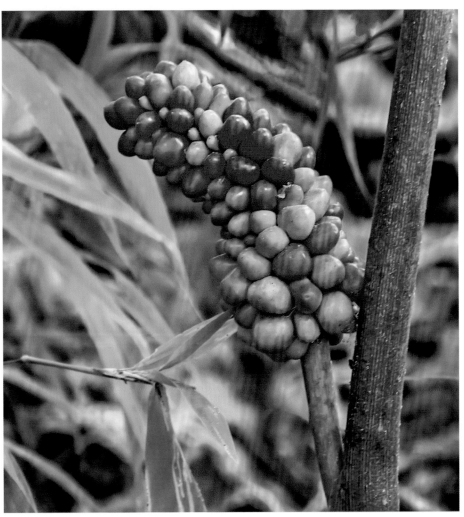

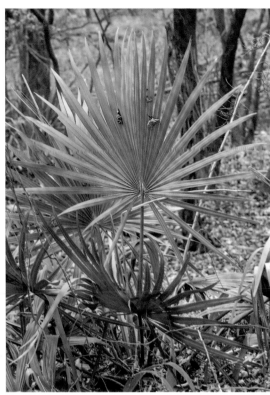

Figure 274. Dwarf palmetto (*Sabal minor*).

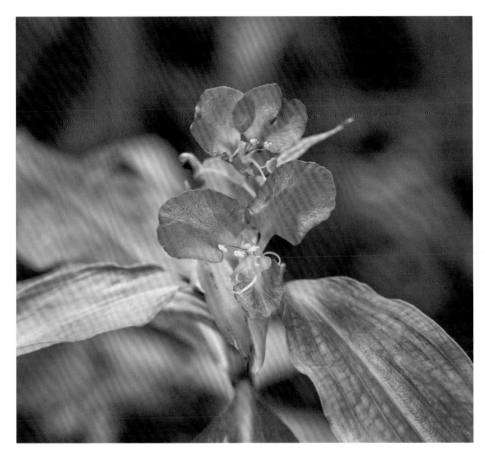

Figure 275. Virginia dayflower (*Commelina virginica*).

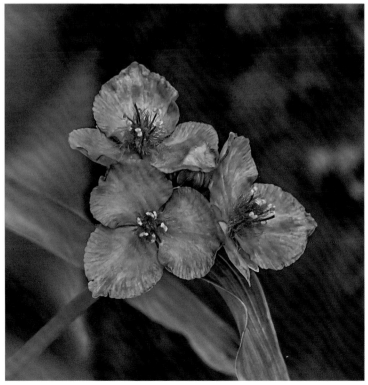

Figure 276. Bluejacket (*Tradescantia ohiensis*).

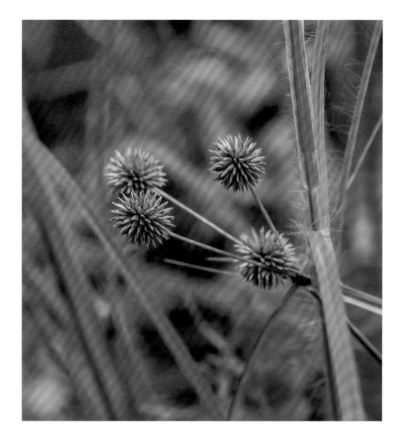

Figure 277. Globe flatsedge (*Cyperus echinatus*).

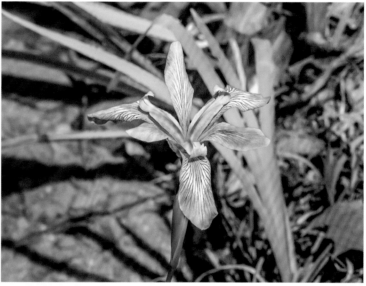

Figure 278. Southern blue flag (*Iris virginica*).

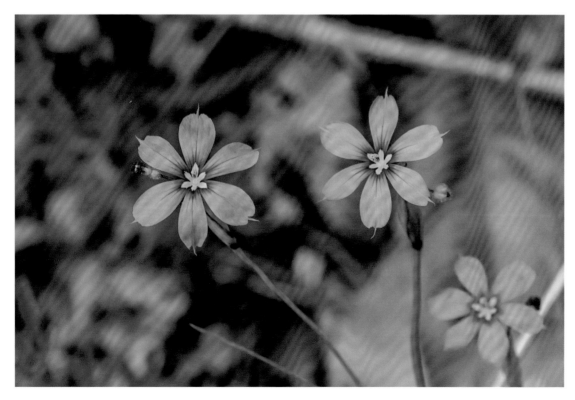

Figure 279. Narrow-leaved blue-eyed grass (*Sisyrinchium angustifolium*).

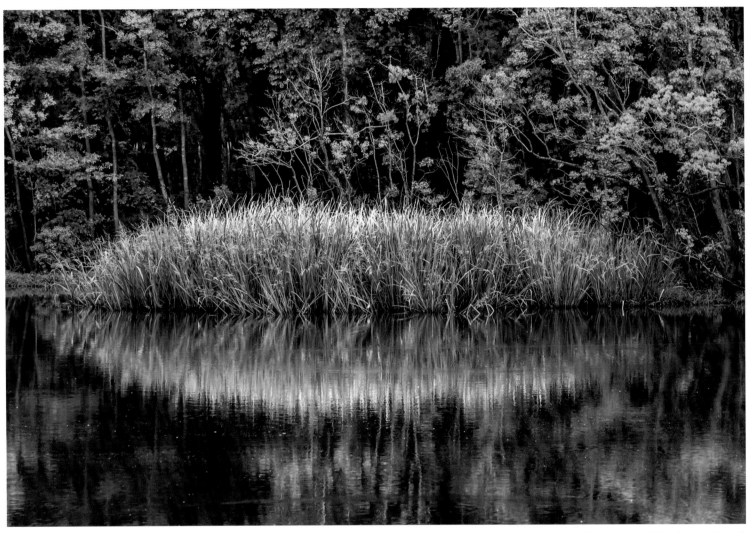

Figure 280. Giant cutgrass (*Zizaniopsis miliacea*).

Figure 281. Inland wood oats (*Chasmanthium latifolium*).

Figure 282. Saw greenbrier (*Smilax bona-nox*).

Figure 283. Bristly greenbrier (*Smilax tamnoides*).

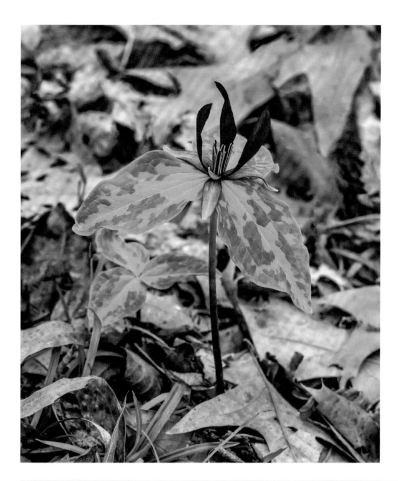

Figure 284. Little sweet Betsy (*Trillium cuneatum*).

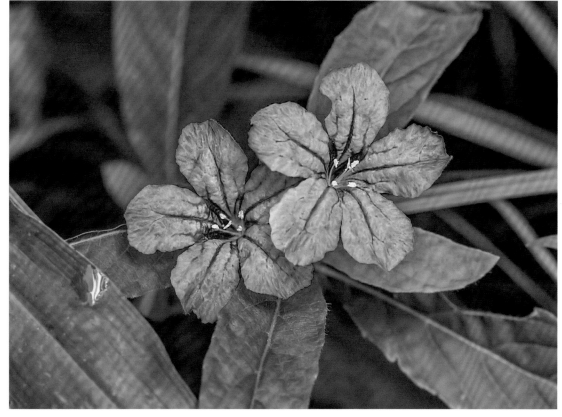

Figure 285. Carolina ruellia (*Ruellia caroliniensis*).

Figure 286. Box elder (*Acer negundo*).

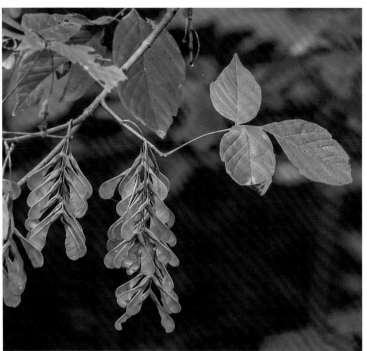

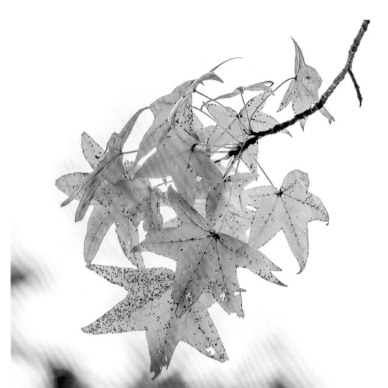

Figure 287. American sweetgum (*Liquidambar styraciflua*).

Figure 288. Smooth sumac (*Rhus glabra*).

Figure 289. Poison ivy (*Toxicodendron radicans*).

Figure 290. Crossvine (*Bignonia capreolata*).

Figure 291. Virginia creeper (*Parthenocissus quinquefolia*).

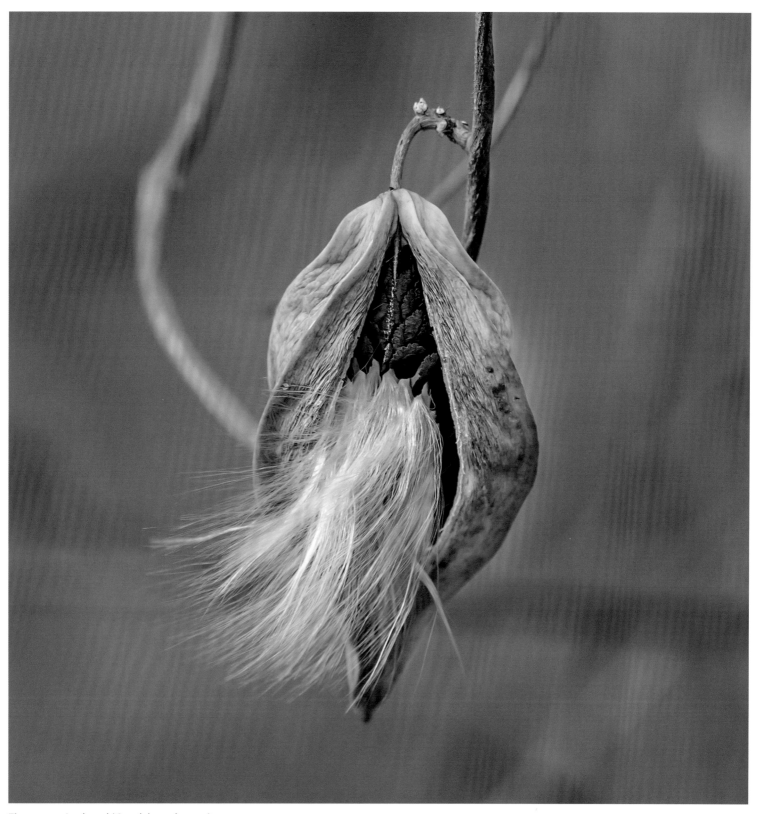

Figure 292. Anglepod (*Gonolobus suberosus*).

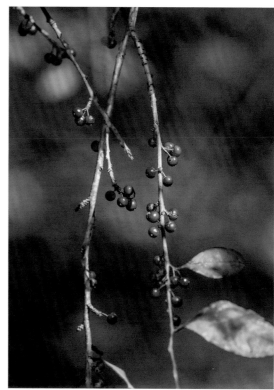

Figure 293. Possumhaw (*Ilex decidua*).

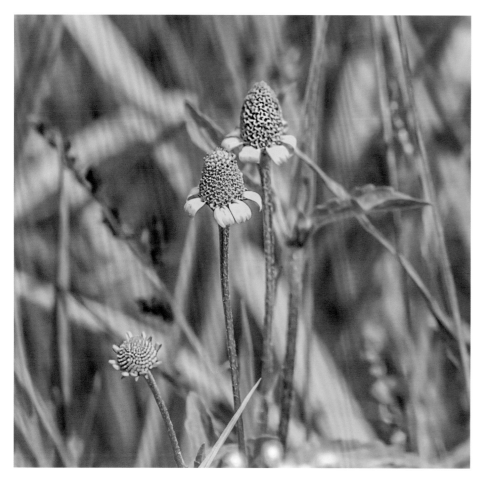

Figure 294. Oppositeleaf spotflower (*Acmella repens*).

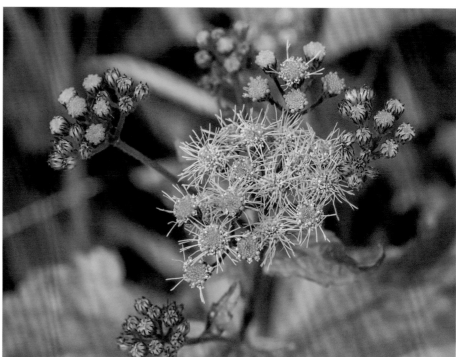

Figure 295. Blue mistflower (*Conoclinium coelestinum*).

Figure 296. Plains coreopsis (*Coreopsis tinctoria*).

Figure 297. Philadelphia fleabane (*Erigeron philadelphicus*).

Figure 298. Butterweed (*Packera glabella*).

Figure 299. Camphor weed (*Pluchea camphorata*) with nectaring pipevine swallowtail butterflies (*Battus philenor*).

Figure 300. Calico aster (*Symphyotrichum lateriflorum*).

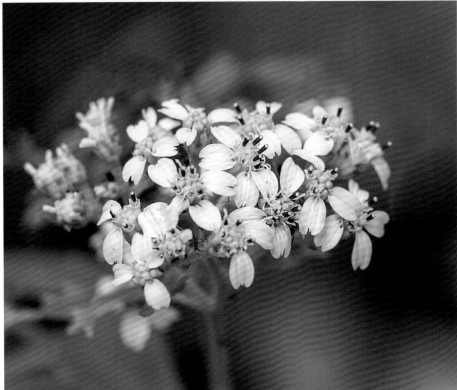

Figure 301. Frostweed (*Verbesina virginica*).

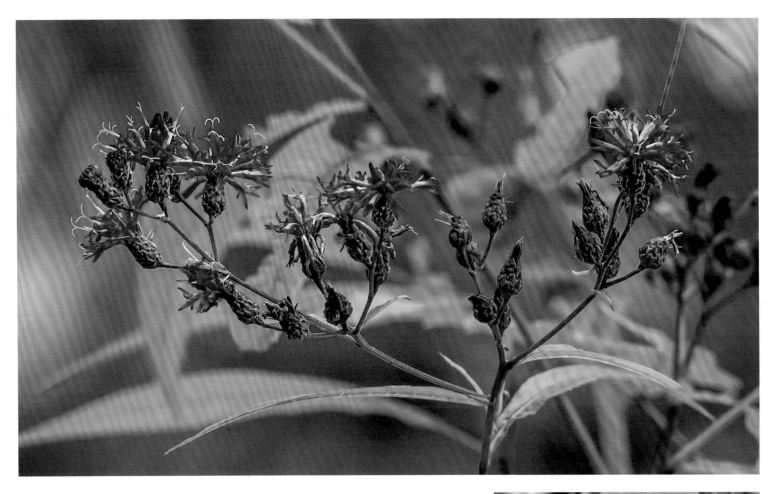

Figure 302. Tall ironweed (*Vernonia gigantea*).

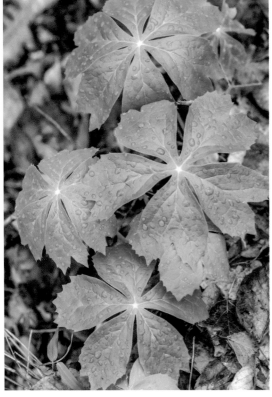

Figure 303. Mayapple (*Podophyllum peltatum*).

Figure 304. American hornbeam (*Carpinus caroliniana*).

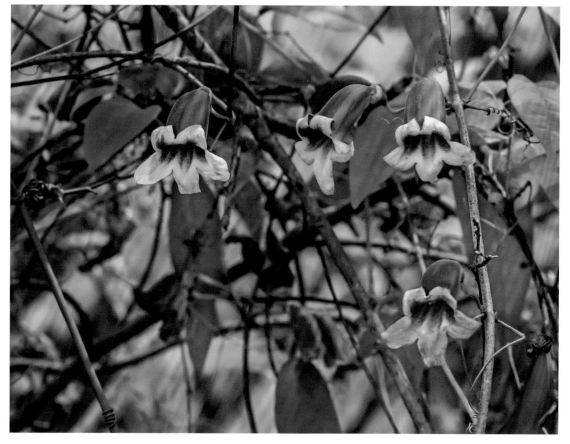

Figure 305. Crossvine (*Bignonia capreolata*).

Figure 306. Cardinal flower (*Lobelia cardinalis*).

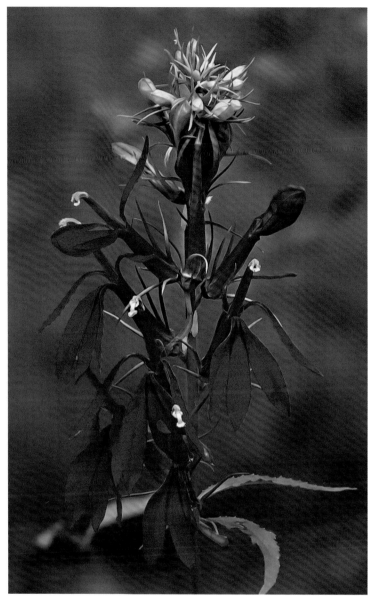

Figure 307. Sugar hackberry (*Celtis laevigata*).

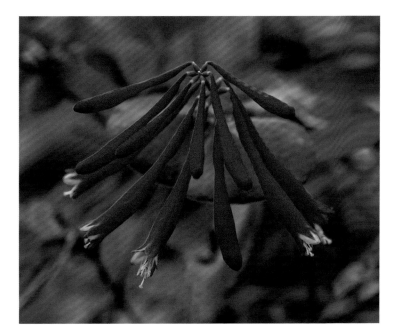

Figure 308. Coral honeysuckle (*Lonicera sempervirens*).

Figure 309. Strawberry bush (*Euonymus americanus*).

Figure 310. White star (*Ipomoea lacunosa*).

Figure 311. Water tupelo (*Nyssa aquatica*).

Figure 312. Fivelobe cucumber (*Cayaponia quinqueloba*).

Figure 313. Common persimmon (*Diospyros virginiana*).

Figure 314. Mountain azalea (*Rhododendron canescens*).

Figure 315. Chinese tallow (*Triadica sebifera*). Introduced.

Figure 316. American groundnut (*Apios americana*).

Figure 317. Boykin's clusterpea (*Lackeya multiflora*).

Figure 318. Maryland senna (*Senna marilandica*).

Figure 319. Trailing fuzzybean (*Strophostyles helvola*).

Figure 320. Chinese wisteria (*Wisteria sinensis*). Introduced.

Figure 321. American beech (*Fagus grandifolia*).

Figure 322. Overcup oak (*Quercus lyrata*).

Figure 323. Swamp chestnut oak (*Quercus michauxii*).

Figure 324. Yellow jessamine (*Gelsemium sempervirens*).

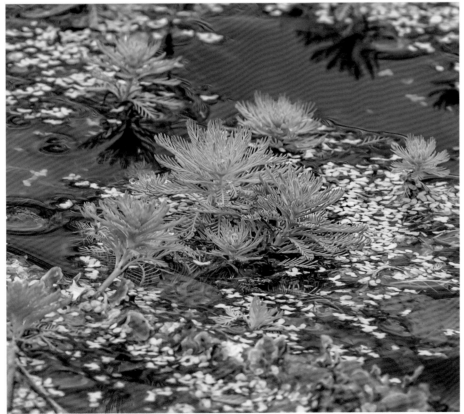

Figure 325. Parrot's feather (*Myriophyllum aquaticum*). Introduced.

Figure 326. Red buckeye (*Aesculus pavia*).

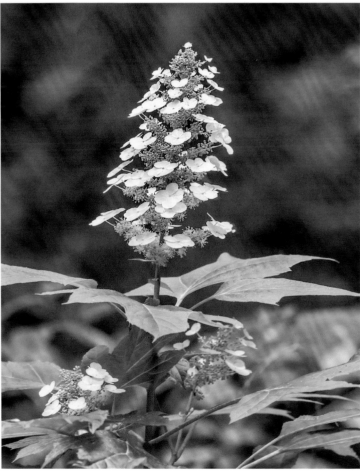

Figure 327. Oakleaf hydrangea (*Hydrangea quercifolia*).

Figure 328. American beautyberry (*Callicarpa americana*).

Figure 329. Red deadnettle (*Lamium purpureum*). Introduced.

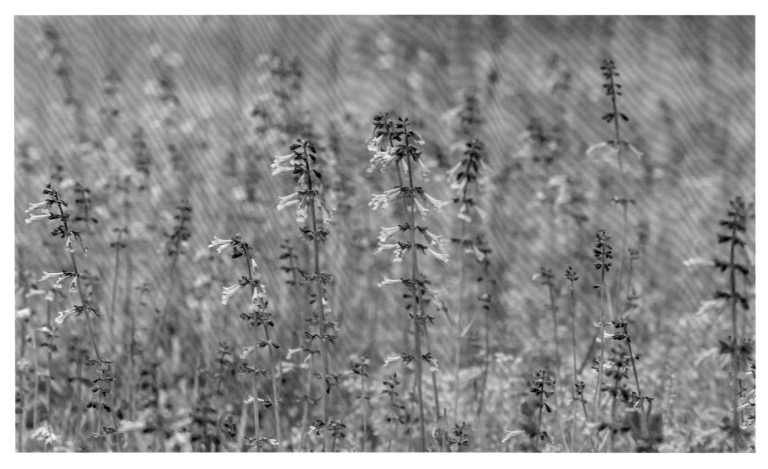

Figure 330. Lyreleaf sage (*Salvia lyrata*).

Figure 331. Indian pink (*Spigelia marilandica*).

Figure 332. Wooly rosemallow (*Hibiscus moscheutos lasiocarpos*).

Figure 333. Red mulberry (*Morus rubra*).

Figure 334. Wax myrtle (*Morella cerifera*).

Figure 335. Wing-leaf primrose-willow (*Ludwigia decurrens*).

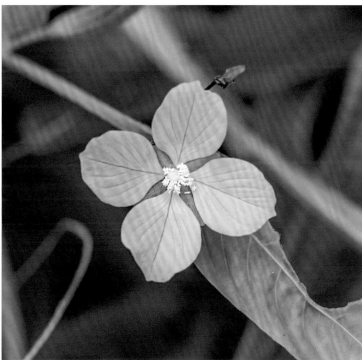

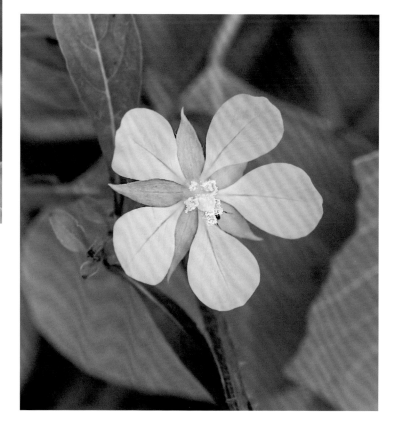

Figure 336. Anglestem primrose-willow (*Ludwigia leptocarpa*).

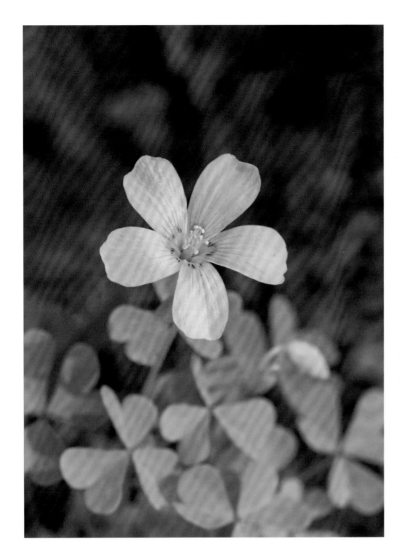

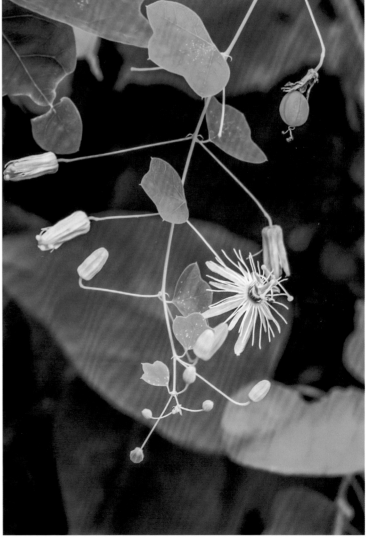

Figure 337. Slender yellow woodsorrel (*Oxalis dilleni*).

Figure 338. Yellow passionflower (*Passiflora lutea*).

Figure 339. American pokeweed (*Phytolacca americana*).

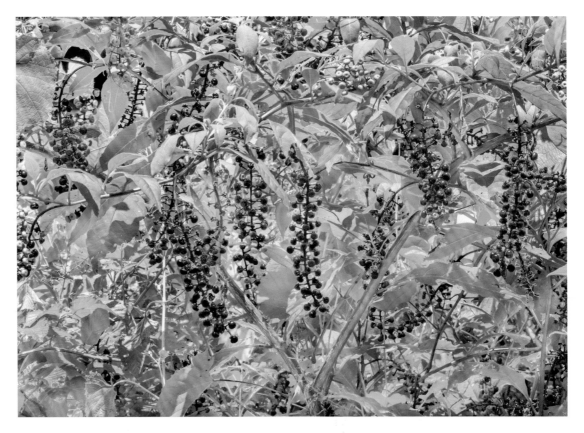

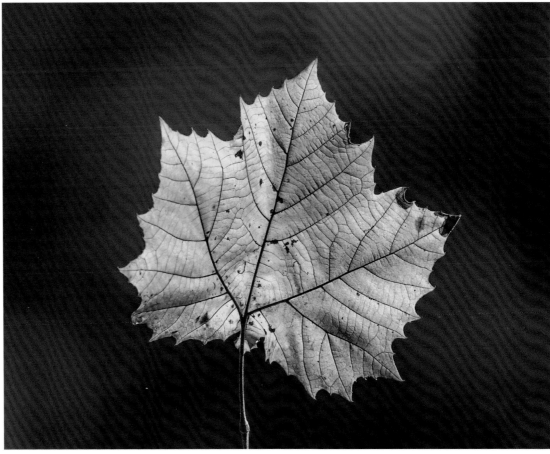

Figure 340. American sycamore (*Platanus occidentalis*).

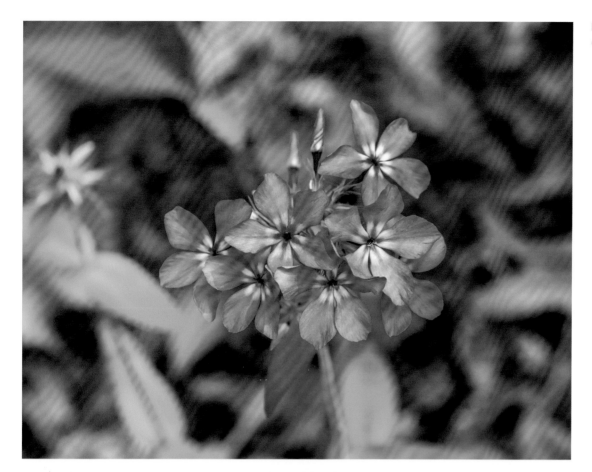

Figure 341. Blue phlox (*Phlox divarica*).

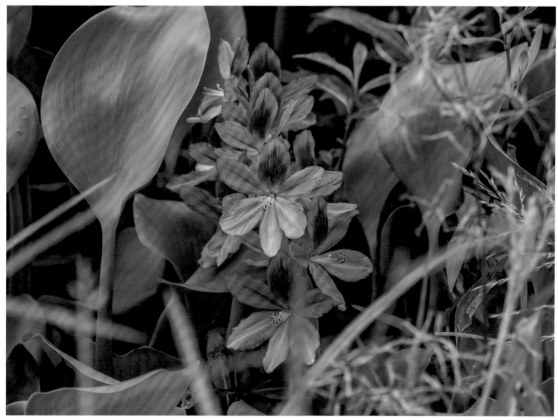

Figure 342. Common water hyacinth (*Pontederia crassipes*). Introduced.

Figure 343. Southern dewberry (*Rubus trivialis*).

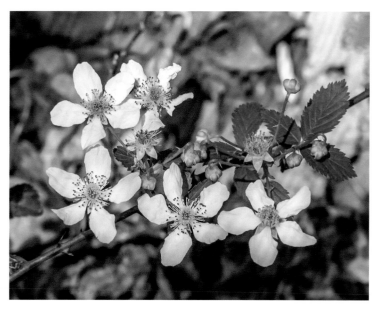

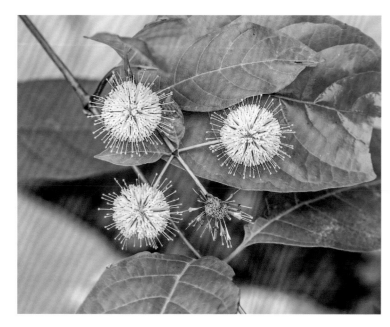

Figure 344. Buttonbush (*Cephalanthus occidentalis*).

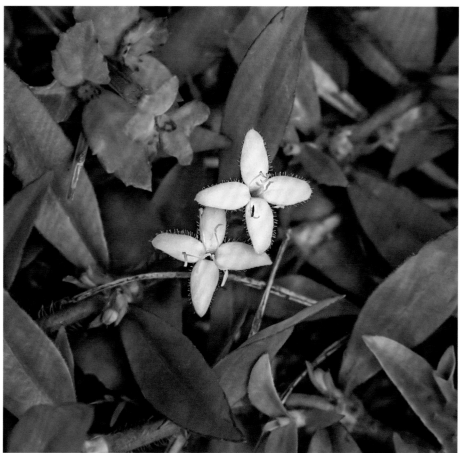

Figure 345. Buttonweed (*Diodia virginiana*).

Figure 346. Partridgeberry (*Mitchella repens*).

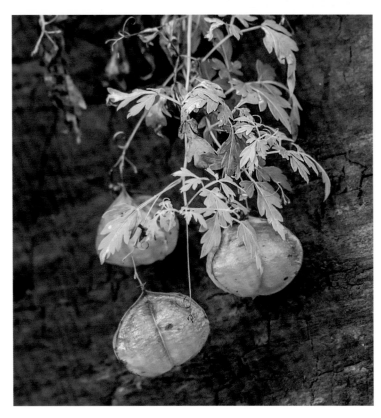

Figure 347. Balloon vine (*Cardiospermum halicacabum*).

Figure 348. Carolina horsenettle (*Solanum carolinense*).

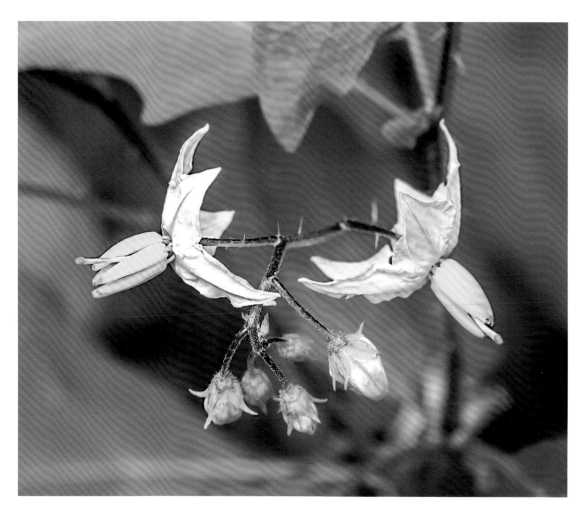

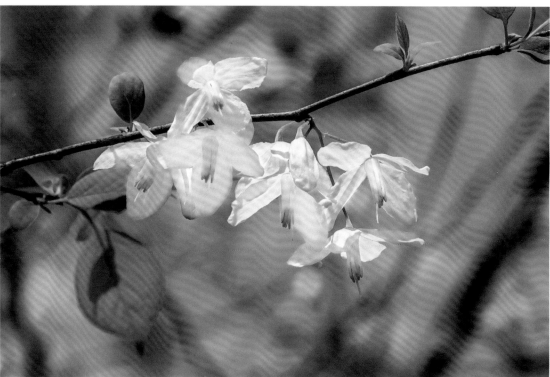

Figure 349. Two-wing silverbell (*Halesia diptera*).

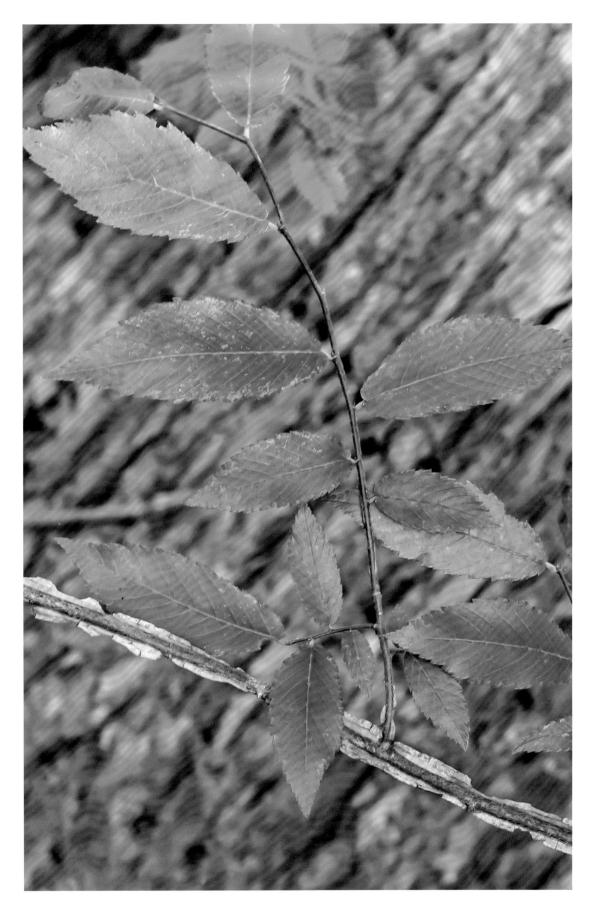

Figure 350. Winged elm
(*Ulmus alata*).

Figure 351. Beaked cornsalad (*Valerianella radiata*).

Figure 352. Lanceleaf frogfruit (*Phyla lanceolata*).

Figure 353. Common blue violet (*Viola sororia*).

Figure 354. Peppervine (*Nekemias arborea*).

Figures 355 and 356. Muscadine (*Vitis rotundifolia*).

Figure 357. Summer grape (*Vitis aestivalis*).

Figure 358. Carolina cranesbill (*Geranium carolinianum*).

Figure 359. Catherine's moss (*Atrichum undulatum*).

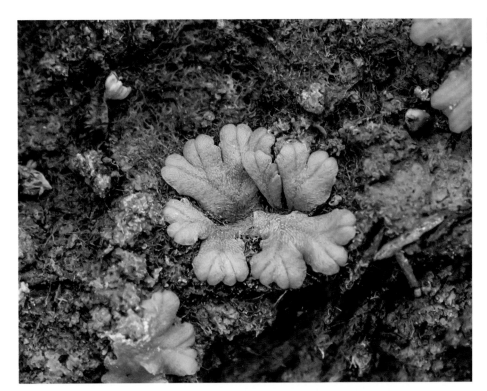

Figure 360. Fringed heartwort (*Ricciocarpos natans*). Liverwort.

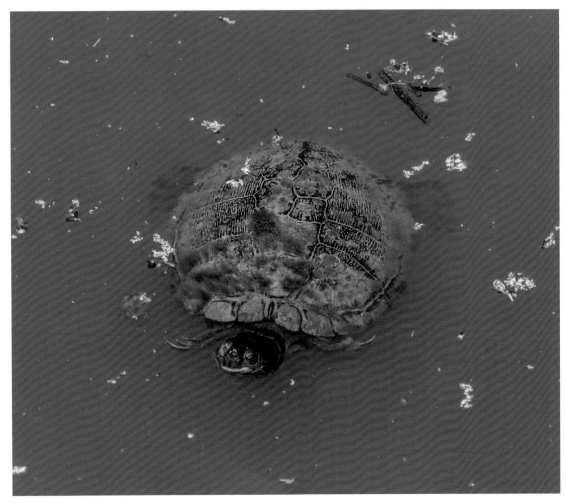

Figure 361. Red-eared slider (*Trachemys scripta elegans*) with symbiotic green algae (*Basicladia* sp.) growing on its shell.

Figure 362. Frost flowers. When air temperatures drop below freezing but ground temperatures remain above, water may freeze as it moves from a plant's roots into its stem. As the water freezes, it expands and ruptures the stem, exuding a ribbon of ice crystals until the sun melts them or the ground freezes and water transport stops. The plant in this photo was camphor weed (*Pluchea camphorata*) along the bank of the Pearl River in the park.

Chapter 8

FUNGI, LICHENS, AND SLIME MOLDS

The fungi are a natural group that have chitin in their cell walls and typically get their nutrition by secreting enzymes into their local environment and then absorbing the digested nutrients. They are the greatest decomposers on the planet. Lichens, however, are composed of fungi that are not decomposers but instead enter symbiotic relationships with algae and rely on the latter for energy.

Most naturalists know basidiomycete fungi by their various mushroom fruiting bodies. Mushrooms are noted for their beauty and as a food source. However, the greater part of basidiomycete fungi lie below the surface of their environment, whether soil or an organism. The subsurface structures of these fungi are multicellular strands called hyphae; when these hyphae branch, they are called mycelia. Fungal cells have all the organelles of plants and animals except for chloroplasts and feature a similar subcellular organization. The mycelia live in what appear as loose networks either in the soil or in living or dead plants and animals. When the mycelia occur in living organisms, they can be considered parasites; when found in dead or dying organisms, they are decomposers.

At various times in the life cycle of basidiomycete fungi, an individual hypha may form spores on its own cell wall or the mycelium may form a mushroom fruiting body above ground to release

spores. In either case, the spores will be dispersed and start the next generation of hyphae. Naturalists typically use those mushroom structures and their spores to identify the different basidiomycete species.

Mushrooms may or may not be safe to eat. When young, I learned the hard way that eating a mushroom can lead to a quick trip to the emergency room and date with a stomach pump. As the saying goes, "All mushrooms are edible; some only once."

Few recognize ascomycete fungi and their cup-shaped fruiting bodies when they are free-living individuals, but when they form lichens, they clearly decorate many Mississippi trees year-round. A lichen is not a single organism but the symbiotic relationship of a fungus and an alga. An ascomycete fungus typically forms the overall lichen structure, and the algae live within it and produce sugars through photosynthesis. Whereas the hyphae of most basidiomycete fungi are hidden below the surface of the soil, the ascomycete hyphae of the lichen are exposed because the algae must have access to sunlight.

We classically think of speciation events as a population being split by some environmental event and producing daughter populations that may go on to become separate species. Our phylogenetic trees are filled with these splitting events. However, in the cases of cyanobacteria (chloroplasts) in plant cells, bacteria (mitochondria) in plant and animal cells, and lichens, we now know that distantly related populations have united to make species that previously did not exist, a process called reticulate evolution.

Slime molds are now part of the kingdom Protista, but because they were thought to share some attributes with the fungi and used to be located there, they are included in this chapter. Slime molds are microscopic unicellular organisms similar to amoebas that hunt the forest floor and rotten logs for bacterial, fungal, and plant material to ingest. When environmental conditions are right, which is often when environmental conditions deteriorate, these unicellular organisms fuse together to form a macroscopic organism for reproduction. Despite its size, the organism remains unicellular—that is, it is a single large cell with many nuclei. So a slime mold that measures between 30 and 60 centimeters (1–2 feet) in diameter (or even larger) constitutes one of the largest cells on the planet with thousands of nuclei. It moves over the surface of living or rotting logs by cytoplasmic streaming of a network of strands. The cell may become dormant when water becomes scarce, or it can form fruiting bodies that produce spores, which are dispersed by wind, water, and animals, restarting the process.

Figure 363. Turkey tail
(*Trametes versicolor*).

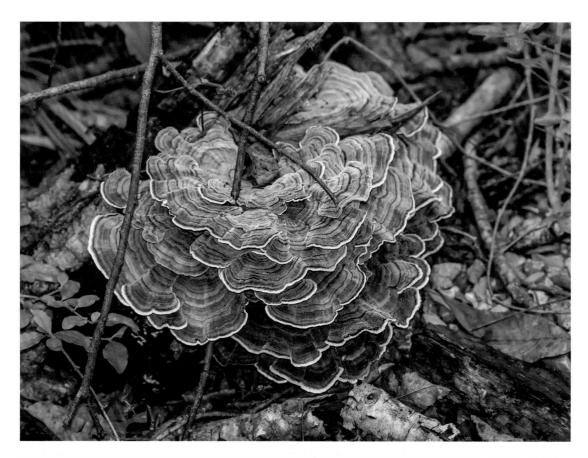

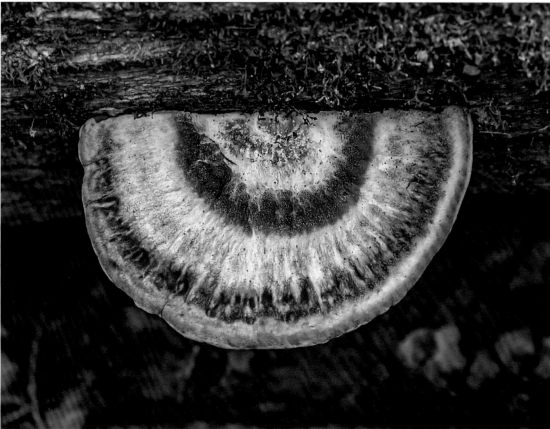

Figure 364. Bracket fungus
(*Trametes cubensis*).

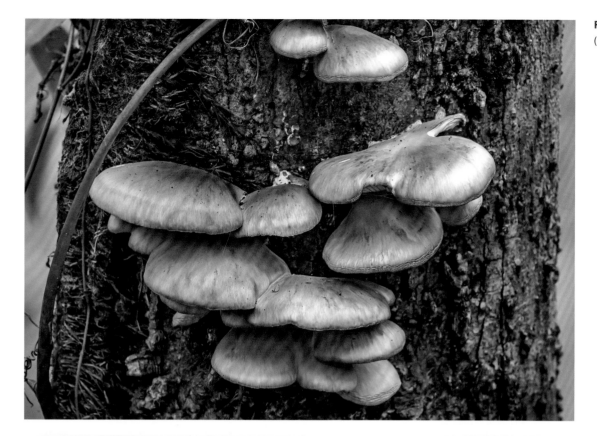

Figure 365. Oyster mushroom (*Pleurotus ostreatus*).

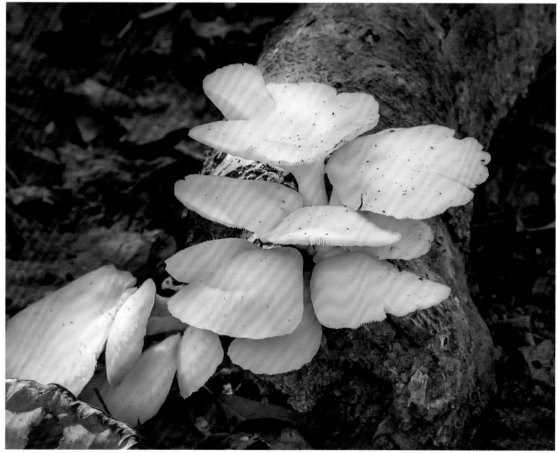

Figure 366. Summer oyster mushroom (*Pleurotus pulmonarius*).

Figure 367. Snow fungus (*Tremella fuciformis*).

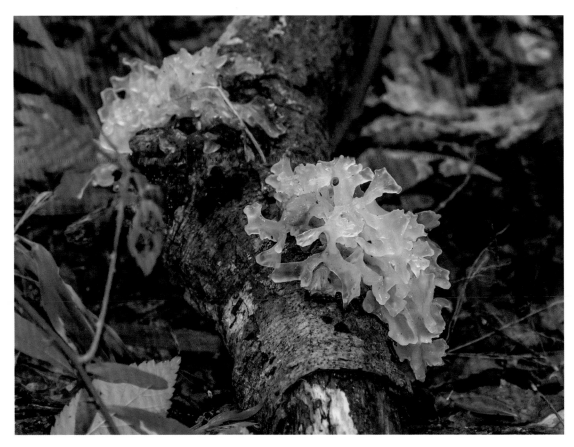

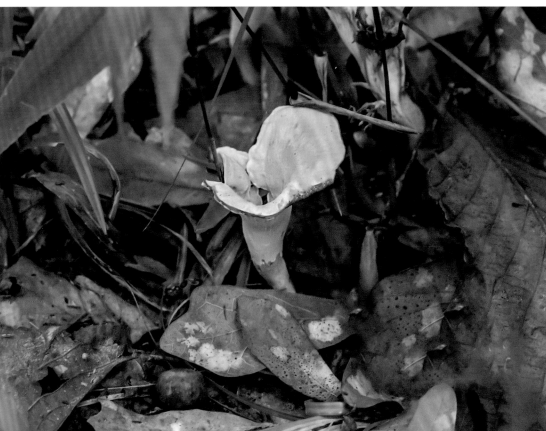

Figure 368. Smooth chanterelle (*Cantharellus lateritius*).

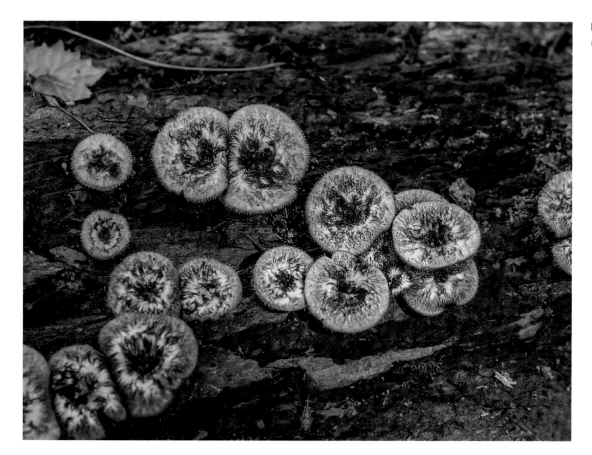

Figure 369. Fringed sawgill (*Lentinus crinitus*).

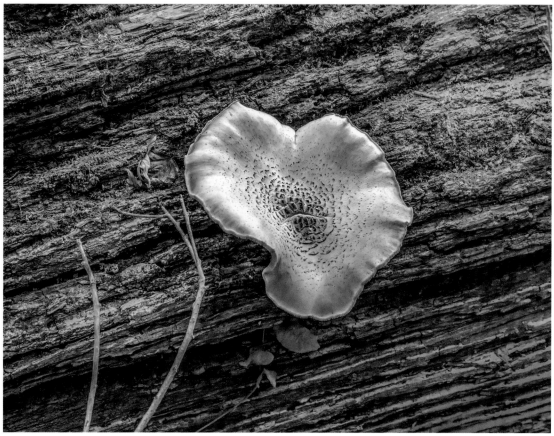

Figure 370. Train wrecker (*Neolentinus lepideus*).

Figure 371. Scaly shield (*Pluteus petasatus*).

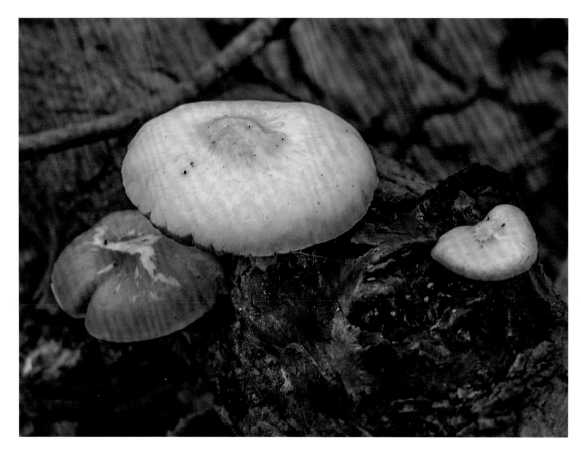

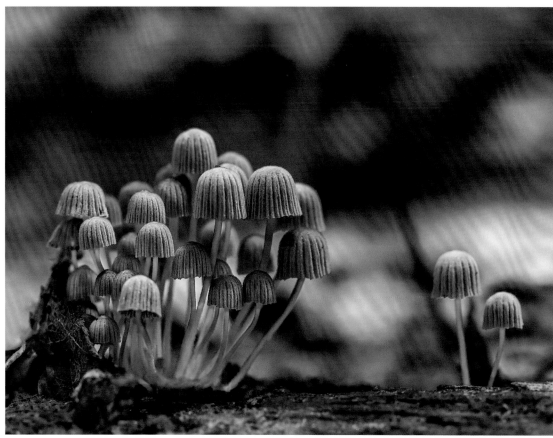

Figure 372. Trooping crumble cap (*Coprinellus disseminatus*).

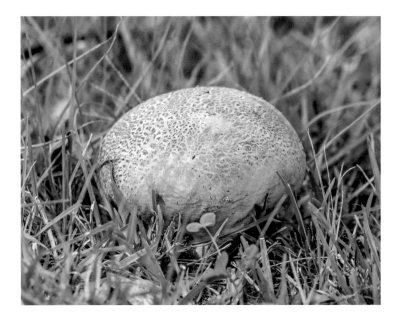

Figure 373. Purple-spored puffball (*Calvatia cyathiformis*).

Figure 374. Pear-shaped puffball (*Apioperdon pyriforme*).

Figure 375. Lion's mane (*Hericium erinaceum*).

Figure 376. Coral tooth fungus (*Hericium coralloides*).

Figure 377. Brittlegills (*Russula* sp.).

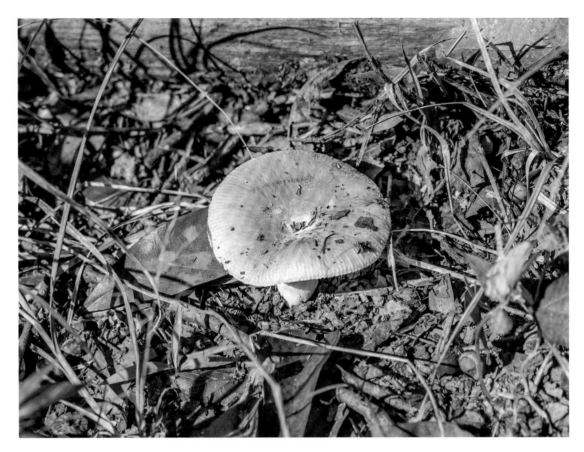

Figure 378. Green quilt russula (*Russula crustosa*).

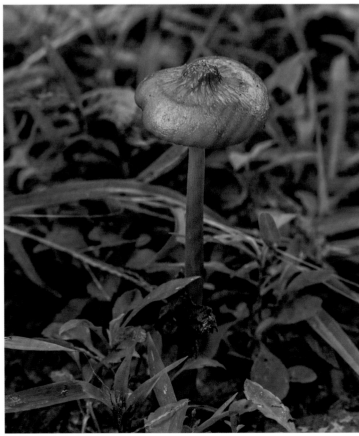

Figure 379. Rooting shank (*Oudemansiella radicata*).

Figure 380. Elbowpatch rust (*Fomitiporia punctata*).

Figure 381. Milk-white toothed polypore (*Irpex lacteus*).

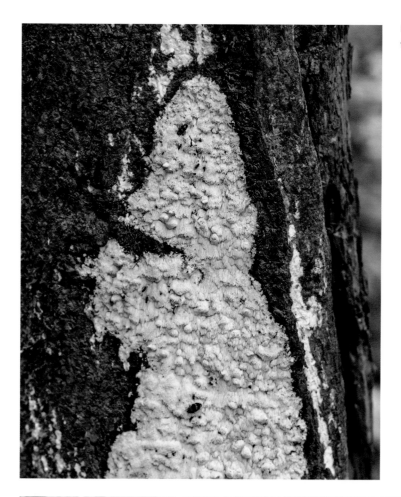

Figure 382. Split porecrust (*Xylodon paradoxus*) and two four-spotted fungus beetles (*Ischyrus quadripunctatus*).

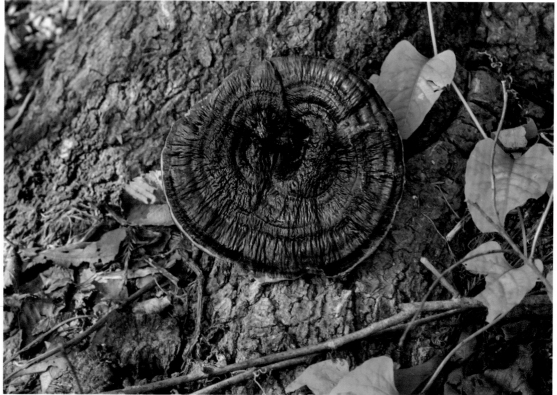

Figure 383. *Ganoderma sessile.*

Figure 384. Golden reishi (*Ganoderma curtisii*).

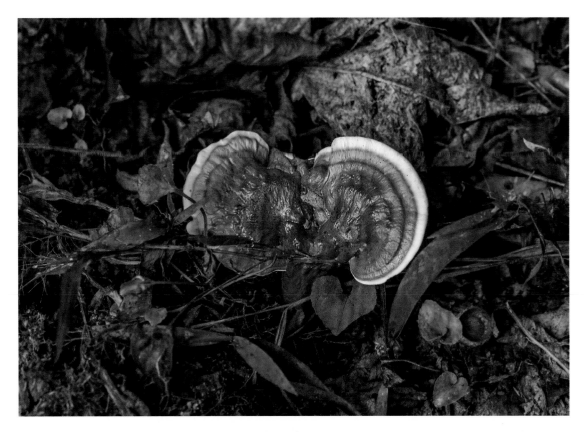

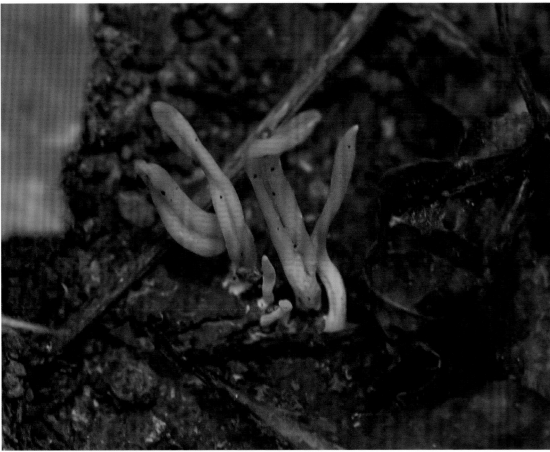

Figure 385. Spindle-shaped orange coral (*Clavulinopsis aurantiocinnabarina*).

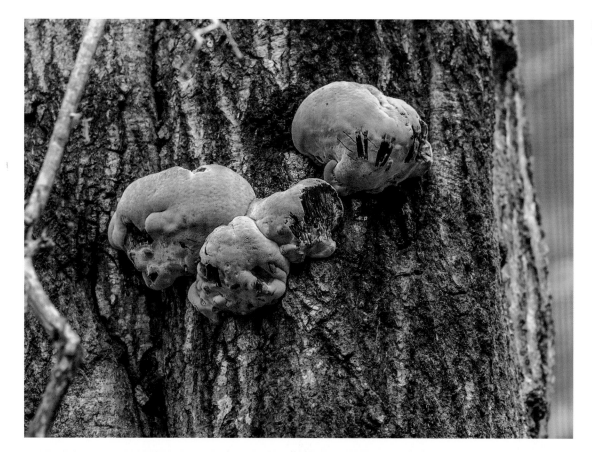

Figure 386. Shaggy bracket (*Inonotus hispidus*).

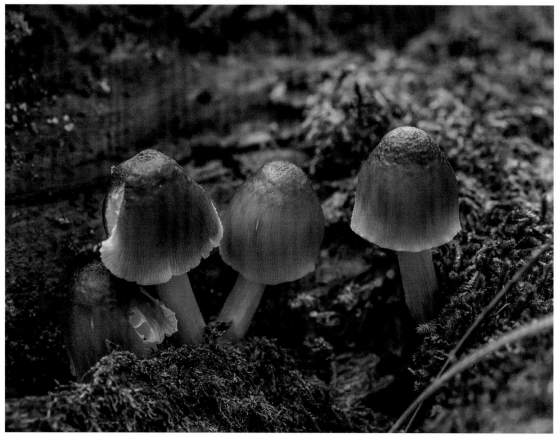

Figure 387. Clustered bonnet (*Mycena inclinata*).

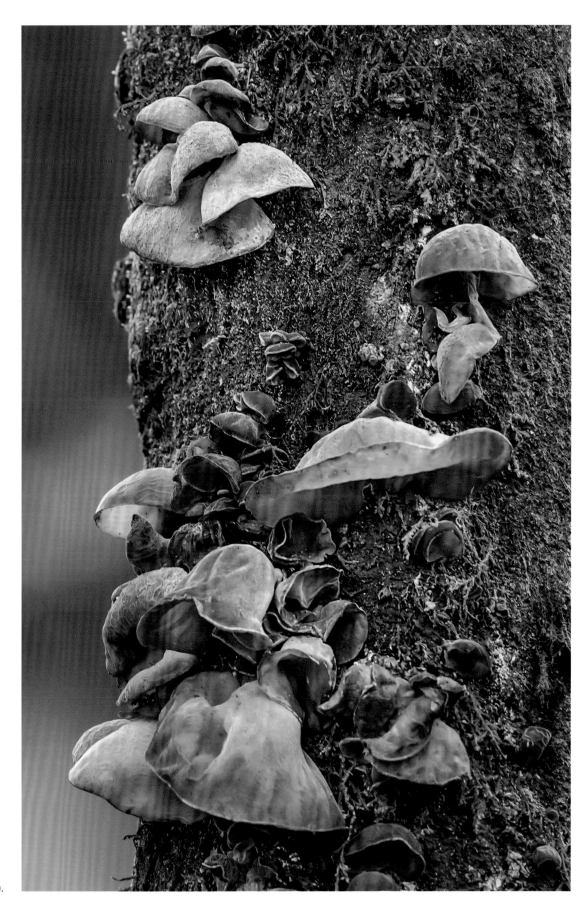

Figure 388. Wood ear (*Auricularia* sp.).

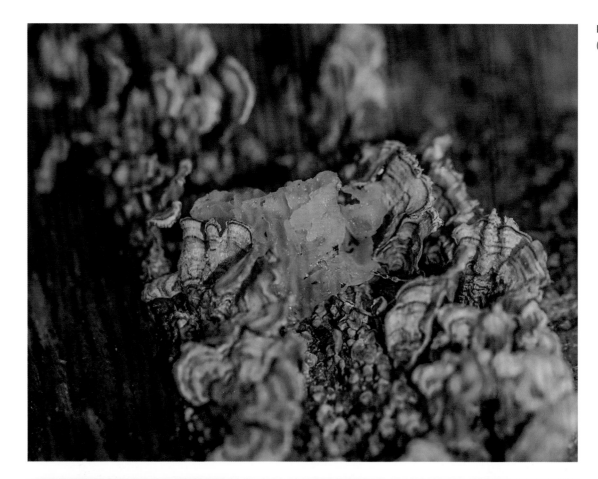

Figure 389. Golden ear (*Naematelia aurantia*).

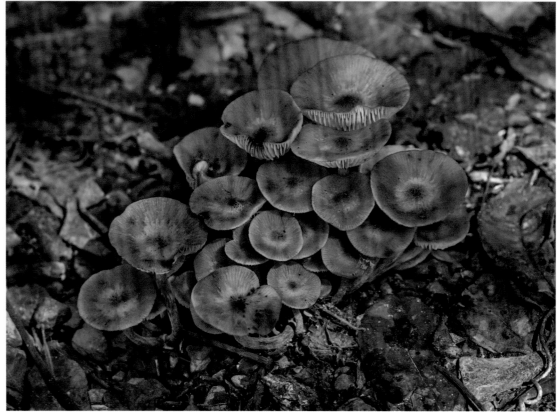

Figure 390. Ringless honey mushroom (*Desarmillaria tabescens*).

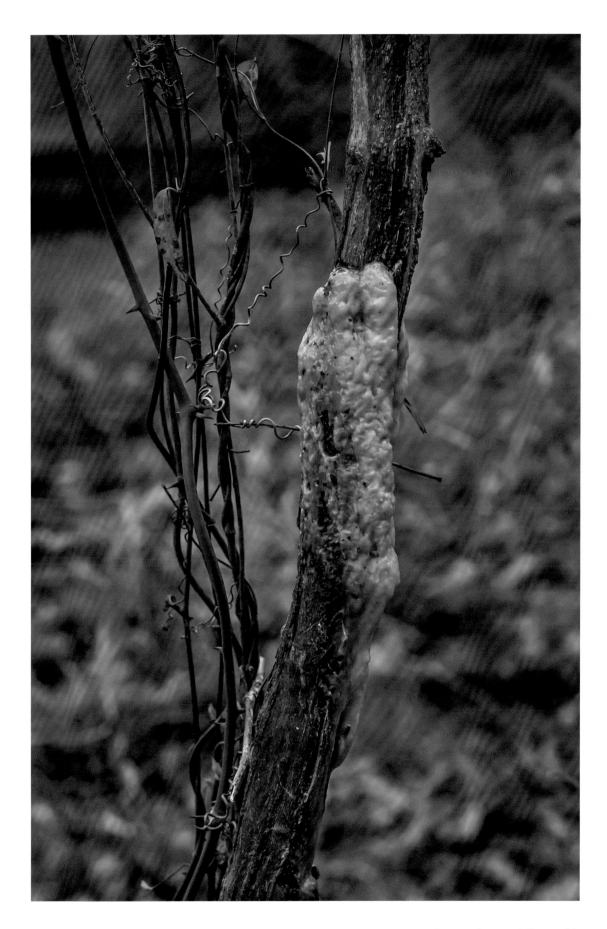

Figure 391. Deer vomit (*Fusicolla merismoides*).

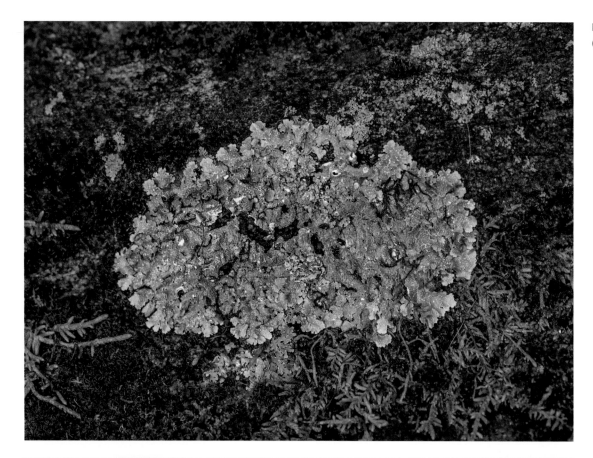

Figure 392. Rough speckled lichen (*Punctelia rudecta*).

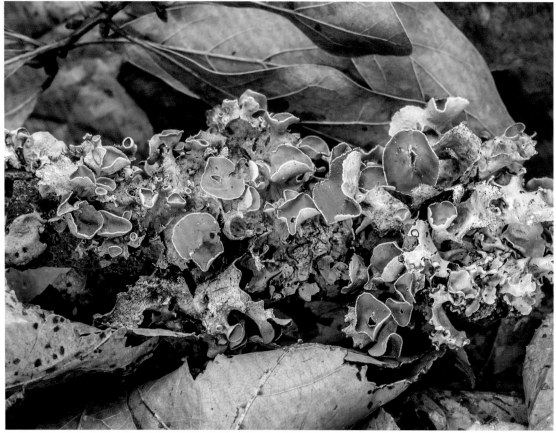

Figure 393. Perforated ruffle lichen (*Parmotrema perforatum*).

Figure 394. Bushy beard lichen (*Usnea strigosa*).

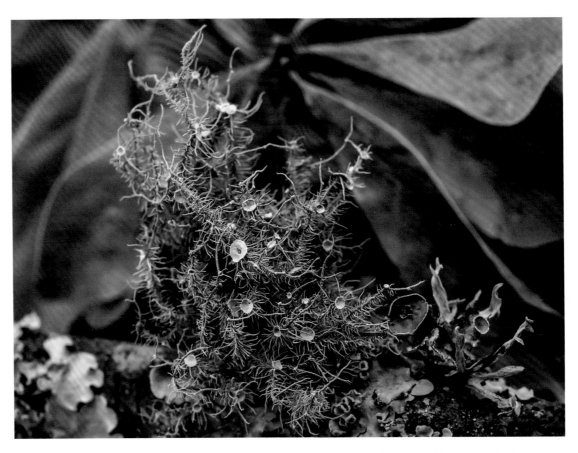

Figure 395. Fluffy dust lichen (*Lepraria finkii*).

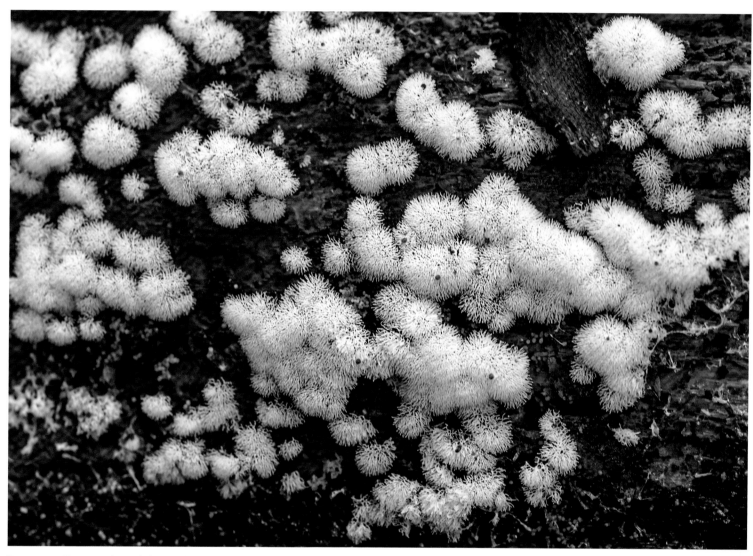

Figure 396. Honeycomb coral slime mold (*Ceratiomyxa fruticulosa*).

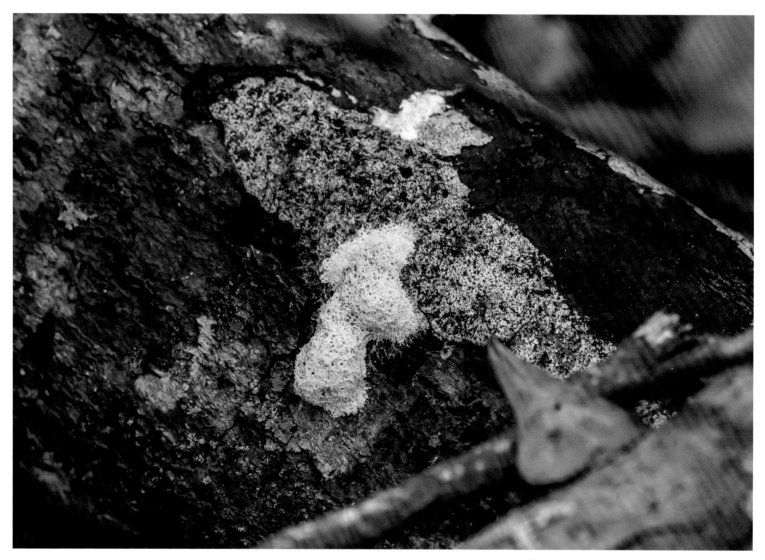

Figure 397. Dog vomit slime mold (*Fuligo septica*).

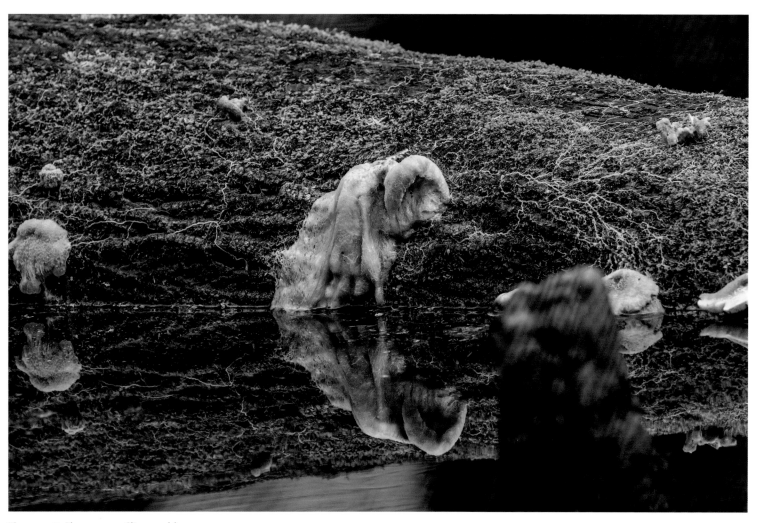

Figure 398. *Physarum* sp. Slime mold.

Figure 399. Chocolate tube slime mold (*Stemonitis splendens*).

Figure 400. Wolf's milk slime mold (*Lycogala epidendrum*).

ACKNOWLEDGMENTS

I thank Tom Mann, Scott Peyton, George Phillips, Heather Sullivan, and Nick Winstead of the Mississippi Museum of Natural Science for their comments on the original manuscript. I also thank the museum's Charles Knight and James Hill for their support.

Professor Frank Hensley of Mississippi College and Libby Hartfield and Dr. Paul Hartfield also provided valuable comments on the manuscript.

REFERENCES

Conant, R. 1975. *A Field Guide to Reptiles and Amphibians of Eastern and Central North America*. 2nd ed. Boston: Houghton Mifflin.

Davis. J. E. 2017. *The Gulf: The Making of an American Sea*. New York: Liveright.

Dockery, D. T., III. 1977. *Mollusca of the Moodys Branch Formation, Mississippi*. Jackson: Mississippi Geological, Economic, and Topographical Survey.

Dockery, D. T., III, J. C. Marble, and J. Henderson. 1997. "The Jackson Volcano." *Mississippi Geology* 18:33–45.

Galicki, S., and D. Schmitz. 2016. *Roadside Geology of Mississippi*. Missoula, MT: Mountain Press.

Le Page du Pratz, A. S. 1758. *The History of Louisiana, or of the Western Parts of Virginia and Carolina*. Baton Rouge, LA: Claitor's, 1972.

Prum, R. O. 2017. *The Evolution of Beauty*. New York: Anchor.

Sibley, D. A. 2014. *The Sibley Guide to Birds*. 2nd ed. New York: Knopf.

Turcotte, W. H., and D. L. Watts. 1999. *Birds of Mississippi*. Jackson: University Press of Mississippi.

US Department of the Interior, US Geological Survey. *Jackson, Mississippi Quadrangle 7.5-Minute Topographic Map*. 2022. Available at www.usgs.gov.

Wieland, R. G. 2000. "Ecology and Vegetation of LeFleur's Bluff State Park, Jackson, Mississippi." *Journal of the Mississippi Academy of Sciences* 45:150–85.

Yancy, J. 2017. "Louis LeFleur, Frontiersman." *Mississippi Sideboard*, March 18, 2017. https://jesseyancy.com/louis-lefleur-frontiersman/.

INDEX OF SCIENTIFIC NAMES

INDEX OF COMMON NAMES

ABOUT THE AUTHOR

Wesley L. Shoop earned a doctorate in parasitology from Louisiana State University before becoming an assistant professor of parasitology at Murray State University. After several years there, he joined the Merck Institute for Therapeutic Research, where he worked on an antiparasitic drug, ivermectin, with William Campbell, who won the Nobel Prize in medicine for that discovery. Shoop and Campbell also discovered the antiparasitic drug eprinomectin. During his two decades at the Merck Institute, he became head of the parasitology group and published more than one hundred scientific articles in peer-reviewed journals. After retiring from Merck, he joined DuPont as vice president and global head of animal health, where his discoveries included afoxalaner, the active ingredient in NexGard, the first oral drug against fleas and ticks in companion animals. After retiring from DuPont, Shoop moved to Mississippi and began photographing and identifying the flora and fauna in LeFleur's Bluff State Park. In this book, he shares some of the nearly one thousand species he has found.

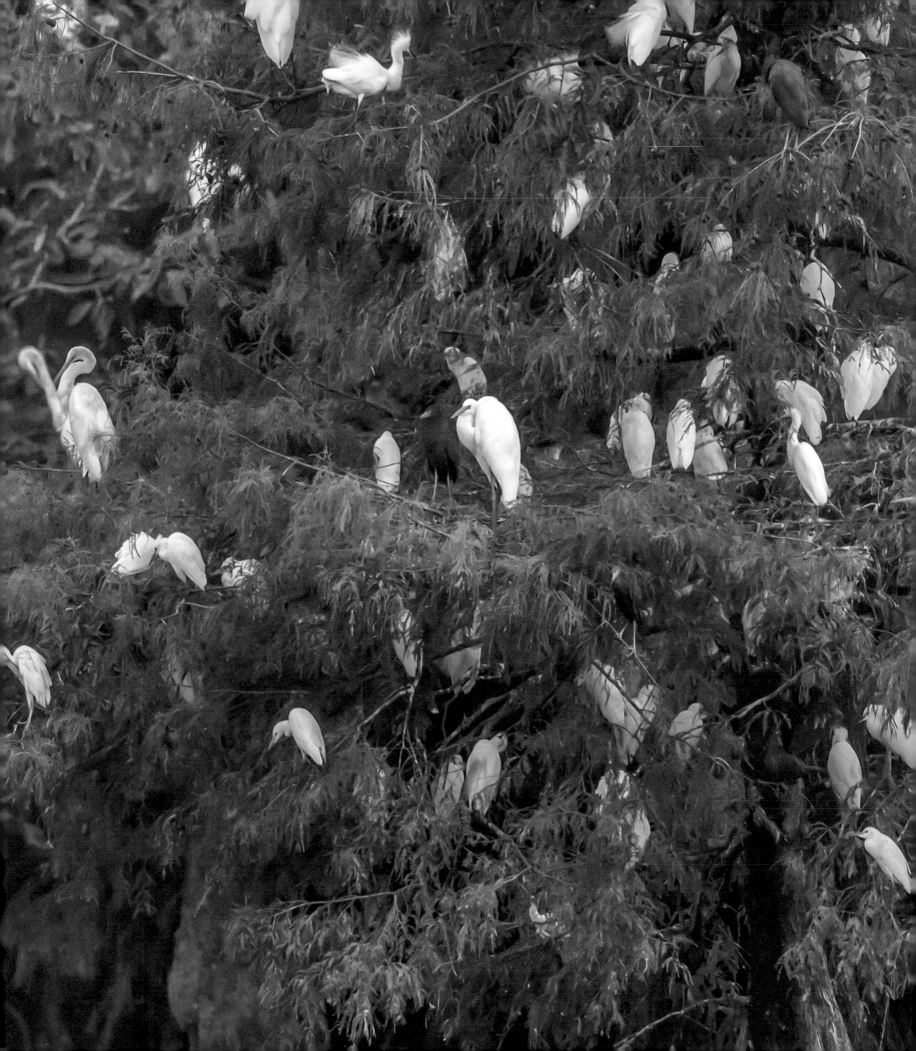